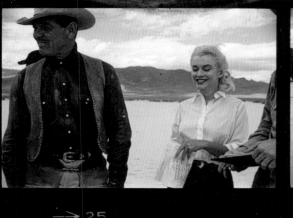

→ 25

→ 26

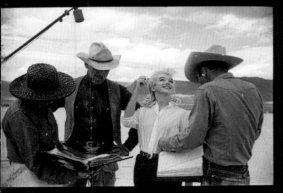

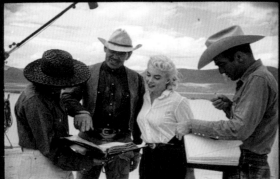

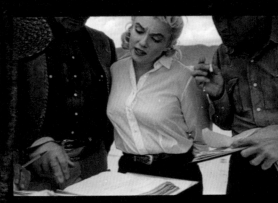

→ 19

→ 20

→ 21

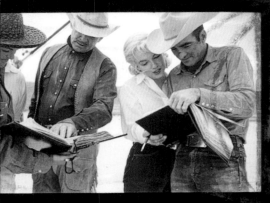

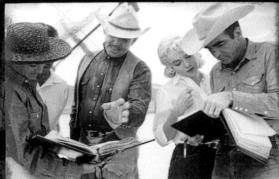

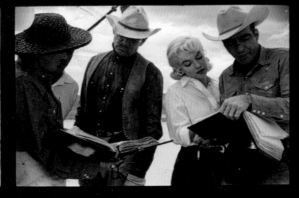

→ 13

→ 14

→ 15

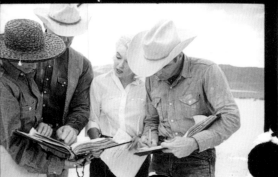

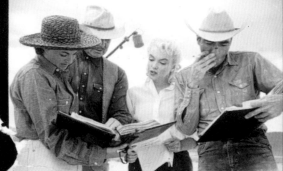

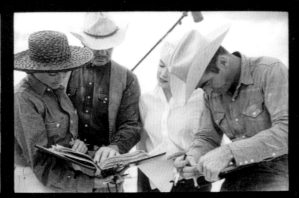

MAGNUM LEGACY

Eve Arnold

Janine di Giovanni

MAGNUM LEGACY
EVE ARNOLD

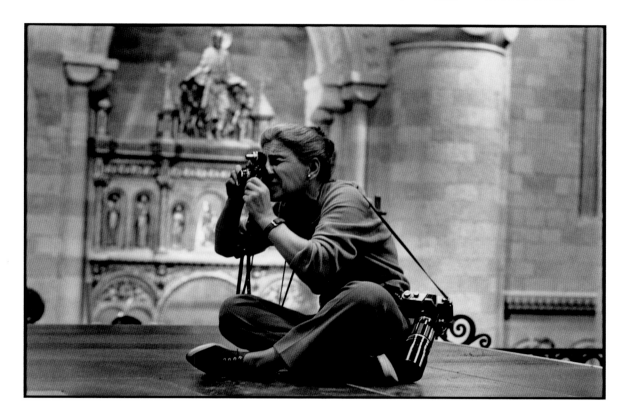

Magnum Foundation

Prestel Munich · London · New York

What do you hang on the walls of your mind?

—Eve Arnold

The Magnum Foundation's Legacy Program preserves and makes accessible materials related to Magnum Photos and the larger history of photography to which it has uniquely contributed. This series explores the creative process of Magnum photographers, from the agency's founders to its contemporary members, through a mix of biographical text, archival materials, and iconic imagery.

Managing Editor: Andrew E. Lewin
Series Editor: Carole Naggar
Advisory Board: John P. Jacob, Susan Meiselas, Martin Parr

CONTENTS

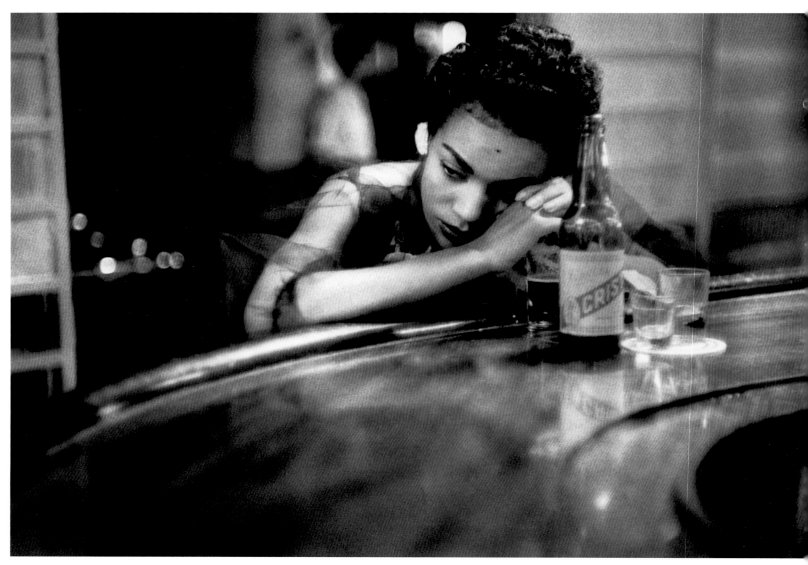

2. Bar girl in a brothel in the red-light district, Havana, Cuba, 1954

Perhaps you would notice her, perhaps not. She is the small, quick figure at the fringes of the crowd or at the center of it. She is pulled together, as if held to neat, efficient motion. Even her cameras seem part of her person. If you faced her, you would see not the lens but her dark eyes full of intelligence and sympathy. And she would have you on film.

—GENE BARO, CURATOR OF THE EXHIBITION
IN CHINA, BROOKLYN MUSEUM, 1980

3. Marilyn Monroe at premiere of *East of Eden*, New York, 1955

FOREWORD

No photographer better represents the link between the founding generation of Magnum Photos and the present than Eve Arnold. She started alongside Robert Capa and Henri Cartier-Bresson in the fifties and was an active photographer until 1997, when she was eighty-five. It is therefore fitting that this first volume of the Magnum Legacy series be devoted to her.

Arnold was among the group of photographers who struggled to keep the Magnum community going after the sudden, unexpected deaths of Capa and Werner Bischof in 1954 and David Seymour ("Chim") soon after in 1956. She learned from all of her colleagues, and her membership in Magnum transformed her into one of the renowned photojournalists of the twentieth century.

The Magnum Legacy series seeks to explore a photographer's life between and around the photographs. Through the combination of biographical text, archival materials, and iconic imagery, each book will be devoted to one former or living Magnum photographer. It will explore his or her individual creative and work process, the mechanics of story making, and the evolving relationship of photojournalism and documentary photography to the various media outlets and beyond that Magnum has served since its inception in 1947.

The idea of establishing a series of books addressing Magnum photographers and their work in the context of their lives grew out of discussions concerning how best to address the legacy of Magnum and the lessons of its past and how best to share it with a generation facing a new paradigm of photography. Barely sixty-seven years after Magnum's founding, photography is now everywhere, and anyone with a smartphone can become a photojournalist. Print magazines and other traditional outlets for photojournalism are fast disappearing while new channels such as Instagram are replacing them. The global online network is expanding photographers' visibility but not providing financial sustainability. Magnum's members have

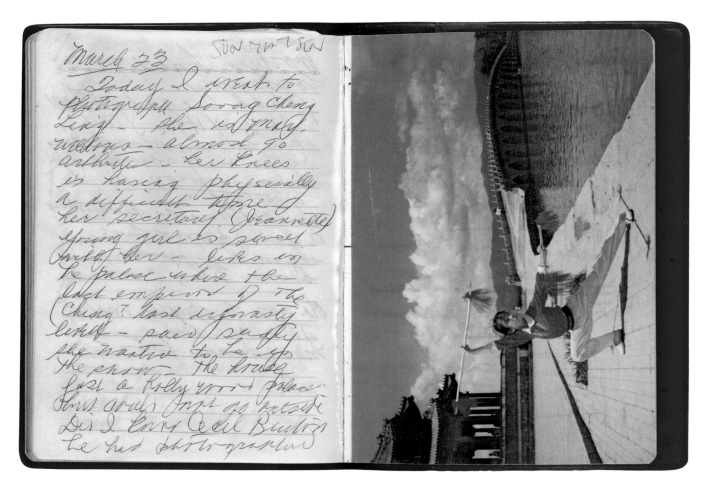

4. One of Eve Arnold's notebooks from her trip to China, 1979

come from varied backgrounds, but little has been published about how their personal experiences shaped and impacted their work, in particular their choices of what and where to photograph and their commitment to telling stories over an extended period.

The aim of the series is to examine past and present Magnum photographers through the prism of their lives and their archives. In Arnold's case, this is the first study of her work that relies on her diaries, letters, and other archival materials more than on personal reminiscences and anecdotes. Access to her voluminous papers recently deposited at the Beinecke Rare Book and Manuscript Library at Yale University made this publication possible. The book reveals a new perspective of Arnold as she transformed herself from a Long Island housewife in the early 1950s to a seasoned photojournalist for the London *Sunday Times* and other international magazines. We want to provide a window into her life as well as her photography as a way to explore the interrelationship between the two.

And Arnold's life was extraordinary. Born to a family of poor Russian immigrants in Philadelphia in 1912, the year of the *Titanic* sinking, she died in 2012 in England, nearly one hundred years old, having been awarded

an Order of the British Empire by Queen Elizabeth in recognition of her services to photography. Arnold came to her vocation by chance: in the 1940s, while she was a medical student, she received a camera from her boyfriend. The boyfriend did not last, but Arnold's passion for photography did. She took a six-week photography class with Alexey Brodovitch at the New School for Social Research in 1950 as a thirty-eight-year-old with a young child. That class would be her only formal education in photography; she learned by doing.

Arnold's photographs combine empathy with boldness, delicacy with strength. Her range over the latter half of the twentieth century is impressive. One of the characteristics of her work was her ease with people from all professions and walks of life and her ability to win their trust. She photographed migrant workers and movie stars, Malcolm X and Mikhail Baryshnikov, Marilyn Monroe and Joseph McCarthy. She photographed veiled women in the Middle East, transvestite nuns, lesbian brides, English public school girls, drug addicts, and vicars.

Proficient both in black and white and color, Arnold was drawn to landscape as well as portraiture. She also explored film and produced *Behind the Veil*, a groundbreaking and acclaimed documentary, for the BBC. Arnold was above all an accomplished and eloquent writer; for her stories, she wrote articles to contextualize her own photographs, and she most often chose to compose the texts for her books. The numerous letters and index cards in her Yale papers and the material kept at the Magnum Foundation demonstrate the depth of her convictions and commitment to her work. The archives reveal the unusual life behind the pictures and invite us to imagine the intensity she brought to the making of her photographs.

Susan Meiselas
President, Magnum Foundation

Andrew E. Lewin
Managing Editor, Magnum Legacy series

I was born poor, in America, of Russian immigrant parents. I went to work early, and, working, had to prove myself.[1]

1. BORN POOR IN AMERICA

Eve Arnold was the fifth of ten children, born in Philadelphia on April 21, 1912, to William and Bessie Cohen. Her parents, originally named Velvel Sklarski and Bosya Laschiner, were Jewish immigrants from Ukraine who at the turn of the century had fled pogroms and poverty only to struggle in their new home. Crammed into a small frame house in a neighborhood that Eve later called "strange and tumbledown," the Cohens were surrounded by other European immigrants, all of them trying to get a foothold in a foreign culture where they could not speak the language.

William had trained as a rabbi. An educated man who tried to do his best for his children, he taught them to relish books and spirited discussion, but without hope of regular work for himself, he became a rag-and-bone man, trundling through the streets with his horse and cart while Bessie took in laundry. In the 1920s, the family was further devastated when, back in the Ukraine, Bessie's brother, his wife, and their eight children were murdered in a pogrom and when two of Eve's siblings died in infancy. It was left to Bessie, the indomitable matriarch who could barely read, to hold the family together and put a brave face on things.

Gertrude Cohen, Eve's sister-in-law, recalls an often-told family story that Bessie sometimes left a pot of water boiling on the stove for hours so that the neighbors would think she was making soup. "It would have been unthinkable for her to let the neighbors think she had nothing to feed her children," Cohen recalls. "[Anything] rather than the truth—that there was simply no food."[2]

Born the year of the *Titanic*'s sinking, Eve grew up at a time of great change, one that saw horse-drawn carriages replaced by automobiles and the rapid spread of new technologies such as radio and motion pictures.

5. Self-portrait, improvised in a studio, Philadelphia, 1948

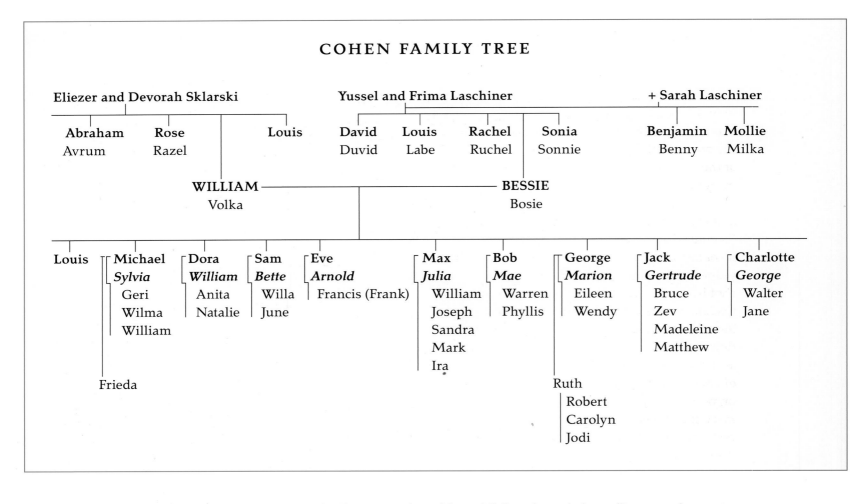

COHEN FAMILY TREE

Eliezer and Devorah Sklarski

Abraham	Rose	Louis
Avrum	Razel	

Yussel and Frima Laschiner

David	Louis	Rachel	Sonia
Duvid	Labe	Ruchel	Sonnie

+ Sarah Laschiner

Benjamin	Mollie
Benny	Milka

WILLIAM ——————— **BESSIE**
Volka Bosie

Louis	Michael	Dora	Sam	Eve	Max	Bob	George	Jack	Charlotte
	Sylvia	*William*	*Bette*	*Arnold*	*Julia*	*Mae*	*Marion*	*Gertrude*	*George*
	Geri	Anita	Willa	Francis (Frank)	William	Warren	Eileen	Bruce	Walter
	Wilma	Natalie	June		Joseph	Phyllis	Wendy	Zev	Jane
	William				Sandra			Madeleine	
					Mark			Matthew	
					Ira				
	Frieda						Ruth		
							Robert		
							Carolyn		
							Jodi		

6. Cohen family tree

As Eve remembered her childhood much later, "images of poverty, laughter, irritation, bare feet (shoes were at a premium) and love crowd each other."[3] Everyone went to the dilapidated film house, which the Cohen kids called "the Spittoon." Eve remembered it well. "I would be eight or so, my parents would give me a nickel and I would go every Saturday. Those films affected my thinking and my living. They affected all our lives."[4] Small for her age, inquisitive, and independent, Eve roamed her neighborhood and, maybe without realizing it, observed the lives of the poor and the voiceless in a way that influenced her future work.

Meanwhile, she had to do her part to support the family. Encouraged by her father to be both confident and ambitious, she flirted with the possibilities that might await her. She thought of being a doctor, a writer, or a dancer, and she was fascinated with color and the images that flooded her mind. However, like her older siblings, she left high school knowing that a college education was not affordable. Instead, she went to business school, as her sister Dora had done, to train as a secretary, and she ended up in a prosaic day job as a bookkeeper in a local real estate office, while taking

basic premed classes at night.[5] Eve's father died after a long illness when she was twenty-two, and after that, it was inevitable that she would eventually leave to pursue the more fulfilling life he had imagined for her. In 1943, at the age of thirty-one, she finally made her break and moved to New York.

Eve's archive at Yale University's Beinecke Rare Book and Manuscript Library is exhaustive in many ways, but it's oddly devoid of information about her early life. While it contains a comprehensive record of her work over fifty years—ideas noted on index cards, letters, tearsheets and shot lists, interviews—it is not a trove of personal information. Her schooling, her friends, the impulse that made her take up photography, her love affairs (if any), the wartime move to the city—none of that is documented. Maybe as a self-made woman, proud of her achievements, she did not want to dwell on her poverty-stricken background or, years later, on the hurt she felt after the breakup of her marriage. Whatever the cause, until the day she died, she remained resolutely private about personal matters, and the gaps in the archives reflect that.

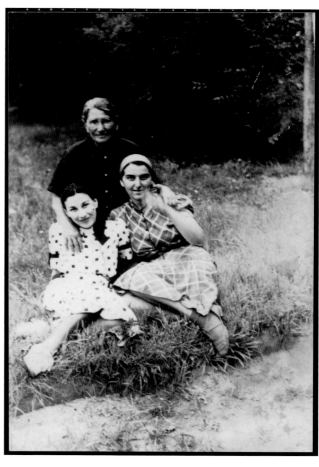

7. Gert Cohen with her two daughters, ca. 1925. Eve Arnold is on the left

In the war years, New York was tumultuous, exciting, and wide open. Eve found an opportunity that sounded promising through an advertisement in the *New York Times*. The job description called for an "amateur photographer," but when Eve arrived for the interview, she learned that her employer would be Stanbi Photos, a photo-processing plant in Hoboken, which meant a daily commute from New York to New Jersey to work in what was essentially a huge factory. Somehow the manager convinced a reluctant Eve to take the job, and what had initially seemed like a way to finance her escape from Philadelphia turned into something more valuable—a first foray into learning about photography and the technical skills necessary to develop and process film.

Stanbi Photos "was run like a Ford plant with conveyor belts," Eve said later. "And these pictures, hundreds of thousands, millions of them going down the conveyor belt, and I had to train people. . . . During the war, there were very few trained people around—including me. I was an amateur and bluffed my way through it." Part of her job involved managing Chinese men. She said, "You hired whoever you could get your hands on. . . . I'd like to think I was imaginative."[6] Bluffing was a skill that would prove important in Eve's later professional life.

She had natural authority. From her early days as a seventy-five-dollar-a-week supervisor in charge of cutting and inspecting pictures, she rose to plant manager, and she became so well respected that she was sent to Chicago for a year to set up a new plant there. Eve later said that the five years she spent at Stanbi laid the foundation for her later work as a photojournalist. "Each day I had to handle new problems," she wrote. "I was involved in technology and I was involved with people."[7]

The camera that started her life's work was a forty-dollar Rolleicord that took a roll with twelve square-format exposures. It is unclear when and where she got it. All she ever said was that a boyfriend had given it to her. After work and on weekends, she wandered New York City with it, taking black-and-white shots of urban life: "The usual amateur delights," she later wrote, with her customary acerbity. "Drunken bums sleeping in the Bowery, sun glinting off rope, texture of paint peeling off walls . . ."[8]

While at Stanbi, she met and fell in love with Arnold Arnold, a Jewish refugee from Hitler's Germany, and they married in 1943. Much about their courtship and life together is mysterious; the marriage ended in bitterness, and Eve never discussed her feelings about Arnold with anyone, even her son, Frank. What is known is that Arnold's original surname was Schmitz, and he grew up wealthy. His family had owned a department store in Frankfurt, but they lost everything when they fled to England in 1934. Thirteen-year-old Arnold was admitted on scholarship to an English boarding school, and he later attended London's prestigious Saint Martin's School of Art, where he trained as an industrial designer. In 1941, he emigrated to America, leaving his name behind.[9] As Frank Arnold says today, "He didn't want to be a Jew in Germany, or a German in the States."[10]

At first glance, the two seemed an unlikely match. Eve had risen from the ghetto to become an independent and outspoken woman with ambitions. At thirty-one, she was well past the marrying age for the time. Arnold was much younger than her, a sensitive twenty-two-year-old, brilliant and worldly, but traumatized by what he had seen as a child in Germany. Frank speculates that his mother was drawn to the young man's sophistication and artistic sensibility, while Arnold depended on Eve's feisty determination to protect his damaged soul and propel him forward.[11]

During World War Two, as a newlywed, Arnold was drafted into US Army intelligence, sent to France, and badly wounded when his jeep hit a landmine. Back in America with a Purple Heart and a mangled leg, he spent over a year recuperating in Eve's care. In their early married years, the two were happy. Arnold ran a design school in New York, and excited by his wife's potential, he actively encouraged and influenced her as she taught herself to

take pictures. When she signed a contract with a record company to design photographic record covers, the two of them collaborated on the project.[12]

In 1948 the couple had a son, Francis, known as Frank (fig. 8). Eve left Stanbi to care for her baby, but she was becoming more and more interested in her photography and soon felt restless. Despite her burgeoning expertise and abundant creative energy, she was a new mother without a formal photographic education, and she had no idea how to move forward. Then in 1950, a friend told her about a six-week course at the New School for Social Research in New York City, and with her husband urging her on, she enrolled.

The class was led by Alexey Brodovitch, the renowned art director of *Harper's Bazaar* (fig. 9). A Russian-born aristocrat, he had fled to Paris in 1920 and settled in Montparnasse, surrounded by artist-friends such as Archipenko, Chagall, and Nathan Altman. He made a career designing sets for Diaghilev's ballets and advertising posters before immigrating to America and finding his niche at the magazine.

Brilliant, mercurial, and moody, Brodovitch challenged his students—who ranged from amateurs to professionals such as Richard Avedon and Irving Penn—to avoid clichés, capture the essence of a situation, use their mistakes, and look within themselves for the solutions to problems. "When the novice photographer starts taking pictures, he carries his camera about and shoots everything that interests him," he said. "There comes a time

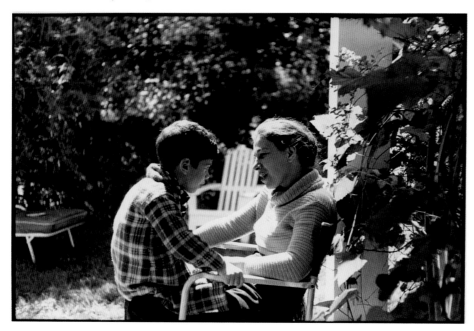

8. Eve Arnold and her son, Frank, ca. 1956

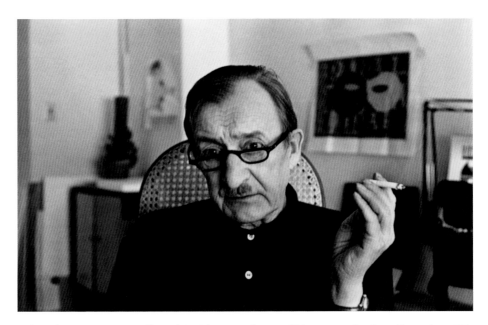

9. Alexey Brodovitch, New York, 1962.
Photo: Henri Cartier-Bresson

when he must crystallize his ideas and set off in a particular direction. He must learn that shooting for the sake of shooting is dull and unprofitable."[13]

Brodovitch's six-week class turned out to be the only formal training Eve ever received, and it was life-changing. Eve remembered that Brodovitch would begin by saying in a soft, heavily Russian-accented voice: "Is Socratic method. I will not teach. You will learn from each other." Each week he would assign a subject for the pictures they were to take: "They were broad-based, like fashion, or a record cover. We would return for the next session clutching our offerings, then the master would collect them all and hold up each picture and let the class loose to criticism. Often the photographer would explain or defend what he was trying to do. But the free-for-all was lively and stimulating and had the effect of spurring on the more intrepid."[14]

Lively or not, Eve's first experience was crushing. Reluctantly, she was pushed into showing her first amateurish pictures, and the class found fault with them, one after another. It was brutal; she felt "flayed alive." Arnold comforted her. She recalled, "I was married to a very sympathetic, understanding man who said, 'You don't have to go back to that class.' . . . We spent the next day walking around New York, with me trying to get my ego back in shape."[15] Of course, she went back, and in later years she wrote, "I learned more that night about the meaning of a photograph than I have learned from anyone since. It was my true start."[16]

Brodovitch liked to tell his students that he was looking for an "element of surprise," and when he assigned a fashion story, it was Dora, Frank's nanny, who helped Eve find that element. At home, Eve was worrying aloud about how to bring a fresh sensibility to the artificiality of fashion photography, and Dora mentioned that in Harlem there were more than three hundred fashion shows a year. In those days, the fashion world ignored black

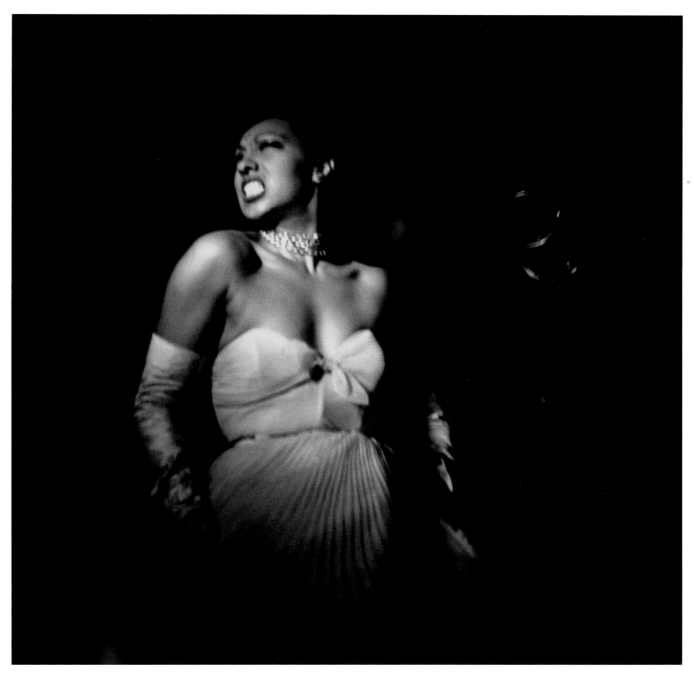

10. Josephine Baker, Harlem, 1950

women, who resorted to making their own designs and showing them on models from the agencies Sepia and Black & Tan. Eve contacted Edward Brandford, who ran the agencies, and he invited her to meet his star model, Charlotte Stribling, known as "Fabulous."

In the 1950s, even a cosmopolitan city like New York was segregated, and if white people ventured north to Harlem, it was only for the nightlife at the clubs. Eve was under five feet tall, with a long, prematurely gray braid of

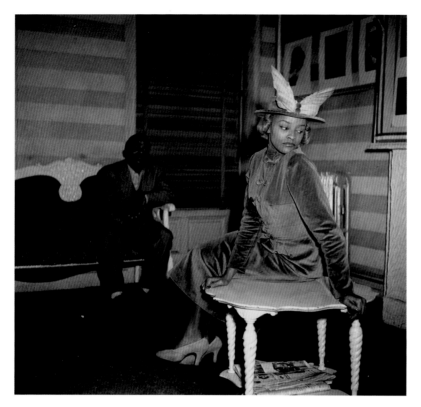

11. Charlotte Stribling, aka "Fabulous," poses in Harlem-made clothes in a nightclub, New York, 1950

12. "Fabulous," stepping onto the stage, New York, 1950

hair that she often twisted into a chignon, and she could hardly go unnoticed. Nonetheless, she took the subway to capture the world of the shows—as a reporter rather than a fashion photographer.

The project was daunting. The all-black audiences were surprised at her presence, and when they saw her camera, people inevitably smiled or struck poses, but Eve managed to slip backstage and get the informal images that she wanted. Because the shows took place in all sorts of venues, from bars to nightclubs, the lighting was always a problem. "I started out with flash on my one and only camera—a forty-dollar Rolleicord—but, when the mechanics failed, wound up shooting Blacks in badly lit rooms without additional lights and then spending hours developing and pushing the film to get a moody murky print."[17]

This radical, new combination of a handheld camera and available light was to become Eve's trademark. Even more significant for her future career was her decision to follow the models backstage so that she could shoot them journalistically, without the smiles and the poses. Just as Brodovitch had instructed, she captured their essence. She later said, "I was not aware that you didn't follow them—and I've done it over the years . . . simply out of a wish to learn, not to be prurient."[18]

Despite her difficulties, the images she produced were extraordinary, not least because of the radiant presence of Fabulous, who, said Eve, "moved like a golden animal—a leopard, perhaps, or a tiger."[19] Fabulous had a uniquely modern sense of fashion—she dyed her hair blond, and she was a natural at presenting herself for Eve's camera, whether she was on the runway, applying makeup, trying on clothes, or doing stretching exercises (figs. 11, 12).

In learning how to navigate this foreign environment, Eve honed the skills that she later used in her intimate portraits of Marlene Dietrich and Joan Crawford. She also developed what would become a major theme for her work—documenting the lives of black Americans at the dawn of the civil rights era.

When Eve nervously handed over her portfolio, Brodovitch kept it back, saying to the class, "I will talk about these myself." He showed her pictures last, commenting that they were the most interesting fashion

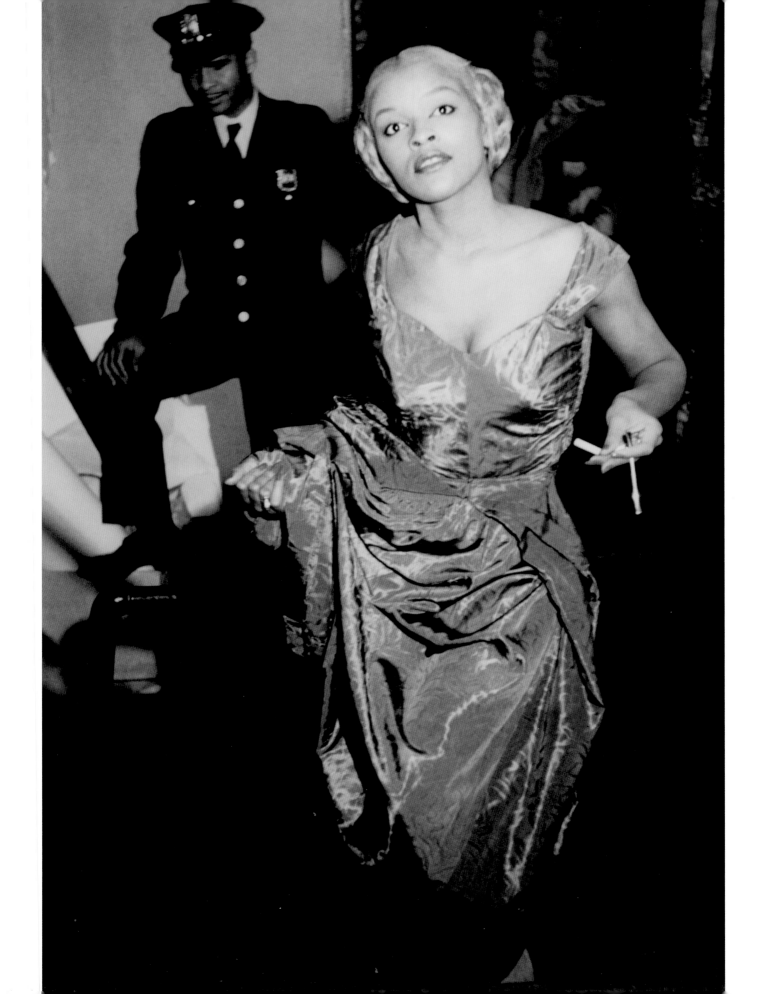

13. A beauty class for young black women, New York, 1950

14. Models taking off their makeup at Harlem fashion show, Abyssinian Baptist Church, New York, 1950

photography he had seen in a long time. Eve had turned an accident into an opportunity and achieved a dark, brooding quality not seen in fashion photography at the time. Her candid approach recalled the work of a photographer she did not know: Martin Munkacsi, a Hungarian sports photographer whom the editor of *Harper's Bazaar* had hired in the 1930s for his informal, freewheeling approach. Brodovitch instructed Eve to go back to Harlem instead of moving on to the next assignment with everyone else.

She did as he suggested. On weekends for a year or so after the class had ended, Eve photographed models and dressmakers, documenting skin whitening and hair straightening and, as she put it, "recording social history." Her pictures were intimate, dramatically different from the rigidly formal fashion photographs of the day (figs. 13–15). It was unprecedented to see models looking so unself-conscious and relaxed, let alone black models, and no American picture magazine was interested. This infuriated Arnold. He still had professional contacts in England, and without telling Eve he sent the images to *Picture Post*, a well-respected English magazine.

The editor loved them and ran the story over eight pages (figs. 16, 17), but—and here was an important lesson for the aspiring photojournalist—he used a writer who misrepresented what she had done and sounded patronizing toward the models. Eve never forgot how much her point of view had been distorted. For the rest of her life, she fought to retain editorial control over her work and, whenever possible, wrote the accompanying text herself. Liz Jobey, a journalist who came to know Eve in the Magnum years, later wrote: "She prided herself on writing the captions and often wrote longer texts to support her pictures. She had learned early on, when her captions had been altered by editors, that it was not only the rights to her photo-

15. Modeling shoes at the Abyssinian Baptist Church, New York, 1950

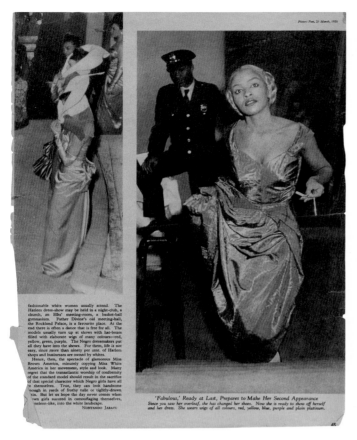

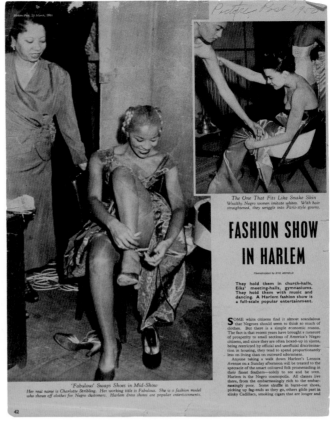

16, 17. Tearsheets from "Fashion Show in Harlem," *Picture Post*, 1952

graphs that she had to protect, but her words. And she was not the sort of photographer who believed pictures could tell the whole story."[20]

With one published piece to show and a list of possible ideas, Eve doggedly made the rounds of the picture and women's magazines, but without success. Undeterred, she talked a publicist into letting her photograph opening night at the Metropolitan Opera, and she also started documenting the gritty world of Times Square (fig. 18). Shot in square format, the pictures highlighted the giant clothing publicity billboards that were still a novelty at the time, the neon illuminations and the posters on the walls of the Hubert's Museum, a peep show. Years later, she remembered vividly "the people who roamed the streets, the all-night honky-tonk joints, the flea circus, the dance halls and the peek-a-boo vending machines." Photographing New York was "a total education—I saw a lot and I learned a lot . . . how to move quickly, to react instantly or to wait for the right moment."[21]

In 1951 the family began spending summers in Brookhaven Township, on the North Shore of Long Island, and Eve realized that this quiet rural enclave could be a rich source for stories. She started what would turn out to be a ten-year project on one family, the Davises, whose Long Island roots dated back to 1710. "This chronicle," she later wrote, "was almost too good to be true. American Gothic faces, the same family on the same land

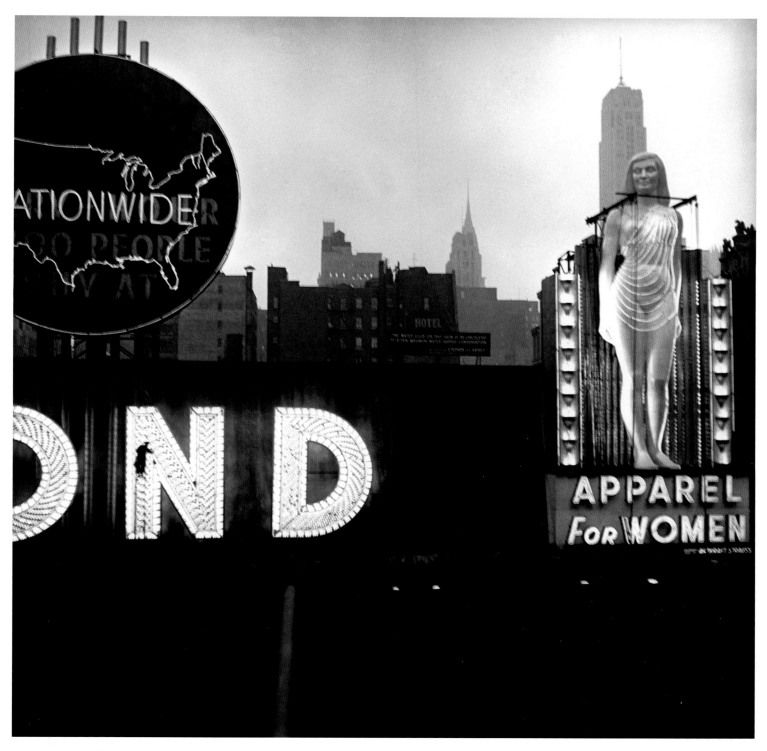

18. Times Square, New York, 1950

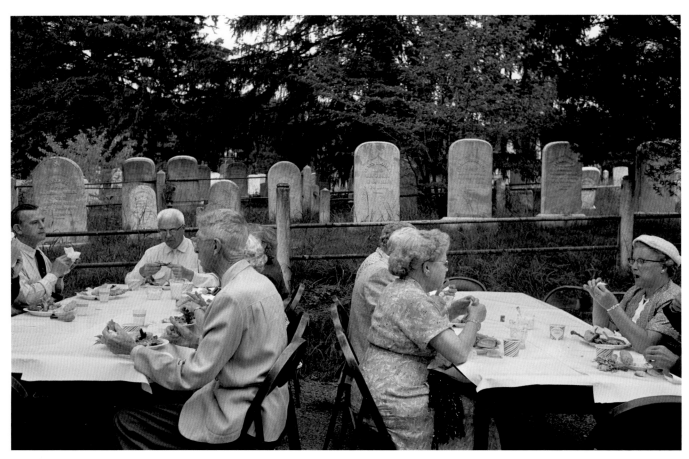

19. The Davises eat their church supper near the tombs of their ancestors, Brookhaven, Long Island, 1958

20. Contact sheet from the essay "Migrant Workers" showing Eve Arnold's edits, 1951

for almost two and a half centuries."[22] She photographed them at the court-house and the library, at clambakes and meetings of the Daughters of the American Revolution. In one striking image, the Davises are pictured having a church supper near the tombs of their ancestors (fig. 19).

Arnold suggested that she also photograph the migrants who worked all summer in the Davis family's fields. Picking strawberries and sorting potatoes, they lived in overcrowded, insanitary, ramshackle camps. Eve spent days with them, in their living quarters and in the fields, trying to capture their daily struggle (figs. 20–25). She later typed the following words on an index card that she taped to the back of one of her photographs: "I have never been as shocked as when I entered the one-room shacks with the old iron bedsteads and thin pads, with one shaded bulb, in which as many as eight to ten people sleep . . . no toilet facilities, no water . . . it's below the lowest possible standard of 30 or 40 years ago, let alone today's standards."[23]

Eve again used her Rolleicord, working without flash in low, murky light, which gave the pictures a haunting stillness and intimacy. In one image (fig. 25), taken inside the workers' shed, a ray of sunshine falls on an enamel dish almost empty of food and on the profile of a man, whose face betrays melancholy, loneliness, and resignation. The workers in the background are left

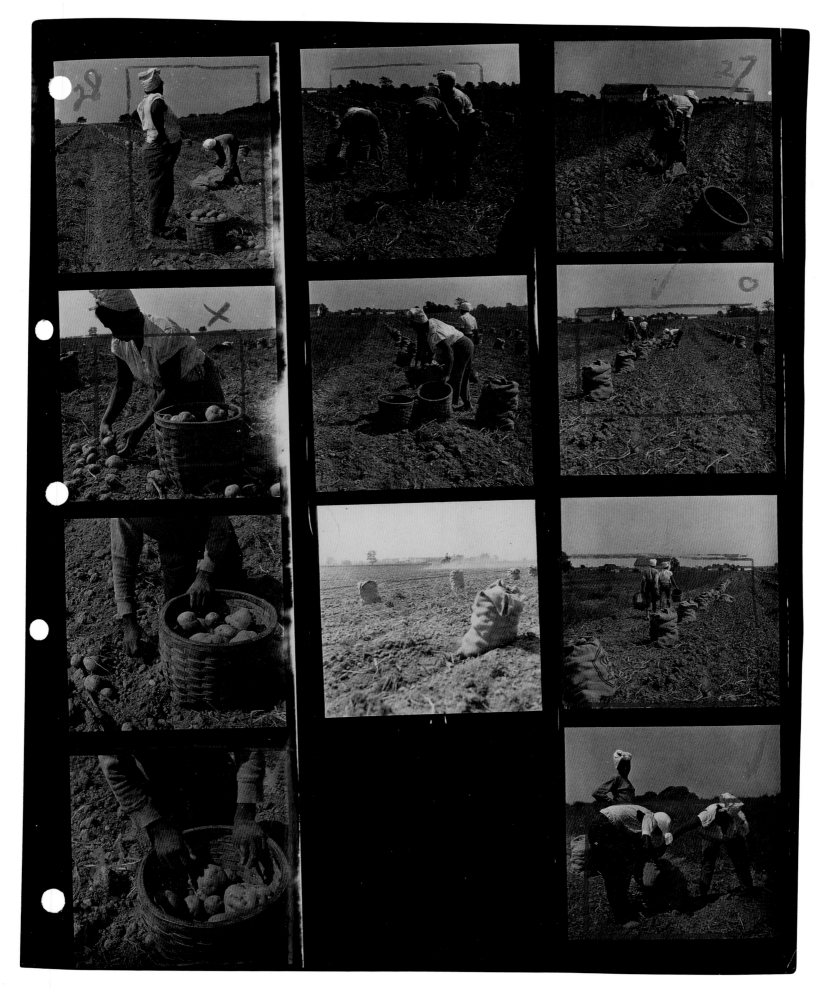

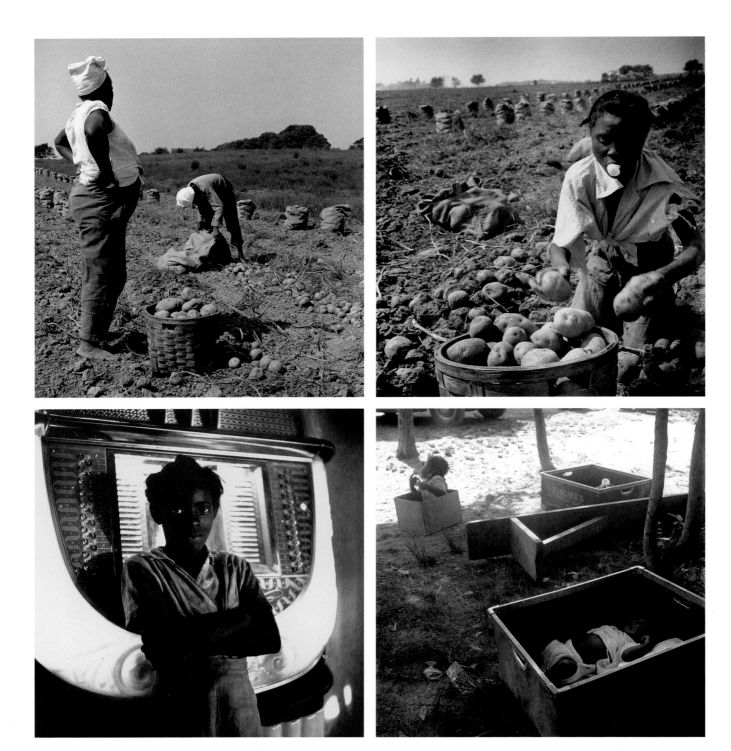

21, 22. Migrant workers sorting potatoes, Port Jefferson, Long Island, 1951

23. Daughter of migrant potato pickers, Port Jefferson, Long Island, 1951

24. Migrant labor camp, Port Jefferson, Long Island, 1951

25. Inside the workers' shack, Port Jefferson, Long Island, 1951

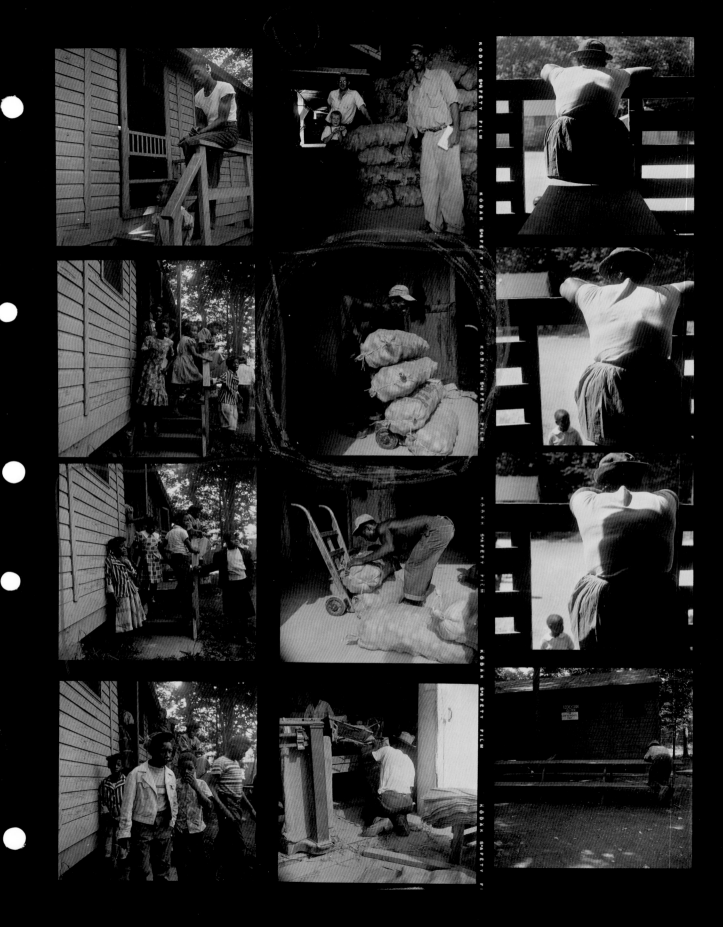

out of focus. With its simplicity and chiaroscuro lighting, the photograph quietly illuminates the harsh lives of the alienated and exploited. It was another step in Eve's development as a photojournalist with a deep social awareness.

Eve was a late starter, but by 1951, when she was thirty-nine years old, she had the beginnings of a portfolio. In addition to her pictures from Harlem and the Metropolitan Opera, she had her first images from Brookhaven and Times Square. She was developing her eye and, most importantly, learning how to take portraits, a skill that would be at the heart of her future career. However, as she later said, "I still had no direction, no guarantees, and was beginning to worry seriously about how to proceed."[24]

She had heard that Magnum Photos, the photographers' cooperative based in Paris, was opening a New York office. Doubtful that such a prestigious organization—founded in 1947 by legendary photojournalists Robert Capa, Henri Cartier-Bresson, George Rodger, and David Seymour (Chim)—would admit her, she nonetheless packaged up her two completed stories, Harlem and the Metropolitan Opera, and marched in to apply for an associate job. "I had no illusion or hope that they would consider me for membership," she said. "But I was desperate."[25]

The idea behind Magnum was to protect the work of its photographers by ensuring that they, rather than the people who assigned them, owned the copyright to their work. As the story goes, the four founders divided the world between them: Africa for Rodger, Europe for Chim, China and the Far East for Cartier-Bresson, and anywhere he chose for Capa, the "roving correspondent." Why would a group with such a prestigious body of work and such far-reaching ambitions even consider a photographer as inexperienced as Eve?

By then, Capa had realized that Magnum needed to change. The photographers who had come through the war were men in their thirties and forties, and he was looking for new people to redefine the image of the agency and document the postwar generation, which he was convinced would be very different from its predecessors. So the New York and Paris offices were actively seeking out photographers with a fresh outlook, including women.

The most noted woman photographer of the day was Margaret Bourke-White, who had joined *Life* in 1936, photographed Gandhi and Stalin and, as a war correspondent, taken pictures of Buchenwald at its liberation. However, since she was part of the same generation as the Magnum men, and also associated with *Life*, she did not fit the bill.

Maria Eisner, who ran the New York office, conducted Eve's interview, and when Eve pulled out her Harlem fashion show portfolio, Eisner smiled and, to Eve's astonishment, said she had already seen and admired the

26. Contact sheet from the essay "Migrant Workers" showing Eve Arnold's edits, 1951

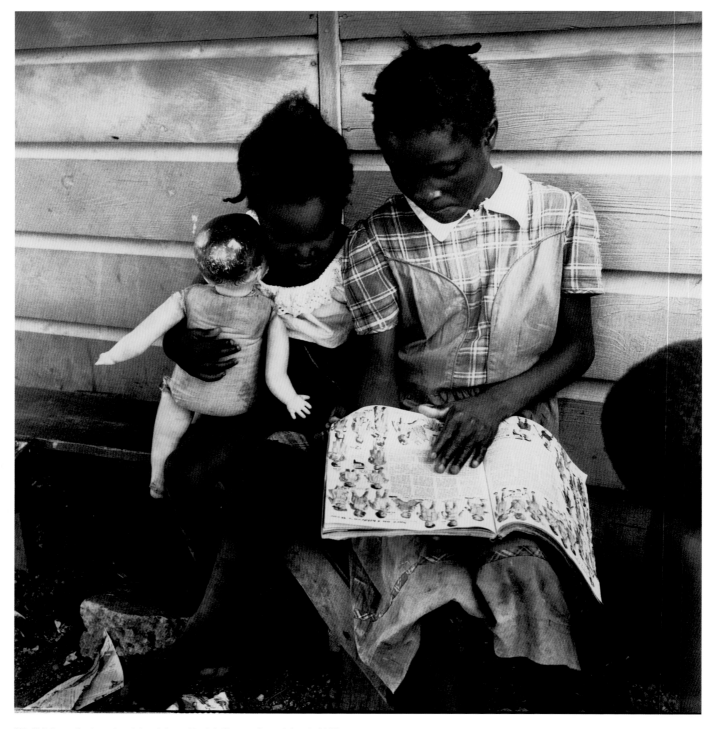

27. Children of migrant potato pickers, Port Jefferson, Long Island, 1951

pictures in French and German magazines. It turned out that a German agent had somehow obtained the images from *Picture Post,* arranged the syndication, and illegally pocketed the profits. This was upsetting, but the outcome was not: Eve was hired as the first female American stringer. At the same time, Inge Morath was hired in Paris, bringing the total number of women photographers at Magnum from zero to two.

Of the two women, Morath was the more obvious choice. Eleven years younger than Eve, a university graduate and an accomplished journalist, she had already worked with Ernst Haas and for Simon Guttmann at his photo agency, Report. Her portfolio of photographs from Spain was about to be published. Eve, on the other hand, was a middle-aged housewife with no track record other than her Harlem pictures. However, Capa and Eisner had a remarkable ability to sense promise, and they saw something extraordinary in her. Although Eve did not have Morath's credentials, she would turn out to be a gifted writer who played a key role in articulating Magnum's aims and fostering collaborations over the next fifty years.

Inge Bondi, then a Magnum secretary and researcher who was learning photo editing from Ernst Haas and Werner Bischof, and later on became a writer, remembers the first time she looked at Eve's pictures of Long Island migrant workers. As she sifted through them, she saw desolate lives made real, and she was struck by Eve's readiness to tackle social injustice. "It was not a popular subject then," Bondi wrote in an email to Magnum members after Eve died.[26] Moving into the Great Society years of the early fifties, the last thing people wanted to be reminded of was hardship and poverty in their own country. But this was to become one of Eve's passions—shining a light into dark corners—and it made her an obvious fit at Magnum.

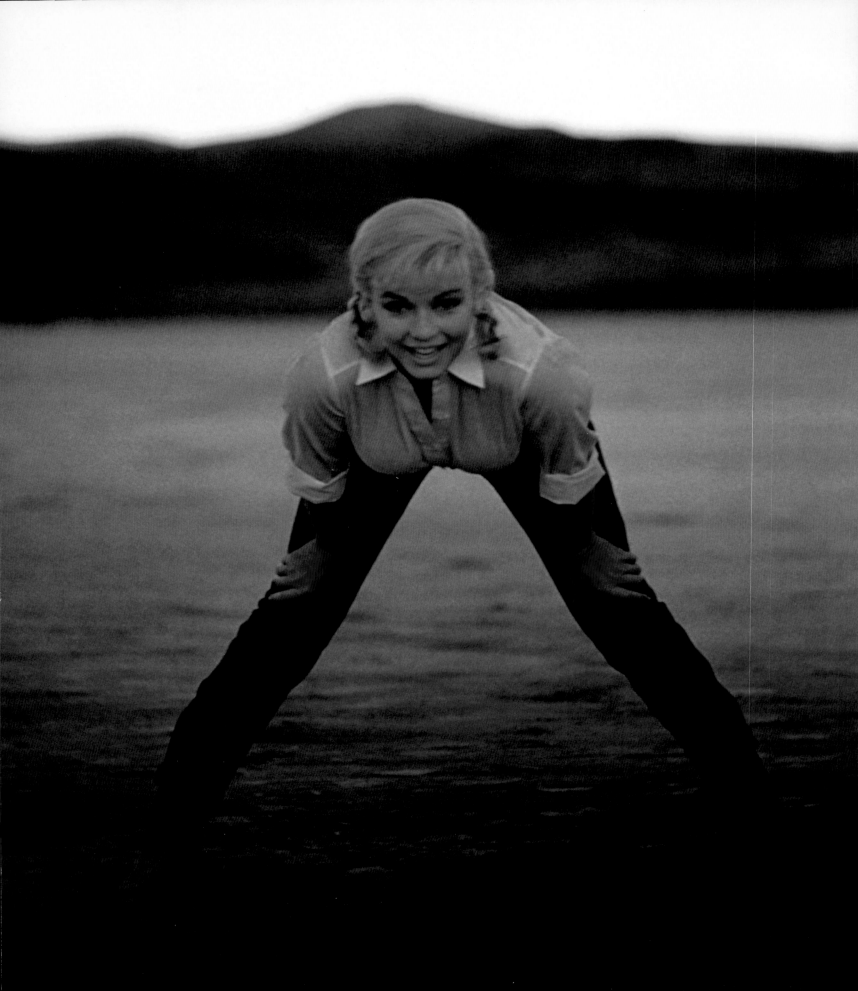

2. A PASSIONATE PERSONAL APPROACH

Magnum was a tough environment for Eve to navigate, and the atmosphere was not supportive, at least at the start. Her early colleagues were a legion of men who would go on to be greats, such as Elliott Erwitt, Burt Glinn, and Erich Hartmann. Erwitt wrote that when he first met Eve, "she was essentially a home-maker—a Long Island housewife and mother living in the village of Port Jefferson baking very good cookies."[28] He called her "a tiny, unaggressive kind of person who you wanted to pick up and be nice to."[29]

Eve later said, "I was green and awed by the male founder members," but "I hated the 'there-there little girl' pat on the head attitude of a few of my colleagues."[30] When asked by a reporter toward the end of her life what it was like to be a woman in a man's world, she turned defiant, fixed her with a beady-eyed gaze, and pronounced in her low, gravelly voice: "It's *man* in a *woman's* world!"[31]

Eve's views about women were complicated. Despite fierce pronouncements like these, she had been born just before World War One and firmly believed that men and women were different in key ways that could benefit her work: while men were more technically accomplished, women had "feelers" that helped them get to the heart of the moment. Frank says that his mother quite unself-consciously "used her size and her femininity to get what she wanted, to get the photographs she needed."[32]

As Erwitt and the other men would soon discover, Eve was there to excel. She described Magnum in the fifties as having "a certain yeastiness, a sense of excitement that I have never felt before or since."[33] Primed to acquire new skills—in reportage, picture design, and most importantly for her future work, thorough research—she doggedly applied herself. She compared notes

28. Marilyn Monroe on the set of *The Misfits*, Reno, Nevada, 1960

with colleagues, learned from her mistakes, and never stopped working. She called Capa her "photographic university" and puzzled over his contact sheets, trying to understand his method. When she confided in writer Janet Flanner that she was baffled by the fact that Capa's pictures, as she said, "didn't design well," Flanner looked at her "pityingly" and said, "My dear, history doesn't design well either.'"[34] This was a revelation for Eve, the understanding that it was the essence of a picture, not necessarily its form, which is important.

She understood early on that she would have to stand up for herself. Stringers at Magnum had no voting rights, and at her first annual stockholders' meeting, she and the other stringers protested that since they were contributing part of their earnings to the agency, they deserved a voice. Capa gave in. Despite disagreements, miscommunications, and angry letters sent back and forth over the years (Eve kept every letter, invoice, and insurance form), Magnum remained her family, with all the contentiousness and complexity that the term implies. She once told an interviewer, "It's like being part of a family, you don't like all of them, well, you LOVE all of them . . . but you don't LIKE all of them." She was grateful for the connection; it anchored her and made her proud.[35]

While Magnum could give Eve its illustrious name and connections to the right people in publishing, the best way to get a magazine assignment was to come up with independent work that would appeal to editors. So Eve cast her net wider, shooting the 1952 Republican National Convention in Chicago for a London magazine. It was her first venture into politics. She managed to get shots of everyone, from Dwight Eisenhower, Richard Nixon, and a convention newspaper girl to Joseph McCarthy, who would soon be the main subject of one of her stories. She also planned various projects close to home (the Arnolds moved full-time to Brookhaven in 1953), including a continuation of the migrant workers portfolio, which had become so important to her that even little Frank knew about it, calling the farm "the awful place."

Out of the blue, in 1952, she received her first job through Magnum. She was to shoot Marlene Dietrich during a recording session at Columbia Records, replacing Magnum photographer Ernst Haas, who could not make it. The prospect of photographing a celebrity was as intimidating as it was thrilling. Dietrich knew all about lighting and posing, and she was not shy when it came to telling the professionals how to capture her best angles. According to rumor, she had once offered a Cadillac to a cameraman who got her in the perfect light.

Since the session was scheduled at night, Eve expected Dietrich to be dressed casually, in pants and her standard beret. Instead, the star wore a

29. Contact sheet from the essay "Marlene Dietrich" showing Eve Arnold's edits, 1952

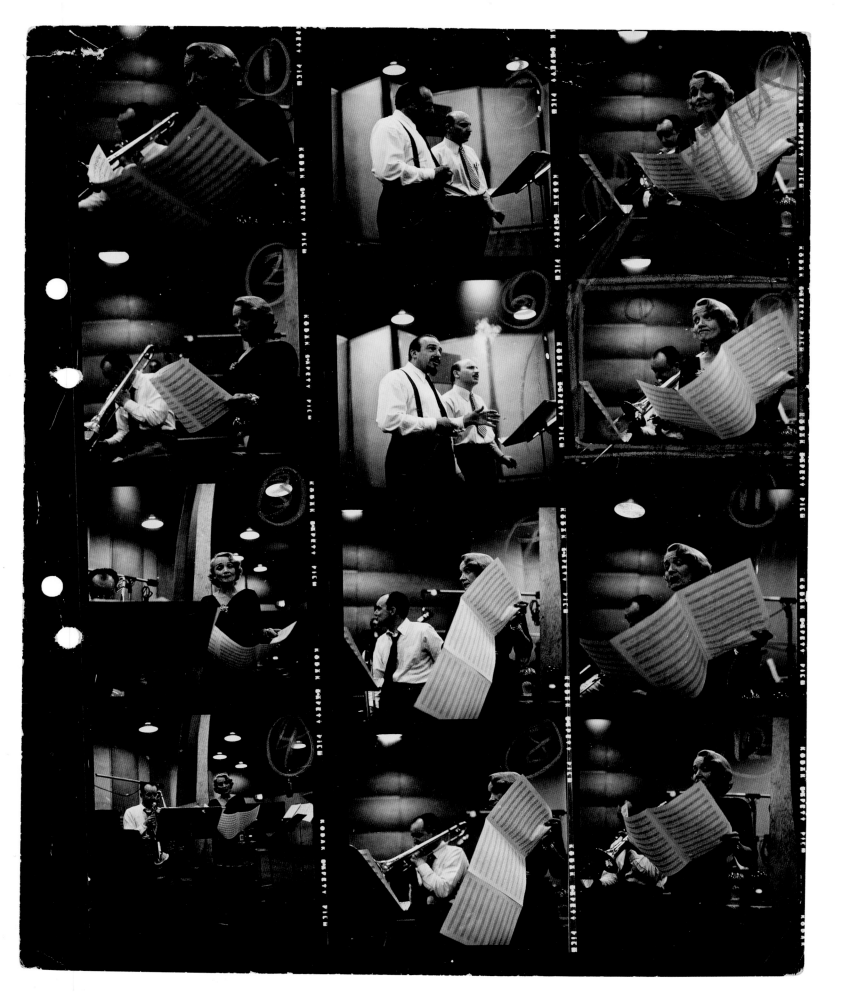

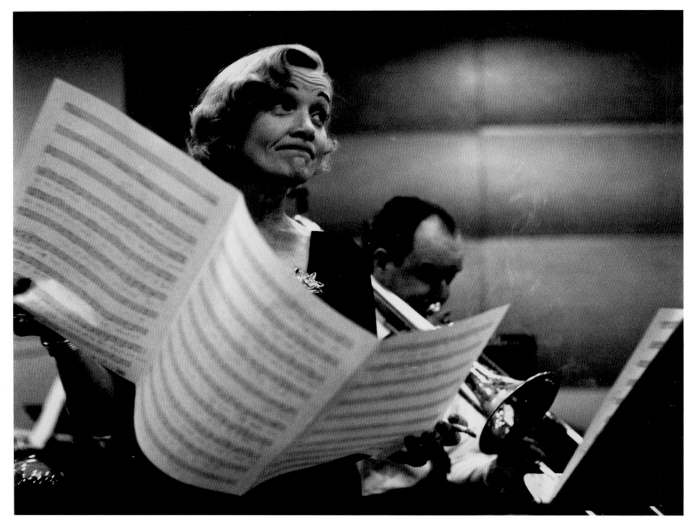

30. Marlene Dietrich at Columbia Records recording studios, New York, November 1952. Columbia was releasing most of the songs Dietrich had performed for the troops during World War Two, including "Lili Marlene" and "Miss Otis Regrets." She was fifty-one years old and starting a comeback in show business

31. "Marlene Dietrich and Joan Crawford," *Telegraph Magazine*, date unknown

Marlene Dietrich

When she went through the pictures she wrote instructions – in eyebrow pencil – for retouching: narrow down the chin, cut down the waist, remove the dimple, the ankle should be slimmer.

Joan Crawford

cocktail dress with a diamond brooch. It was a stroke of luck: Eve would make her famously beautiful legs even more iconic. To Dietrich's irritation, Eve photographed her throughout the night as Dietrich worked, in Eve's words, "like a ditch digger . . . from midnight when she arrived until six in the morning."[36]

The shots that resulted had a rare freshness (figs. 29–31). Dietrich looks natural and relaxed, a singer at work rather than a glamorous celebrity posing for the camera. Eve later recalled that Dietrich took the prints and marked them all with an eyebrow pencil exactly where she wanted them retouched—a chin narrowed here, a dimple removed from the knee. Instead of retouching them, Eve simply made better prints.

Reprinted widely, the story got Eve noticed—people were intrigued to see a star as a real person—and it marked the beginning of her astonishing success photographing the famous, from musicians and movie stars to politicians and writers. When he saw the pictures, an admiring Capa summed up Eve's particular niche in these terms: "Metaphorically speaking, her work falls between Marlene Dietrich's legs and the bitter lives of migrant potato workers."[37]

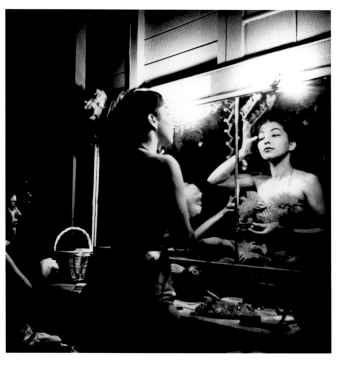

32. The dressing room of the Tropicana, Havana, Cuba, 1954

By 1954, Eve's efforts were paying off. The previous year, a British magazine had sent her to Jamaica to photograph Queen Elizabeth. It was her first foreign assignment and, she wrote, "I was green and scared and game."[38] Then Magnum dispatched her to Cuba and Haiti to take pictures for magazine projects that Capa had arranged. In both countries, she was confronted with destitution on a level she had never seen, beyond even the migrant farm workers. A Cuban family she was photographing begged her to adopt their nine-year-old daughter, Juana, to save her from a life of poverty and prostitution (figs. 33, 35), and she was so moved by them that she cried when she left.[39] In Haiti, she observed early trials of a tranquilizer called Milltown that was being tested on "guinea pigs" inside a Haitian insane asylum.

Yvonne Sylvain, Haiti's first woman doctor, arranged for Eve to visit the asylums, where she encountered grim scenes of teenage girls undergoing the experiment—their eyes deadened by the drugs. The experience shocked her. "First it was rats, then Haitians, and if the drug proved safe for humans, Americans would have it," she wrote bitterly.[40] One of her images, a portrait of a young girl, is especially powerful (fig. 38). Wearing a loose dress that hangs on her like a potato sack, the girl crosses her arms in a

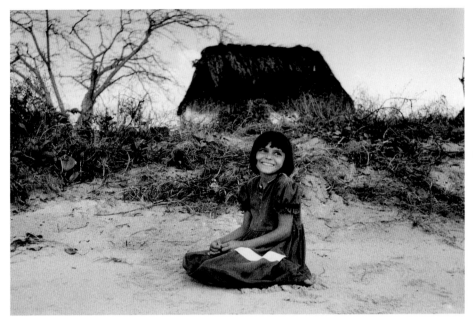

33. Juana Chambrot at age nine on the beach at Cayo Carenero, Cuba, 1954

34. Fisherman and family, Bahia Honda, Cuba, 1954

35, 36. Tearsheets from "The Girl on the Beach," unknown Chinese magazine, c. 1997

37. Contact sheet from the essay "Haiti Insane Asylum" showing Eve Arnold's edits, 1954

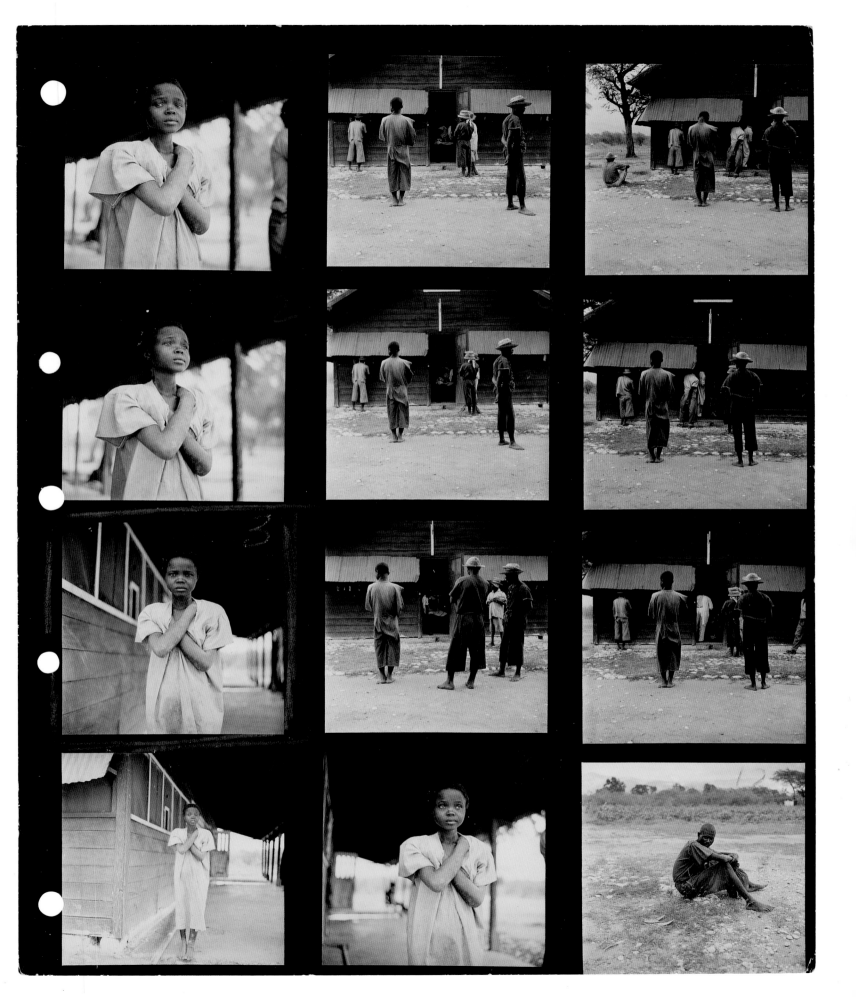

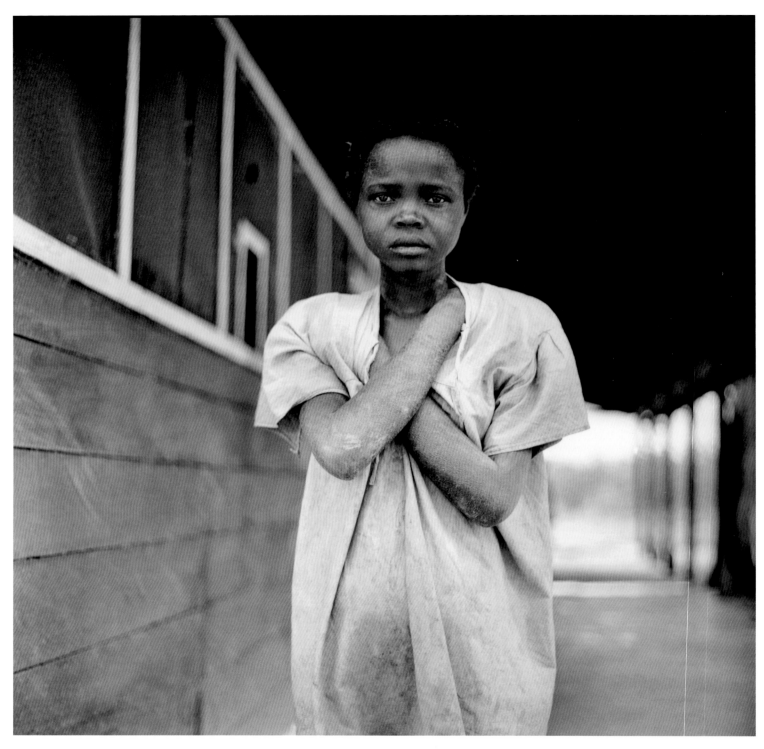

38. Haiti insane asylum, 1954

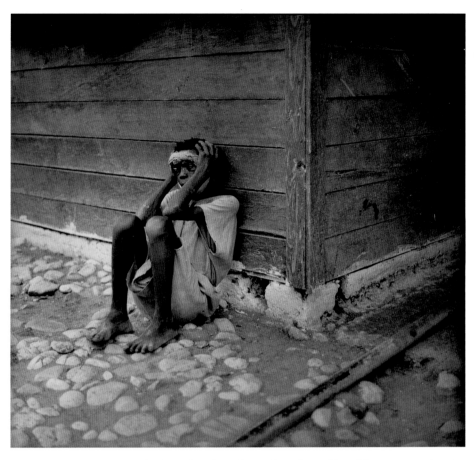

39. Haiti insane asylum, 1954, where American drug companies tested Milltown, an early tranquilizer

gesture of protection, hiding her hands under the collar. The expression in her eyes and mouth, a mix of despair and defiance, is striking. Eve focused on her alone, leaving the background fuzzy, as if the child was stepping out of a dream or a vision.

In Haiti, Eve experienced voodoo—the mélange of Christianity and African tribal ritual practiced on the island. The practice was illegal, but Eve managed to shoot actual voodoo scenes. "It is said that Haitians go to church on Sundays but are voodoo all the rest of the week," she quipped.[41]

That same year, Eve came up with a bold idea that propelled her to a new level of visibility and, as it turned out, controversy. She decided to photograph hearings of the House Un-American Activities Committee, chaired by Senator Joseph McCarthy.

They made an unlikely pair. McCarthy was the loud, bellicose junior senator from Wisconsin who was in ruthless pursuit of the Communist spies he claimed to have discovered inside the government, the film industry, publishing, and journalism. Eve, on the other hand, was small, quiet, and focused. As the daughter of parents who had escaped the horrors of the Russian pogroms, she felt deeply for anyone who suffered for their religious or political beliefs.

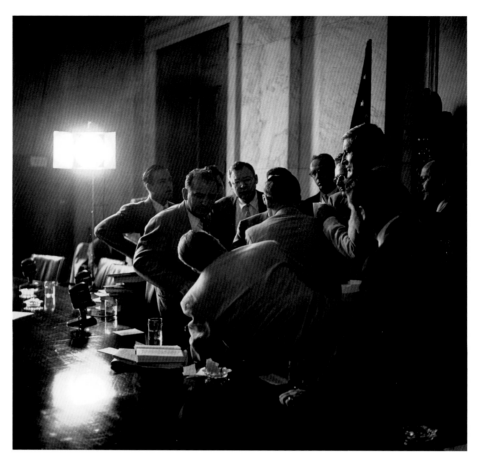

40. Senator McCarthy with his team, Washington, DC, 1954

Eve hoped to sell the story to a newspaper or a good picture maga-zine that would position it in the right way, but when she asked Capa for advice, he was uncharacteristically quiet, and he asked her to wait a while before taking on the project. Later she learned that Capa was having visa problems that might result in his expulsion from the United States, and he did not want Eve to get embroiled in his troubles. He eventually resolved the issue, but his anxious response showed the reach of the senator's scare tactics. However wild and unsubstantiated his claims, McCarthy destroyed the lives and reputations of hundreds of people.

When the time was right, Eve threw herself into research. She discov-ered people in New York who had suffered at McCarthy's hand. They were ordinary people who were living in fear, emotionally devastated by their powerlessness in the face of a man whose influence swelled in tandem with America's paranoia about the Cold War. "I felt that research like this, although it might not appear in the final reportage, was essential to understanding the situation. . . . I likened my preparations to those of a boxer training for a fight."[42]

Then she went to Washington, not expecting the crush of journalists who were reporting on the hearings. It was, she would recall, a "crazy cir-cus"—camera crews, lights, a battery of flashes surrounding McCarthy and

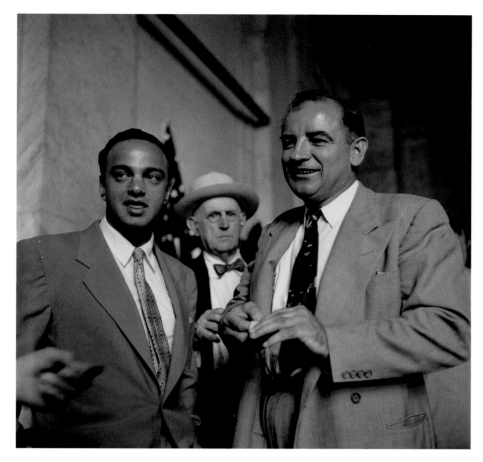

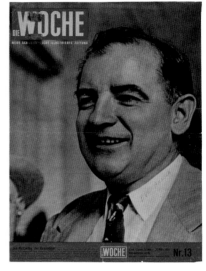

41. Roy Cohn and Senator McCarthy, Washington, DC, 1954

42. Cover of *Die Woche*, March 25, 1954

his team. At one point, McCarthy wandered over to her— "I was the only woman reporter there and he was playing to me" —and rested his hand on her shoulder. Alarmed and all too aware that the reporters were watching her, she lifted her hand to remove his but hesitated for fear of alienating him. Much to her chagrin, their hands stayed joined for a moment before she extricated herself, muttering to the senator that she had to get back to work. The damage was done.

Downstairs in the Senate dining room, the other journalists, thinking that McCarthy had befriended her, pointedly ignored her. None of them talked to her or even acknowledged her. She was frozen out of the press corps. "Such was the climate of distrust that I did not even dare tell them what had happened for fear of betrayal."[43]

Her black-and-white pictures tell the story of the hearings. McCarthy is confident and smiling, flanked by his acolytes, Roy Cohn and G. David Schine, and they are feeling like winners (figs. 40, 41). But Eve's portraits reveal the stark evil that pervades the scene. "The ugliness of it all was apparent on the faces of his henchmen," she wrote.[44]

The story gained her some attention, some success, and as she said, "a pat on the head from Capa," and it reinforced her determination to be

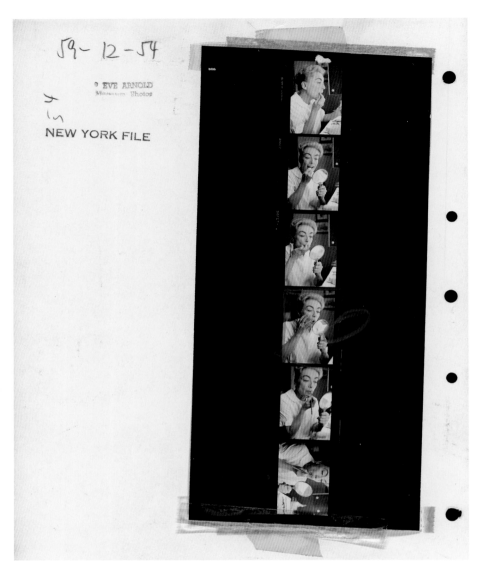

59- 12 -54

© EVE ARNOLD
Magnum Photos

NEW YORK FILE

43. Contact sheet showing Joan Crawford
applying makeup, 1959

44. Contact sheet showing Joan Crawford
applying makeup, 1959

a documentary photographer. She thrived on the research and loved the story's challenge, and it whetted her appetite for more. Her next big political assignment would be a piece about Malcolm X and the Nation of Islam, but that was years away.

Eve's success in photographing Dietrich, together with her Magnum connection, gave her easier access to the legion of publicists working in New York. Gradually she began to win assignments. Whether she was photographing Joan Crawford or Marilyn Monroe, she said she learned to feel easy. "I was not impressed with the names but interested in why they were the chosen ones."[45] That curiosity helped her famous subjects trust her—sometimes to a reckless and bizarre extent.

Consider her first Joan Crawford shoot. In 1956, *Woman's Home Companion* hired Eve to do a bland little piece around the release of one of

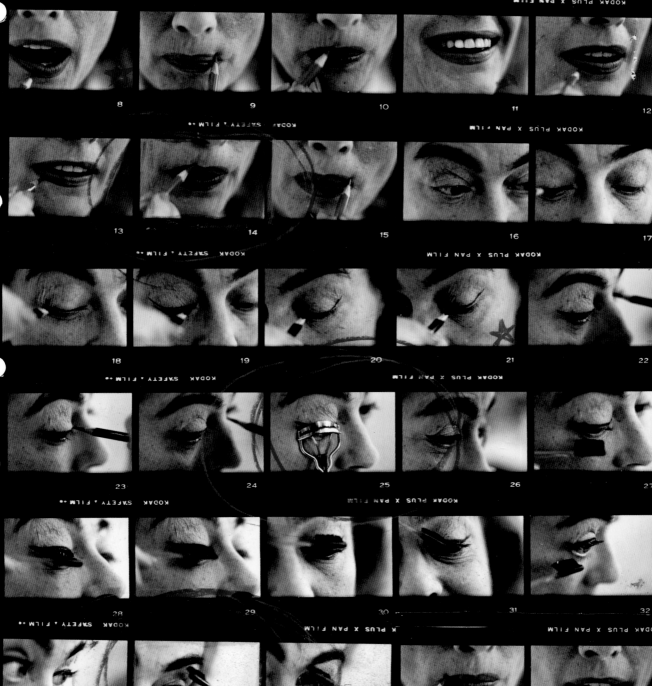

her movies. When Crawford showed up with her daughter Christina and two tiny poodles, she was very drunk. Walking up to Eve, Crawford kissed her on the mouth—the two had never met—took off all her clothes, and demanded that Eve photograph her nude. At this point in her career, Crawford was aging and fearful of losing her place in Hollywood to younger, fresher talent. She seemed desperate to show that she still had the body she had displayed when she started out and (although she tried to bury the fact) appeared in "blue movies," soft-porn films.

Eve was caught in a dilemma. Crawford kept insisting on the nude shots, but even though she was slim and good-looking for a fifty-year-old woman, she was still undeniably a fifty-year-old woman. Eve knew that the pictures would not please her.[46] Furthermore, a year earlier, in 1955, Eve had been elected a full member of Magnum. While Eve might make a great deal of money by releasing the pictures, she would never recover from the damage such an exploitative act would do to her reputation.

In the end, Eve capitulated, but instead of sending out the slides, she gave them to Crawford in a yellow plastic box over lunch a few days later. She was rewarded three years later with a second shoot for a photo-essay, commissioned by *Life,* that was in its way far more intimate and revealing than the nudes. The images showed Crawford preparing for a role—having a facial with her face covered in thick cream and her big eyes covered with cotton pads; getting her legs waxed and her eyebrows dyed; in her girdle, looking vulnerable (figs. 45–47). Eve spent many exhausting days with the star over a period of weeks, and she later wrote, "the more I saw of her, the more complex she seemed."[47] Giving a photographer this kind of access was either reckless or brave, and Eve knew to seize the opportunity. The images she created were modern, provocative. Undermining the myth that beauty is intrinsic, she showed what hard work is involved in presenting yourself to the world as a star.

45. Joan Crawford getting a facial, Hollywood, 1959

46. Joan Crawford at home in Hollywood during a dress fitting, 1959

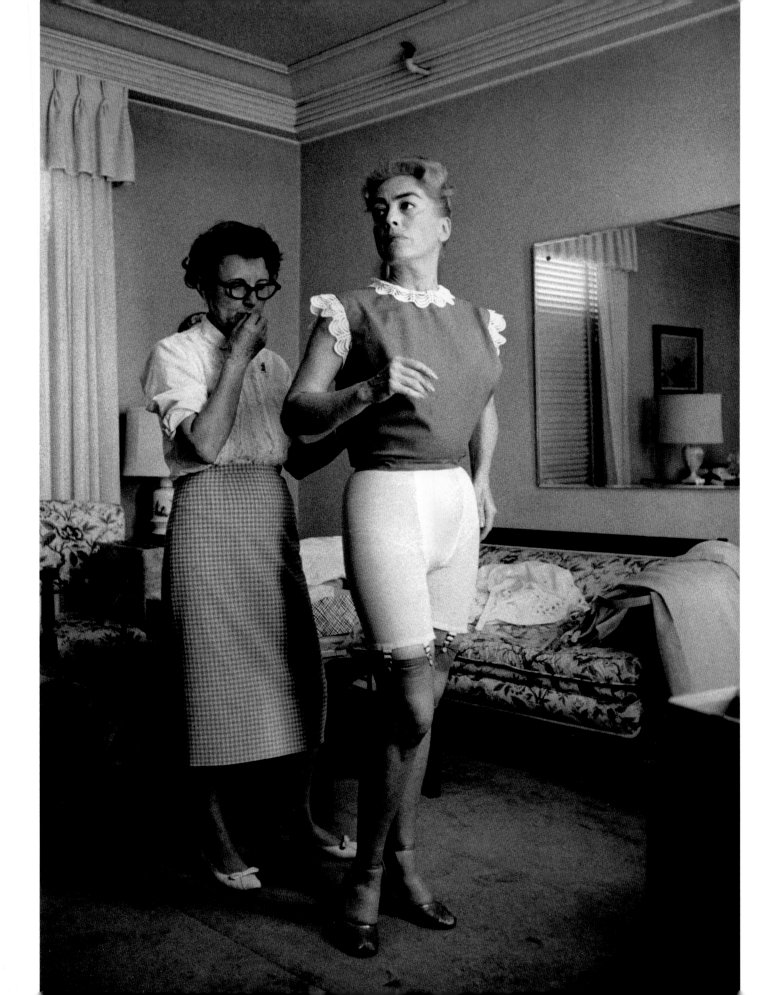

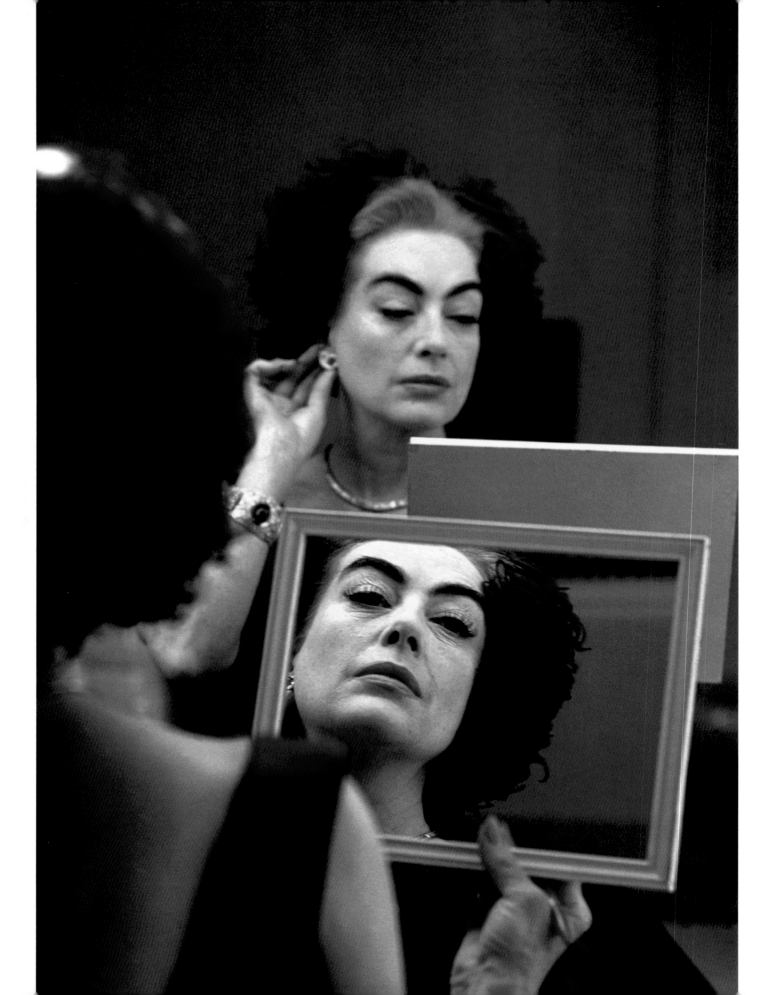

Eve and Crawford stayed in contact for years. Decades later, when an aged Crawford came to London to film a small part in a B movie, she sought Eve out and the two women met. Distressed to see how the once-mighty star had fallen, Eve felt protective of her and tried to get her publicity but without success.

Beeban Kidron, a movie director who worked as Eve's assistant when she was a teenager, had this to say in a documentary about Eve: "She is the tough-love mother. She loves the subjects to death, but doesn't want them to run amok. That's why Dietrich and Crawford and all those incredibly powerful, high-achieving women responded to her. She's just a tough little bundle. You do what she says—I know I do."[48]

James Hill, a war photographer who worked with Eve when she was in her eighties, noted her special rapport with celebrities: "She got pictures that other people would not have gotten," he said, "and *that* is the real talent of a photographer. It's something very precious. Also, she was tenacious. She kept on the case, and did not give up. It's a gift to be able to massage these stars, getting them to be at ease. Things start getting interesting photographically when people forget about you . . . when you are invisible. When I look at her work—it's more than a sense that people are cooperating. You get the feeling she persuaded them to give a piece of themselves."[49]

As courteous as she was direct, Eve came to an understanding with her subjects. In her eighties, looking back, she summed up her approach: "If you're careful with people and if you respect their privacy, they will offer part of themselves that you can use," she told a BBC interviewer.[50]

That tactic played out perfectly in Eve's relationship with Marilyn Monroe. They met for the first time in early 1954 at a party Capa gave for the movie director John Huston. Monroe buttonholed Eve, saying, "If you could do that well with Marlene, can you imagine what you can do with me?"[51]

It was arranged that the starlet and the photographer would shoot on a private beach in Long Island, not far from Eve's home. Eve's son, Frank, was seven years old at the time, and he didn't realize that the pretty platinum blonde in a leopard-skin dress—who tossed a ball with him, laughing—was Marilyn Monroe. Soon, an excited crowd gathered, surrounding her. "I remember she had to actually escape by going into the water, where she was rescued by someone in a speedboat," Frank recalls now. He adds dryly, "It wasn't but it might as well have been a publicity stunt."[52]

This was the beginning of an intricate connection that lasted until Monroe's death eight years later. Each woman unabashedly used the other, but always in a respectful way. "We were important to each other in our

47. Joan Crawford checking her makeup, Hollywood, 1959

professional lives," Eve told a journalist. "She would call me whenever she had something she wanted me to do that she felt I could do for her."[53] While Monroe was a master at manipulating the press, Eve developed a unique ability to capture the emotions on her lovely face in all her unguarded moments.

Monroe was a photographer's dream—playful, responsive, and fun to be with. "She was just a pain in the ass until she showed up," Eve recalled, "but once she got there she was wonderful."[54] She had an almost uncanny feel for the camera. Frank remembers her physical sophistication, her endless ability to use her body in a way that was "fresh and original."[55]

49. Eve Arnold and Marilyn Monroe during filming of *The Misfits*, Reno, Nevada, 1960

48. A washroom in the Chicago airport, 1955. Marilyn Monroe waits for a plane to Champagne, Illinois, where she is to attend the centenary celebrations of the town of Bement

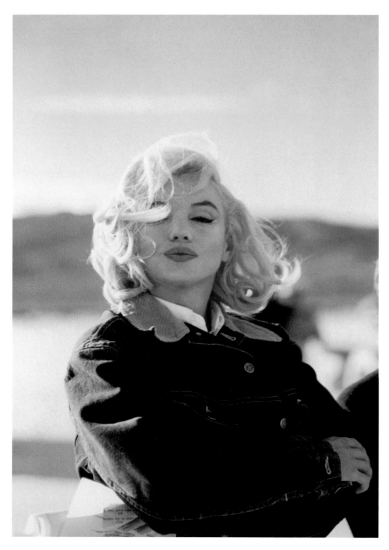

50. Marilyn Monroe on the set of
The Misfits, Reno, Nevada, 1960

51. Marilyn Monroe resting during a break
on the set of *The Misfits*, Reno, Nevada,
1960

Later Eve talked about Monroe with a rueful tenderness: "She was a sort of valiant, funny, witty woman when I met her at first." By 1960, when Eve was on set for Monroe's last completed film, *The Misfits*, she was "still all of that, but there was a string of sadness underlying it."[56]

Magnum had negotiated exclusive rights to shoot the filming of the movie, sending its photographers to the Nevada set, two by two, to cover it from start to finish. Not only would this be profitable for the agency, but it was also a way to highlight Magnum photographers, with each one portraying each star in a different way. Directed by John Huston, with a script by playwright Arthur Miller—Monroe's husband at the time—and starring Montgomery Clift, Clark Gable, and Eli Wallach, the film should have been brilliant. It was a disaster.

When Eve flew down for her two-week stint, she happened to be on the same plane as Monroe, who was returning from the hospital after an overdose. The plane was met by people waving banners that said, "Welcome Home, Marilyn," and Eve tried to sneak away across the tarmac unobserved. However, Monroe saw her, ran over, and greeted her with obvious relief, saying, "I'm glad you're going to be here."[57]

The two women had known each other for five years, and Eve was one of the few photographers Monroe trusted. At Monroe's specific request, Eve ended up staying for two months. She later said, "It began in the heat of the summer and ended in the cold of the desert. It was not a happy set, and it got less happy. But it was open. I knew Arthur Miller quite well, and Marilyn. And so I felt I could tell the story."[58]

Indeed, the heat—108 degrees—was unbearable. Miller was struggling with rewrites; Huston was drinking and gambling on the set, and he sometimes fell asleep while filming. Monroe and Miller's marriage had unraveled; they were fighting nonstop and heading to a divorce. One day after seeing the rushes, the despondent Monroe asked Eve, "How do I look?" Eve replied that she looked wonderful. Monroe said, "I'm tired. I've been on the

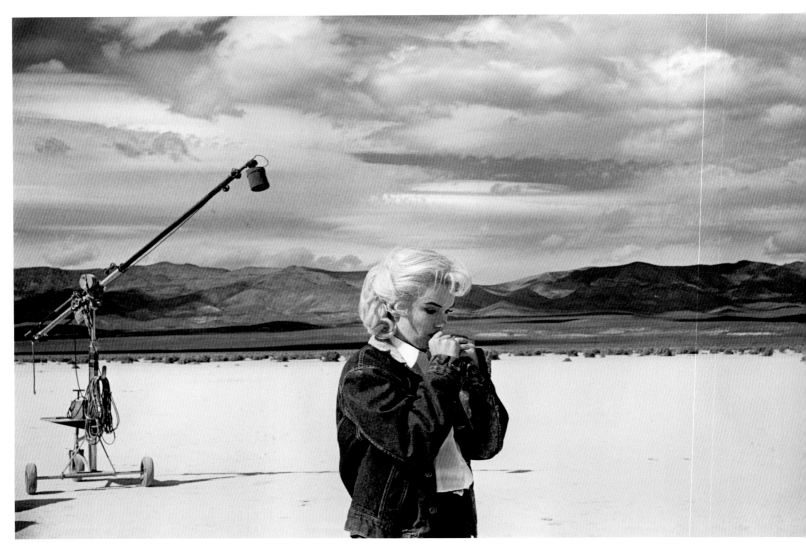

52. Marilyn Monroe in the Nevada desert
going over her lines before performing
a difficult scene with Clark Gable in
The Misfits, 1960

last film for six months, I've been dancing for six months, I'm thirty-four years old, you know, what's going to happen to me?"[59]

One of Eve's most iconic portraits shows Monroe lost in thought, rehearsing her lines against a desert backdrop of sky, mountains, and sand (fig. 52). The black-and-white tones are muted and mournful. Eve has caught the actress stripped of pretense, displaying her vulnerability, her fragility. The image seems to foretell her death. In the midst of a chaotic set and a crowd of Magnum photographers, Eve somehow managed to seize intimacy from all her subjects—notably the ailing Gable—but it was Monroe who, even in her bleakest moments, shaped the shoot.

"I never knew anyone who even came close to Marilyn in natural ability to use both photographer and still camera," Eve wrote decades later. "She was special in this, and for me there has been no one like her before or after. She has remained the measuring rod by which I have—uncon-

sciously—judged other subjects. . . .[60] She had learned the trick of moving infinitesimally to stay in range, so that the photographer need not refocus but could easily follow movements that were endlessly changing. At first I thought it was surface technique, but it went beyond technique. It didn't always work, and sometimes she would tire and it was as though her radar had failed; but when it did work, it was magic. With her it was never a formula; it was her will, her improvisation."[61]

Although the film was well received, largely for the haunting performances of Gable and Monroe, it was a commercial flop. What makes it memorable to this day are Eve's pictures. The tear sheets stored in her archive are full of unforgettable images: Gable, looking fragile (he died of a heart attack twelve days after the wrap); Miller and Monroe, the doomed couple, practicing dance steps (fig. 53); and Monroe in a multitude of poses: sexy, childlike, pensive, lonely, lost. Over the years, they have been endlessly reproduced in magazines around the world.

53. Marilyn Monroe with Arthur Miller, who shows her dance steps for a scene in *The Misfits*, Reno, Nevada, 1960

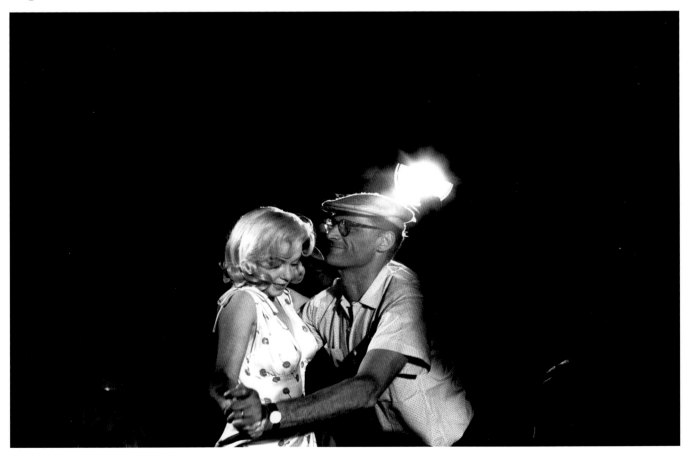

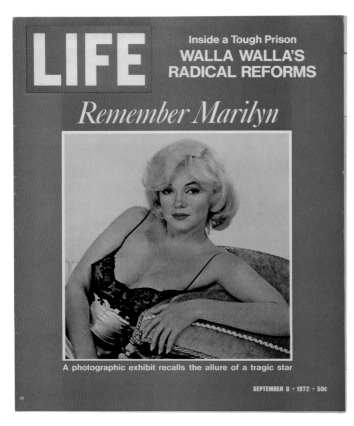

LIFE

Inside a Tough Prison
**WALLA WALLA'S
RADICAL REFORMS**

Remember Marilyn

A photographic exhibit recalls the allure of a tragic star

SEPTEMBER 8 · 1972 · 50¢

54. "Remember Marilyn" cover, *Life*, September 8, 1972

Years later, Eve still felt at a loss to explain Monroe's death, beyond saying that she had simply become too tired to go on. "Her enemy was sleeplessness. And I think that what had happened to her was that she couldn't sleep. She took these pills, she couldn't remember whether she had taken them. She would take them again, and I think it was an accident."[62]

While she immersed herself in portraiture and high-profile stories, Eve was also consciously struggling to create a workable freelance existence. Like most freelancers, she found herself either overwhelmed with work or between assignments and anxiously contemplating empty days. In a letter to her sister-in-law Gert, she once glumly described the enforced leisure time as "suspended animation," adding: "Instead of accepting it and relaxing with it, I spend too much energy fighting it. If I were smart I would just go to bed and pull the covers over my head or go away somewhere marvelous on a holiday and let the necessary gestation get on with it. But I don't suppose I ever will learn."[63]

To help herself stay focused, she devised a three-tiered routine that she followed all her life. "1. Editing and writing the current story. 2. Preparing for the next assigned story. 3. Reading for and researching a third story." If she was organizing herself for a shoot, "there would be film to buy, cameras to clean, money in foreign currencies to secure, injections against various diseases to have. . . . Friends would drop in for last-minute hugs. . . . As I raced for the plane, the cameras strapped to my back, already homesick, the depression would hit. To allay it would come ironic memories of my friends telling me what a glamorous life I lived."[64]

Perpetually worried about money, Eve made tentative forays into advertising. It started with a Simplicity Patterns campaign in the late fifties, when she traveled the lower forty-eight states and Alaska, photographing women against appropriate backdrops in dresses they were supposed to have made from the company's patterns. In fact, there was just one set of dresses, and they had been sewn in New York by professionals.

Not only did Eve have to find and shoot the perfect situation for each picture, she also had to transport the clothes from place to place. The pictures turned out well, but the appropriate backdrops were removed, scrubbed out of existence. Undaunted, she pressed on, shooting ads for toys and phar-

maceutical and cosmetic companies. She learned for the first time how to communicate a specific message and work with an art director.

Other editorial assignments kept her on the move: to Virginia and Washington for civil rights stories; to Hoboken, New Jersey, to photograph Italian American families; and to Oklahoma to photograph Oral Roberts, the faith healer. Close to home, she continued with her photographic study of Brookhaven, Long Island, and in 1955 she became a full member of Magnum in the aftermath of the deaths of Robert Capa and Werner Bischof in 1954. Eve had worked closely with Capa, and she became part of the generation that kept the Magnum community going.

Professionally, Eve was well on her way, but her burgeoning career took a toll on her personal life. Balancing freelance photography with life at home was not easy. Her son, Frank, has fond memories of the beautiful house on Miller Place: of walks on the beach where they would collect driftwood and glass and of boisterous evenings with creative people who came out from the city to sit around their kitchen table. He remembers a "sweet man named Hank" coming to dinner. That would be Henri Cartier-Bresson.

Frank also recalls his mother working in the darkroom, developing black-and-white prints. He was probably six when she first let him come in to watch the images float up inside the liquid chemicals, and he thought it magical. She would dodge and burn and explain to him why she needed more contrast. "There would be this shining bright light on her photographic paper, and for a young boy, that was quite fabulous."[65]

In Brookhaven, Frank was often left to his own devices. His father had a career in New York. A gifted advertising and commercial designer, Arnold designed the Parker Brothers classic swirl trademark, was part of a two-man show at the Museum of Modern Art, New York, in 1954, and worked on developing educational games for children and teachers. Eve would sometimes pack a bag, kiss Frank good-bye, and go off on a shoot for days or weeks. A local woman came in to care for him, and although he remembers the nanny as very kind, he says his mother's absence felt "a little strange for an only child."[66] Young as he was, Frank was sweetly proud of his mother. In a 1958 essay, probably written as a school assignment, which Eve kept in her archive marked "IMPORTANT," he wrote:

> My name is Frank Arnold and I am nine years old. I have known my mother all my life. My first memory of her is taking prints from the darkroom to the bathroom to be washed in the bathtub. My mother has done many stories about people. The story I

remember best was the story on Marlene Dietrich. My Mother is a member of Magnum. I think that means that she is one of a group of photographers. I know most of them. The thing I like best about Magnum is their Christmas party.

My mother goes on trips far away to take pictures of things happening in different places. I don't like it when she goes away, but I do like it when she comes back and plays with me and reads to me. Sometimes I go along when she shoots nearby. One time she took me to the awful place where she photographed people who lived there and picked potatoes. I've met Marilyn Monroe and played ball with her on the beach.

My mother uses lots of cameras so that she doesn't have to re-loading [sic] the middle of taking pictures. I like it best when my mother brings back color pictures from strange places and shows them to me on the wall.

She was born in Philadelphia and when she was a little girl she sometimes misbehaved. Before she started taking pictures she had me and before that she kept wishing that she would be a photographer and before that my mother married my father. He is an industrial designer and sometimes my mother and father work together and help each other.

I have a nice camera too and I like to take pictures of my dog playing with other dogs. I don't want to be a photographer when I grow up. I want to be a scientist.[67]

In the late 1950s, Eve suffered a miscarriage, followed shortly afterward by a hysterectomy, and she fell into a deep depression. With typical fortitude, she channeled her anguish and spent the autumn of 1959 visiting Long Island's Mather Hospital, close to her home, to photograph women in childbirth. "It seemed madness to go to the source of the pain," she wrote, "but it did assuage my grief."[68]

The hospital authorities gave her permission to be in the operating room as babies made their journey from the womb to the world, and she brought an anthropologist's awareness to documenting those few moments. She later wrote about what she saw: "the cord is cut; the child is slapped . . . tagged . . . footprinted . . . weighed . . . washed . . . anointed . . . measured . . . swaddled."[69]

The story, "A Baby's Momentous First Five Minutes," ran as a six-page spread in *Life,* and the evocative closing shot, which showed a mother's hand as her newborn clutches her finger, became a classic image (fig. 58).

55. Nurse measures newborn baby, from the essay "A Baby's Momentous First Five Minutes," Port Jefferson, Long Island, 1959

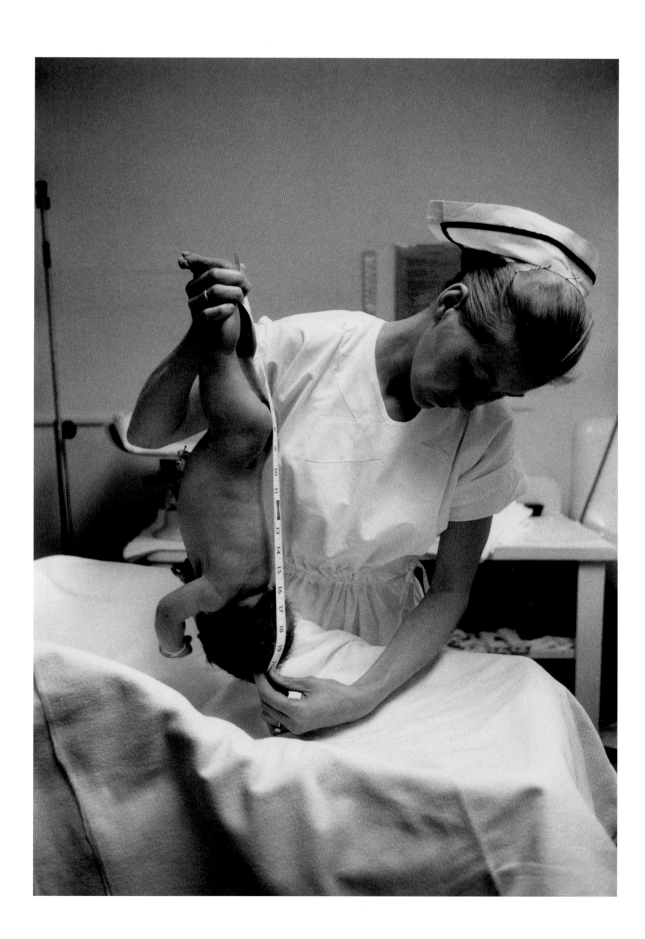

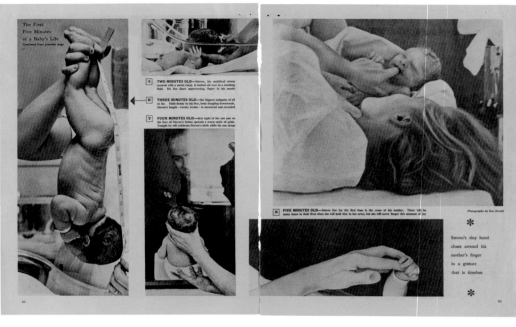

56. "The First Five Minutes of Life"
cover, *La Actualidad Espanola*,
December 28, 1967

57. Tearsheet from "The First Five
Minutes of Life," source unknown

58. A mother's finger is grasped by her
newborn, from the essay "A Baby's
Momentous First Five Minutes,"
Port Jefferson, Long Island, 1959

Eve wrote, "This picture has been used to advertise everything from insurance to corn flakes. Its sale has generated mad money to pay for independent projects I could not otherwise have risked tackling."[70]

In her first ten years as a photographer, Eve achieved so much: big journalistic stories, insightful celebrity portraits, and full membership in Magnum. "Not bad for little Evie from Philadelphia," as she liked to say. She had one more provocative assignment to carry out for *Life*—a political piece on Malcolm X and the Black Muslims.

Her career had been building to this. Eve's visits to Harlem, her affecting work from the Long Island potato fields, Haiti, Cuba, and the civil rights struggle in the South, her brave documenting of the McCarthy hearings—they were all part of her developing social consciousness and her determination to penetrate worlds where a small Jewish housewife with a camera would not be welcomed. After months spent researching and vainly trying to reach Malcolm X, the leader of the Black Muslims (the Nation of Islam), she finally got a commission for the story from *Life*, and she found an intermediary, an African American journalist named Louis Lomax. She paid him a thousand dollars (about seven thousand dollars today) for the promise of an introduction to Malcolm X.[71]

As Eve later described it, Lomax was two hours late for their meeting in a New York restaurant. When he finally showed up, he said, "You don't want to do a story. You just want to sleep with a black man, don't you?"

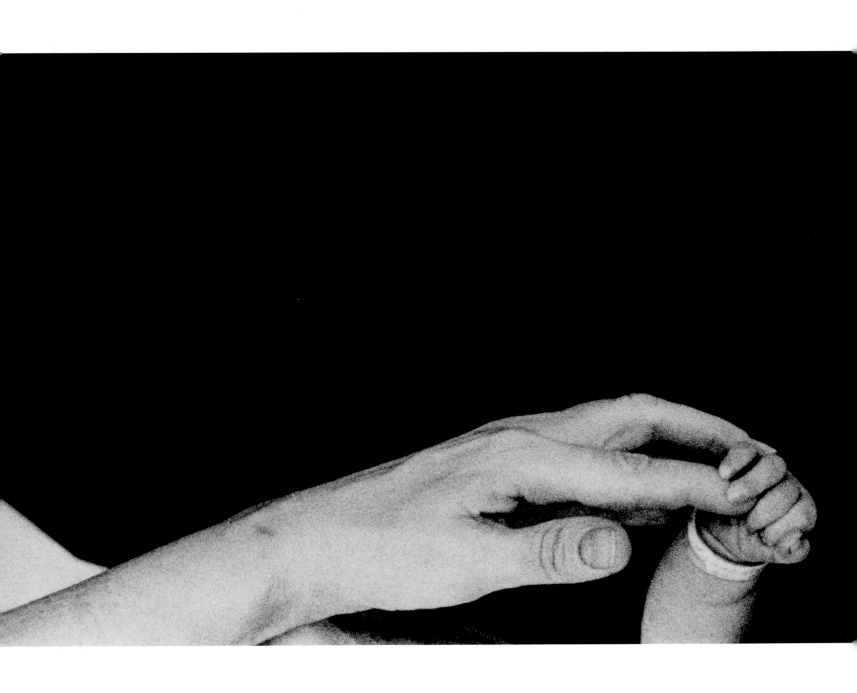

59. Black Muslim children on their way to
the Metropolitan Museum, New York, 1961

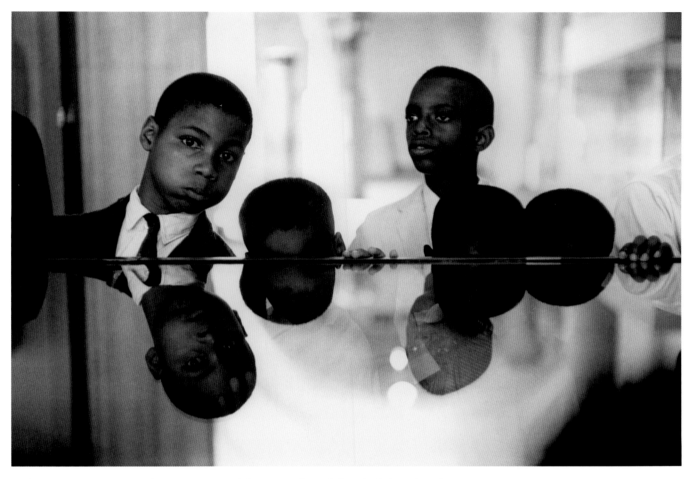

Whereupon Eve gave him a piece of her mind and headed for the door. Lomax stopped her and apologized, saying he had just been testing her. Then he agreed to put her together with Malcolm X.

60. Black Muslim children at the Metropolitan Museum, New York, 1961

Born Malcolm Little, Malcolm X was then thirty-five years old. His father had been murdered by white supremacists when Malcolm was a child, and one of his uncles was lynched. His mother was placed in a mental hospital when he was thirteen. He grew up in foster homes, unloved, unwanted, and abused, and in his late teens, he went to prison for breaking and entering. It was there that he encountered the Black Muslims. Opposed to the civil rights movement because it called for integration, the Black Muslims believed in black supremacy, and they advocated the separation of black and white Americans. Rejecting the names they had been given from their slave owners, they were intent on setting up their own territory within the United States.

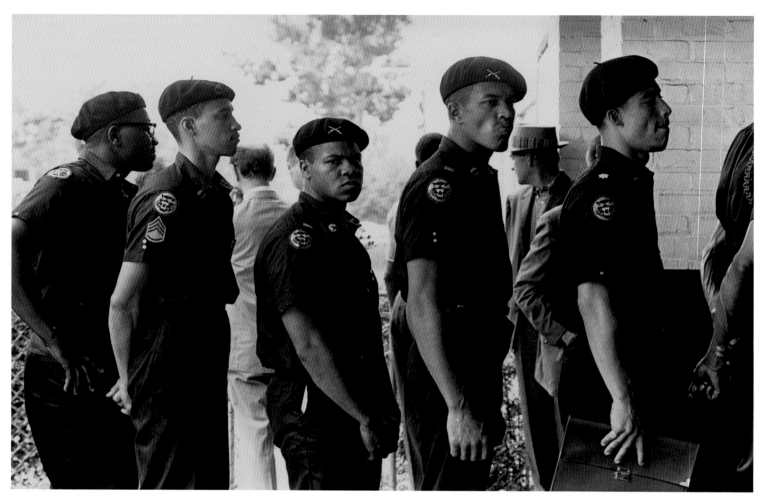

61. The Fruit of Islam, Black Muslim troops who are taught to kill with their hands, at a Black Muslim meeting, Uline Arena, Washington, DC, 1961

62. Back of previous image with Eve Arnold's handwriting

63. Contact sheet from the essay "Black Muslims" showing Eve Arnold's edits, 1961

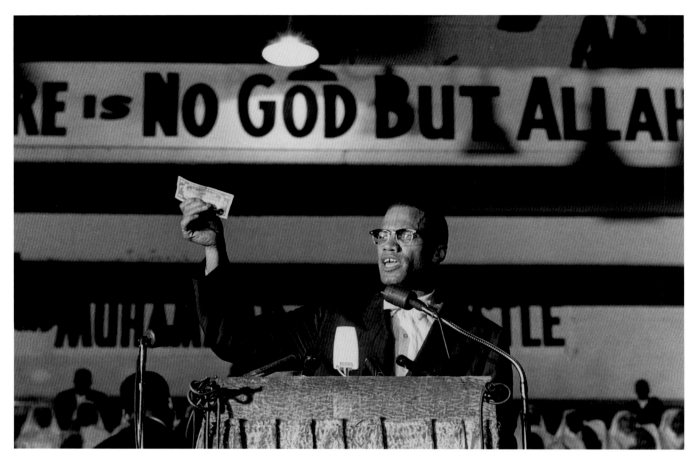

64. Malcolm X at Black Muslim rally,
Washington, DC, 1961

Eve knew all this and more about the group, but she could not have anticipated how attuned Malcolm would be to every nuance of her work. "He obviously had an idea of how he wanted the public to see him and he maneuvered me into showing him that way," she wrote. "I am always delighted by the manipulation that goes on between subject and photographer when the subject knows about the camera and how it can best be used to his advantage. Malcolm was brilliant at this silent collaboration."[72]

She photographed him for the first time in 1961 at a Black Muslim rally in Washington (figs. 64, 65), and over the next eighteen months, Malcolm periodically allowed Eve into his entourage. They developed a strong friendship. Some of Eve's friends guessed that she was physically attracted to the leader; she told one that it was electrifying to be near him. She followed him to meetings and rallies across the country. People yelled, "Kill the white bitch," and spat at her; when she arrived home and took off her wool sweaters, she would find the back polka-dotted with cigarette burns.

65. Malcolm X at Black Muslim rally,
Washington, DC, 1961

Malcolm suggested that she visit him in Chicago, where the Muslims had organized an economic boycott, setting up their own shops, schools, factories, and restaurants. At the hotel, he would phone every morning with her schedule and a meeting point from which she would be escorted,

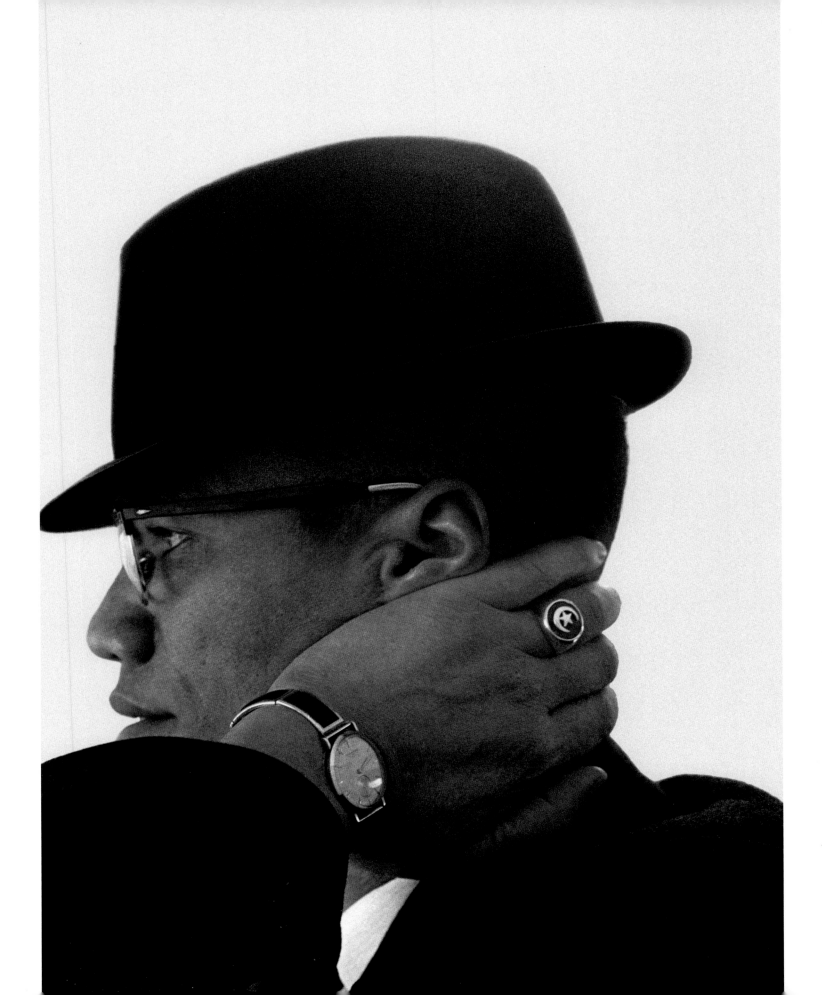

66, 67. Pages from the Magnum
distribution of the Malcolm X story, 1961

unharmed, through the community. And every morning she would receive
a second phone call from someone with a Southern accent who said, "Get
the hell out of town before it's too late."

Eve was not one to back down. She stayed for two weeks and photo-
graphed a rally that was attended by about six thousand people. The young
men—dressed in dark suits, starched white shirts and dark ties, their shoes
shined to perfection—were separated from the women, who wore white
dresses and head coverings. In the front row sat a glowering George Lincoln
Rockwell, head of the American Nazi Party, with his aides, arms crossed,
wearing military uniforms and swastika armbands (fig. 68). Unlikely allies,
the groups shared one interest—a partitioned America, with the Eastern
Seaboard for the Nazis and the rest of the country for the Black Muslims.
When Eve raised her camera to shoot Rockwell, one of his Nazis sneered,
"I'll make a bar of soap out of you." She retorted, "As long as it isn't a lamp-
shade," and continued taking her pictures.[73]

Eve was continually amazed by Malcolm's attention-getting skill,
whether he was working a crowd or bringing her a group of Nation of Islam

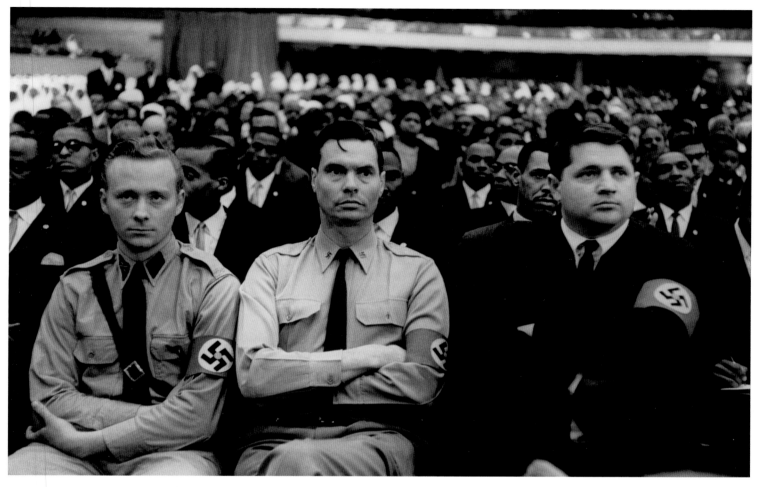

women in luxuriant white robes because he knew what a good picture they would make. Talking about him many years later, she said, "I thought he was brilliant. I thought he was sincere in what he was doing. I thought he was wily and Machiavellian, and an opportunist because he switched when he realized that he was in too deep, and he was in danger of being murdered."[74]

Malcolm left the Black Muslims after becoming estranged from their leader, Elijah Muhammad, and in 1965 he was murdered in the Audubon Ballroom in New York. Eve's story never ran in *Life*. After considerable back and forth, the nervous editors decided against it, infuriating Eve. "But *Esquire* ran it," she said. "It's run many, many places. It's supposed to be the definitive work on Malcolm."[75]

Most importantly, that story marked the beginning of a major transition for her, from America to Great Britain, from suburban married life to a challenging new existence in London, and from struggling as a freelancer to a coveted spot at the world's first newspaper color magazine.

68. George Lincoln Rockwell, flanked by members of the American Nazi Party, listening to Malcolm X's speech at Black Muslim meeting held at the International Amphitheater, Chicago, February 25, 1962

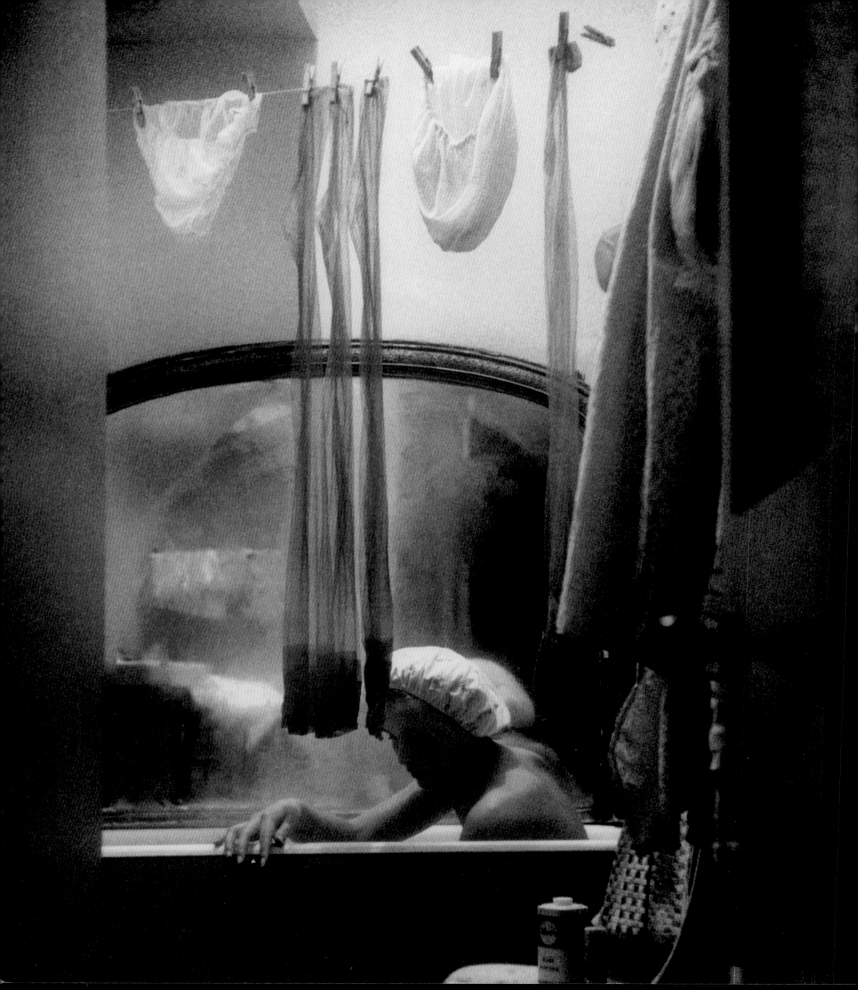

I came to Britain for the first time in 1961 and felt an immediate affinity and affection for these islands that has not diminished in the almost three decades I have known their people and their landscapes.[76]

3. A NEW LIFE IN LONDON

In 1961, Eve and Arnold arrived in England to enroll Frank in boarding school. From the earliest days of their marriage, Arnold had said that he wanted any children he might have to attend Bedales, an elite and determinedly bohemian "public" school (in American terms, an independent, private school) planted deep in the English countryside. This was because in the thirties, when Arnold and his family arrived in England as refugees from Germany, Bedales was the only public school that would accept a Jewish child. Furthermore, the headmaster promised that if the thirteen-year-old boy could become fluent in English in six weeks, he could attend for free. Arnold rose to the challenge, became a star student, and always cherished his memories of his time there.[77]

The plan was to try living in England for a year to make sure that Frank was settled, but within months their marriage ended. The exact circumstances were unclear; Eve would not discuss them, even with family members. However, Frank suspects that his father had been involved with other women and that he left Eve because he was in love with someone else. If so, that someone was probably Gail E. Haley, his subsequent longtime partner, with whom he had two children. After the separation, Arnold went back to America, and Eve stayed in London to be near her son.[78]

Life in England was not easy for either Eve or Frank. Frank was a "wildly unhappy" outsider at his fancy English school, and he defiantly clung to his strong New York accent as a way of staying unclassifiable.[79] At thirty-nine, Eve was faced with making her way alone in a new country. A wet autumn was followed by the coldest winter in a hundred years.

69. Bathroom, from the essay "Three Girls in Search of a Fourth," London, Knightsbridge, 1961

70. Flatmates and a friend prepare coffee, from the essay "Three Girls in Search of a Fourth," London, Knightsbridge, 1961

"The endless gray and chill days of England seemed like a punishment," she wrote. "It added to the sadness of the sudden changes in our lives."[80]

Dogged and uncomplaining—"she just hated complaining," says her sister-in-law Gert Cohen, "she just got on with it"[81]—Eve set about finding somewhere to live, learning the culture, making friends, and most importantly, figuring out how to get the work she needed to support herself and Frank. She was well positioned to do so, with the Magnum imprimatur and a provocative set of published stories in her portfolio, including the Black Muslims photo-essay. She managed to find herself an affordable one-bedroom flat in a third-floor walk-up at 26 Mount Street in Mayfair and began to pursue story ideas.

Intrigued by the idiosyncratic Personal Column that traditionally ran on the front page of the *Times* of London, she proposed to *Queen* magazine a five-part series on the people who placed these ads. She wanted to learn more about them—who they were and what kind of lives they led. Mark Boxer, the magazine's editor, loved the idea.

In one segment, Eve featured three ebullient young women living together in a rented Knightsbridge flat. With their fourth roommate leaving for America, they were looking for a replacement (figs. 71, 72). This was a

time when well-brought-up British girls did not live with their boyfriends after leaving home; they lived together. These three twenty-year-olds entertained and went out in the evening to the extent that their meager budget allowed; they kept in close touch with their parents; they hung their newly washed stockings to dry in the tiny bathroom. Eve was with them as they cooked and chatted and went to work, and she wrote charming text to describe their situation: "It had been super, gorgeous, fabulous, and bliss, and now this phase of it was over. Perhaps the new fourth would be fun, but no matter how she fitted in, the flat would never be the same."[82]

Soon after Eve had finished the series, Boxer moved over to the *Sunday Times,* to launch England's first newspaper color magazine, and he took Eve with him. In 1963, Eve signed a ten-year contract that committed her to contribute stories for six months of the year, either portraits-in-action or major photo-essays that might take months to complete. During the rest of the year, she could continue her freelance work while keeping a maternal

71, 72. Tearsheets from "Three Girls in Search of a Fourth," *Queen*, March 6, 1962

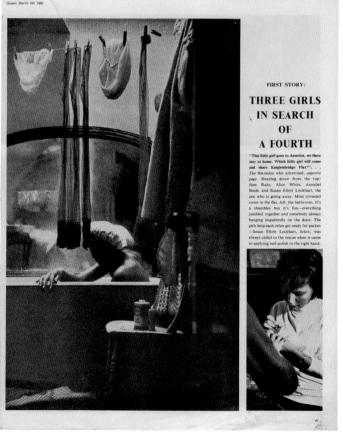

eye on Frank. While the *Sunday Times* offer was exciting for her and for Magnum, the terms were far from generous. "Six major stories and six minor stories, all in a period of one year . . . they will pay 500 pounds for the major stories and 120–150 for the minor."[83] In equivalent US dollars, that was about $1,400 and $300–400, respectively.

The new connection was to be life-changing, but Eve's immediate need was money. She had to pay for her apartment, school fees—according to Frank, Arnold contributed nothing—and all her work-related expenses. Plus, as she wrote plaintively to photographer Wayne Miller, director of Magnum's New York office, "The cost of living is high here."[84]

Letters about money flew back and forth between Eve and Miller. Eve had a clear idea of what she needed to do to succeed in London. She wrote, "The social end of things is terribly important in England. In the States one does not have to be anything other than a good pro. For the kind of work I am doing which is among others top personalities like the Chancellor of the Exchequer, the Archbishops, etc., there is a certain standard of living that I must maintain. I have been having parties with people like O'Toole and Richard Burton, and Liz Taylor and editors and movie people. All this makes for more work but costs a lot of dough and without it there is tough sledding."[85]

Miller was concerned about her "deficit." Magnum had been trying to help her with assignments but had raised its percentage for handling a story, and Eve owed the agency $1,000 (equivalent to £400) —an amount which, she later wrote, seemed "piddling by today's standards, but if you realize that I was paying my assistant three pounds three shillings a day, car included (I paid for fuel and lunch), then you can realize how worrying the burden of debt was for me."[86]

Several things made it possible for her to move forward. The long-suffering Miller advanced her the money to cover the debt. "It took me five years to repay it," Eve wrote. "I have never forgotten his kindness."[87] She also took on some new advertising work and, through Magnum, embarked on a lucrative specialty: documenting the making of feature films produced from Britain. Her money worries subsided but never vanished entirely. Keeping solvent while self-employed was as hard then as it is today, and the archives contain irritated letters from her to Lee Jones, the New York editorial director, about assignments, delays, and missing money. In 1966 she wrote, in a letter that begins "Dearest Lee," "WHERE IS THE MONEY FIVE HUNDRED DOLLARS THAT WAS TO BE DEPOSITED TO MY BANK? BARCLAYS MOUNT STREET BRANCH—ON THE FIFTEENTH OF THE MONTH? WHERE????? WHAT DO YOU EXPECT ME TO LIVE AND WORK ON???? PLEASE RAISE HELL FOR ME ABOUT THIS. IT IS IRRESPONSIBLE IN THE EXTREME AND I'M FURIOUS!!!!!!!!!"[88]

The core of her new existence was the *Sunday Times*, which Eve later described as "an adventure playground for people like me." In Britain, as in so many places around the world, a giddy feeling of change was colliding with tradition, and all of it could be documented at her newspaper. The *Sunday Times* of the sixties was a legendary place, home to many celebrated reporters and feature writers and, especially after the arrival of the great Harold Evans in 1967, the birthplace of groundbreaking investigative stories. At the magazine, the roster of photographic talent was extraordinary—from Lord Snowdon and Don McCullin to David Bailey and Eve—all charged with changing the very nature of newspapers by introducing color photography into journalism.

Although Eve was never overtly political, her passion for social justice and her curiosity about people's lives made her a perfect witness to the emerging currents and trends of the time. With the backing of Evans and her editors and colleagues at the magazine, she flourished. Looking back, she told a British interviewer that she had been fortunate to start her career with the American picture magazines of the fifties. Then, just as television began to eclipse them, she left for Britain, where the pace of change had been slowed by the war. In the sixties, the picture magazines "hit like a hot wind. Instantly I was picked up by the *Sunday Times*—no women were doing what I was doing—and because I wrote and had ideas, it was a whole basket of different skills that we'd been trained to do in the States. I fell in love with what I was able to do here."[89] She was, as usual, an anomaly in this new world of hers—small, American, indefatigable, and female.

Eve always felt that being a woman was an advantage. Whatever her "more militant feminist friends" might believe, she said wryly, "being a woman was just a marvelous plus in photographing!" As she explained, "Men like to be photographed by women, it becomes flirtatious and fun, and women feel less as if they're expected to be in a relationship."[90] Indeed, men from Senator McCarthy to Malcolm X had responded to her attention and women had trusted her. When she photographed an aging Joan Crawford having a facial, or a vulnerable Marilyn Monroe struggling to memorize her lines, Eve had somehow managed to disappear. Shielded by her camera, aided by her gender, she gained access to the secrets of the most complicated individuals.

Her editors took her and her work very seriously. Appreciative of her talents and energy, they let her do what she wanted as long as she stayed within a budget. She would meet with them, discuss stories, receive an advance of money, and take off. There were no budget estimates or reports to prepare, no proposals to write; the work was based simply on mutual trust.

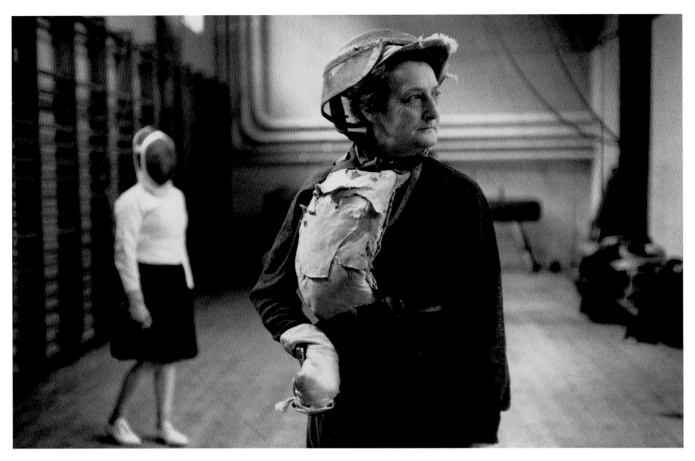

73. Fencing mistress, Wycombe Abbey Girls' School, High Wycombe, England, 1961

Her range was prodigious. A list from 1964 includes the following subjects, several of which were cover stories for the magazine: the British prime minister, the Living Theater, fringe religions in the United States, Alan Bates, Barbra Streisand, whiskey ads, *New Statesman* magazine, Barry Goldwater at the Republican Convention, Andy Warhol, and Kingman Brewster, the president of Yale. While her travels between England and America were exhausting, she felt that working in both places kept her on her toes. In Britain she felt like an American, and in America she felt like an outsider.

That perspective was particularly useful for her studies of African Americans, which had begun with the Harlem fashion shows and continued through Malcolm X and the Nation of Islam. In 1964, she did a story entitled "The Black Bourgeoisie," documenting the life of privileged African Americans, from the black debutante ball at the Waldorf-Astoria to black businessmen, models, a black general at the Pentagon, and a charm school. Her reportage on this little-explored segment of US society twice made the cover of the *Sunday Times Magazine.*

In November, Eve wrote to her son: "I spent the last weekend in Philadelphia doing my negro story, and am just beginning to see daylight and focus—those who made it in spite of the fact that they are negro, and those

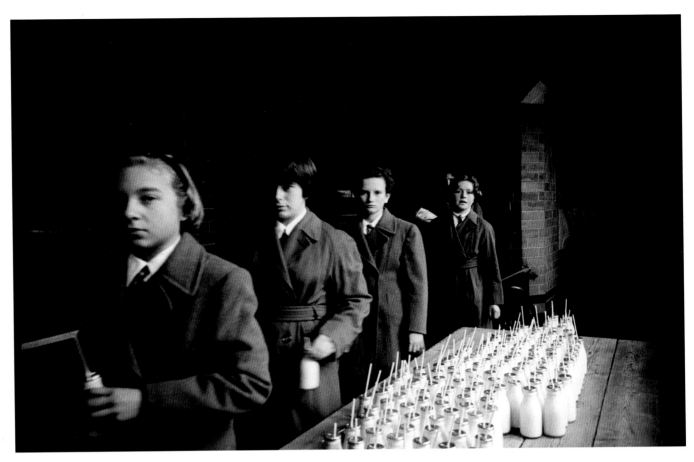

74. Midmorning milk break at Cheltenham Ladies' College, Gloucestershire, England, 1961

who are making it now because they are negro—the whole climate has changed in this country, and now they are accepted because of the spending power (20 billions [*sic*]—as great as that of Canada)—and it is a hell of an interesting story. I am getting a huge charge out of it."[91]

Chris Angeloglou was the young picture editor at the time, straight out of university. He remembers what a joy it was to work with Eve. "She was absolutely full of things she wanted to do," Angeloglou says today. "And there was never any feeling of 'I am a great photographer.' She would do a lot of her own research. She would work with writers, and then the next thing you knew, she would come in with her contact sheets." She was that rare thing, "a real pro."[92]

Eve was never short of ideas for future projects, writing them down on index cards that she methodically filed away. Now in her archive, they demonstrate how meticulously she researched her stories, covering subjects from anthropological research to etymology. They also show how deeply she steeped herself in thoughts about photojournalism. One such card reads: "It seemed to me that Goya, who dealt with reality, was a reporter, and that if he had lived in the 20th century he might have used a Leica instead of a paintbrush to document his time."[93]

Eve longed, she said, to go everywhere and see everything. Still, in her early days in England, she was happy to make a gradual shift in focus, away from America and the "political darkness and fear" she had experienced in the era of Joseph McCarthy and the Black Muslims to the British in all their eccentricity and individuality. "I wanted to try to understand the strengths they drew on," she wrote, "the wellsprings of their lives—to work in the British grain."[94]

She had done her homework before she even arrived. "I'd read the novels and the poetry and the speeches made by great men—everything from Magna Carta to Jane Austen. It was important to me to have a sense of where the Americans had got their Bill of Rights."[95] This amount of preparation became typical of all her major projects. Never having attended university and possibly self-conscious about her lack of a formal education, Eve consumed world literature, history, and art. She read everything and talked to everyone and repeatedly referred to the "overwhelming curiosity" that drove her to explore people's lives.

As an outsider, she brought freshness to what British people took for granted. She photographed four elite girls' boarding schools; high-class and high-minded, they were the (more regimented) female equivalent of Frank's school, where he was miserably getting acclimatized (figs. 73, 74, 78). She documented other institutions—the Church of England, the Salvation Army, football fans, and royal societies—along with actors, film directors, debutantes, politicians, and artists: what the *Sunday Times* called "the Essence of England." Within just a few years of her arrival, Eve was becoming one of the most sought-out photographers in London.

Professionally, things would only get better. Her personal life was, however, complicated. Despite their breakup, she and Arnold were in contact. Eve's first letters to Arnold in America betray longing as well as excitement at the thought of being with him and their son at Christmas. In a typical letter from 1961, Eve called him "Dear one," anxiously asking about his situation. "You sound terribly sad and sort of abrupt and I don't know what to make of it. . . . I realize what a miserable and heavy burden you are handling all by yourself and I'm sorry that I'm not able to do more."[96] In other letters from that year, Eve's loving concern is palpable. She fretted about Arnold's well-being and said she was worried about him. Three years later, in letters to Frank, she still referred fondly to Arnold.

Arnold, meanwhile, became elusive. The "burden" that Eve mentioned was undoubtedly financial—Arnold had branched out, developing educational books and games without much success—but his reluctance to communicate must have had deeper roots. Like all concerned parents, the

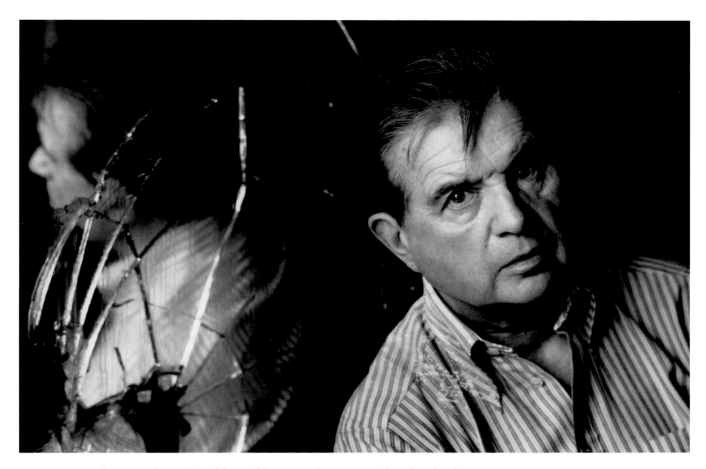

75. Francis Bacon in his studio, London, 1978

two compared notes about Frank's problems and progress, but by the late sixties, Eve's letters had become chilly; the two were in touch only to make holiday and travel plans for Frank, who would alternate school and university vacations with each parent. As Frank remembers it, Arnold and Eve communicated intermittently and with increasing awkwardness into the seventies, but Eve's hurt persisted, so much so that she declined to divorce Arnold for almost thirty years. As for Frank, he kept in some kind of touch with his father until the mid-seventies, but with little enthusiasm.[97]

Eve and Frank had an intensely close and loving relationship. He was her consolation and her joy. Whenever Frank came home, first from boarding school and then from Cambridge University, he would sleep on the sofa in the large Mount Street front room and help her with her work. Against one wall there were fold-down tables and a projector. Eve would project her images against the white wall and, the first time she went through them, throw out all the badly composed ones. For all the others, her assistant would make a list—columns A, B, and C. Eve would throw out the Cs, file the Bs, and pore over the As, looking for the really good ones. Beeban Kidron remembers how ruthless she was in her selections, and also how funny. "It's not that we're so great," Eve said with a wicked smile, referring to them both as a team.

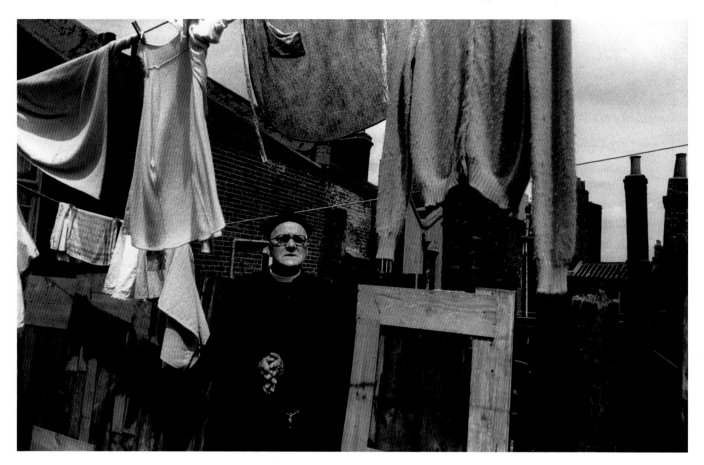

76. A vicar during his visit to his parishioners, London, East End, 1963

"It's that the others are so fucking mediocre."[98] Having made her choices, she would begin to figure out the story, discussing it all as she went along.

Frank helped with research and acted as her sounding board. As a politically inclined young man in the sixties and seventies, he often suggested an edgier approach. "My advice would have been over the top," he says today. A medical student who went on to become a surgeon and human rights activist, Frank remembers how irritated he used to get with Eve for her stylish, sometimes extravagant ways. Once when they were walking home from dinner out, she commented on a dress that she liked in a shop window; it was on sale for two thousand dollars. Frank told her that at his current rate of pay he would have to perform four thousand appendectomies to buy it. Today he remembers fondly what care she took with her appearance—usually clad in well-cut pantsuits, she was proud of her silver hair, dieted obsessively, wore a girdle well into her seventies, and remained uncharacteristically coy about her real age.[99]

Eve took Frank along on assignment whenever it was feasible. Mostly it was not, and for long periods of time she was gone. Looking back today, Frank says, "Eve wanted it all—motherhood and a career—and she managed to have that. But she paid a price. She was very unhappy when she was out of the

country and I was here in my teens." And his feelings? "My reaction was that it was better to have one functioning parent than none."[100]

When she was on assignment, Eve went to great lengths to keep in touch, and she tried to telephone her son every day at 5 pm. In a small Russian town near the Black Sea, she once queued for hours to place a call. It was worth it, she wrote later, just to hear his voice. She sent him endless, loving letters that showed the depth of her feelings for him: "I feel the touch of your hand on mine, and I want you to have the sure knowledge of my love, and my deep deep regard for you. You have courage, intelligence and a rare capacity for life and living, and I love you."[101]

She wrote from all over the world, on hotel stationery and flimsy aerogrammes, and many of her letters survive in the archives. Always touching, often hilarious, they conjure up her world of work so openly and with such richness of detail that they amount to a documentary record of her thinking and the way her pictures came to fruition. Frank wrote back, from school,

77. Father Gregory Wilkins, director of the Society of the Sacred Mission at Kelham, Nottinghamshire, England, 1963

from university, and later on from London. After the twenty-first birthday party she gave him, he wrote: "I have been thinking about us a lot—about what a lucky bastard (not the literal sense) I am to have you for a mother. . . . I miss you, miss you, miss you."[102]

When she was home, Eve avoided loneliness by creating a life full of friends and parties. An excellent cook with a tireless interest in other

people, she loved to entertain, providing, as Chris Angeloglou remembers, "tremendous food, lots of wine." London's most interesting and glamorous people would climb the stairs to her apartment to mingle and eat her special chili. A small group of like-minded women became her closest confidantes. Marcia Panama, a sculptor, was also an expatriate American, and the two would go to dinner or the theater and take trips together. "You are my sister, a loving one . . . the only one I've ever had," Eve once wrote to Panama in a rare outpouring of emotion.[103] Hanan al-Shaykh, a respected Lebanese writer, lived around the corner. They shared a passion for fashion and design, and they talked on and on about the politics of the Middle East.

Eve's business and social lives meshed seamlessly when it came to film work. In the sixties, Britain's movie industry was flourishing, and the producers needed stills to promote and sell their product. Magnum was eager for the work because the studios paid their photographers at a better rate than magazines. Eve was an obvious choice for this, primarily because of her earlier success with Marilyn Monroe and Joan Crawford and her remarkable pictures from the set of *The Misfits.* Her contract with the *Sunday Times Magazine* and her connection to Magnum, with its worldwide distribution, only made her more desirable, to the point where she had her pick of projects. She enjoyed the work—being around her subjects for weeks, even months, made it easier to get the relaxed and intimate shots that she was looking for—and she built strong relationships with both actors and directors.

The films she chose included *Becket*, with Richard Burton and Peter O'Toole (fig. 82); *Anne of a Thousand Days*, again with Richard Burton; *A Man for All Seasons*, with Orson Welles, Paul Scofield, and Vanessa Red-

78. School prayers, Cheltenham Ladies' College, Gloucestershire, England, 1961

79. Simone Signoret during the filming of *The Deadly Affair*, London, 1966

80. Orson Welles rehearsing a scene for the film *A Man for All Seasons*, in which he plays Cardinal Wolsey, London, 1966

grave (fig. 80); and *The Deadly Affair,* with Simone Signoret and James Mason (fig. 79). Perhaps her most hair-raising experience was in Rome, when she filmed the making of *The Bible*, directed by, and starring, John Huston, whom she knew well from her work on *The Misfits*. Huston invited her for the Noah's Ark sequence, which involved three hundred animals and one thousand birds. It was chaos—the stench, the noise, the neurotic giraffes!—but she stayed for weeks, loving the hysteria and the camaraderie. The experience further cemented her relationship with Huston.

Eve went on to photograph more of Huston's movies and became a close friend. She shot portraits of him and his family, including a screen test for his teenage daughter Anjelica when she was up for a starring role in his movie *A Walk with Love and Death* (fig. 81). Earlier photo sessions with Cecil Beaton and David Bailey had made the self-conscious sixteen-year-old look too sophisticated to play the movie's innocent thirteen-year-old character. Eve posed Anjelica in the Irish countryside, wearing a flowing dress designed by her mother. Remembering the session years later, Anjelica wrote: "Looking at those pictures now. . . . I can see Eve, quiet and purposeful, speaking to me in that affectionate, low, froggy voice, and the feeling

81. Anjelica Huston at age sixteen, 1968

that she, the camera and I were as one."[104] Anjelica got the part, and the two remained close for the rest of Eve's life.

However much she enjoyed the movie work, Eve kept searching out the juicy reported stories that satisfied her restless curiosity, and by 1965, she had found several. For a gritty piece called "Women without Men," she persuaded the *Sunday Times* to let her photograph women soldiers, divorcées, single mothers, nuns preparing to become Brides of Christ, and a lesbian wedding, which was considered such a delicate subject at the time that the paper published just one picture—of the guests. This story reflected Eve's interest in the emerging women's movement and also her new preoccupation with women in closed societies around the world, which culminated in her pioneering "Behind the Veil" stories in the *Sunday Times Magazine.*

Feeling confident, Eve expanded her focus over the next several years and took on wider ranging projects. She went to the Vatican to illustrate its workings, to North Carolina to document US Marines training for combat in a mock-up of a Vietnamese village, and to Puerto Rico for a story on the birth-control pill. She built on her civil rights work by photographing, and writing, an influential *Sunday Times* piece called "Black Is Beautiful." But her most important work was in Russia, which she visited twice in 1965 and 1966.

Her first journey was to Georgia in 1965 for a project dreamed up by one of her editors. The idea was to find and photograph the oldest men in the world (a Russian census had turned up two thousand Georgian centenarians). Eve found the perfect interpreter, a British journalist named Gloria Stewart, whom she described in a letter to her mother as "a big-bottomed, Russian speaking English Girl who the Russians adored."[105] The trip stirred up a whirl of complicated emotions. Eve was mindful that her uncle and ten members of his family had been slaughtered during a pogrom in Russia; she was thrilled to be in the land of her ancestors; and she was deeply frustrated at her inability to speak the language.

Feasting and prodigious drinking marked the weeks that she and Stewart spent in the villages where the hearty old men lived. She more than held her own until the day when, unexpectedly sober, she tripped and fell off a porch while filming, broke two teeth, and injured her jaw. Deciding against a local doctor because she had "a nightmare of returning to America with a mouthful of stainless steel teeth," she spent the next two days filming through intense pain and five more days in transit home from snowbound Russia. She said the scarves swathed around her head made her look like a "mute babushka." In the end, things turned out fine, and as she wrote to Arnold: "Fortunately, I am not unsightly."[106] The piece that resulted was so

82. Elizabeth Taylor with her children on the set of *Becket*, watching Richard Burton playing a death scene, London, 1963

84. Soviet Sunday, waiting for a bus, Russia, 1966

popular that when *Sunday Times* readers were asked years later to name the story they remembered best, it came in top of the list.[107]

During their travels, Eve and Stewart had amused themselves speculating about all the other stories she could do in Russia, if only she had the time. In Britain, while waiting for her jaw to heal, she researched the ideas and then presented a list to her editor, who asked what percentage of them she was planning to accomplish. Fifty percent, she said; he gave her the green light, and for the next year she researched and planned the trip to the point where she felt ready.

Eve's editor found a young, energetic, Russian-speaking journalist named George Feifer to help with her ambitious agenda. Feifer had spent time in the USSR, and he knew how to navigate its bureaucratic labyrinth. In 1966, they spent four months reporting, with the aid of an interpreter from the national news agency Novosti. Even though the KGB was monitoring

83. Divorce in Moscow, 1966

86. Wedding, Russia, 1965

all their activities, they managed to gain unprecedented access. Eve said later, "The Russians permitted me to do stories that had been taboo before. When I asked how come I had been given such privileges, they said nobody had asked before."[108]

This trip was much more difficult than the first. Their goal, Eve said, was to "investigate how the people lived fifty years after their Revolution." Eve managed to shoot twenty-nine stories, 70 percent of her original list—photographing divorce courts, mental hospitals, a circus school, clinical death trials (in which animals were bled to death and then resurrected), jails for juvenile offenders, and Tolstoy's oldest grandson. On the collective farm where she and Feifer spent a month, she said, "We lived with the peasants—their word—had our meals with them, took our Saturday-night bath when they took theirs, went to bed when they did, and rose with the dawn."[109]

Eve later wrote of the trip, "What bothered us as we travelled around the country was the unhappiness on the faces of the people and the grey

85. Dancing school, Russia, 1966

grim look of their surroundings."[110] That bleak atmosphere pervades many of the pictures. Sean O'Hagan of *The Observer* wrote about the photo "Divorce in Moscow, USSR, 1966" (fig. 83): "In a drably functional room, a distraught man looks away from the camera to the right, while his wife stares stoically off in the opposite direction. The body language speaks volumes: his head rests on his hand; her hands are clasped tight, her wedding ring just visible. The physical space between the couple is minimal, but the emotional space is vast. In the background, oblivious, a man reads a newspaper, while another is engrossed in a book. Arnold catches the full weight of this fraught moment, and the universal truth that great personal suffering, as [poet W. H.] Auden put it, often 'takes place when someone else is eating or opening a window or just walking dully along.'"[111]

Eve's Russian experiences helped her see her family and her childhood in context, and it gave her a new appreciation of her parents' decision to emigrate. Working around the logistical challenges of the bureaucracy, the anxiety and unhappiness that people exuded when they talked to her, and the grim look of the Soviet state required all her mental energy. But with her characteristic intelligence and erudition, she found the truths she had been seeking. In a letter to her mother, she summed up her time in Georgia: "Under the thin veneer of Communism there are all the Russian novels one has ever read. It is *War and Peace*, Chekhov and Turgenev, *Ivanov* and *The Seagull*, Gogol's *Dead Souls* and *The Cherry Orchard*—visually it is all of this rolled into one photographer's dream, and I am longing to go back."[112]

Many years later she attempted to go back to Ukraine, where her parents were born, but her next major journey would begin in 1969 and tackle a very different part of the world. One evening in 1968 while in Tunisia to photograph Anouk Aimée during the filming of *Justine* (fig. 87), Eve bumped into an American friend, a photographer for the US Information Agency, in the hotel coffee shop. The man invited her to go with him the following day to hear President Bourguiba speak at a rally. She went and was powerfully affected by his words. Bourguiba spoke directly to the women of his country, urging them to come out from behind the veil and become a part of the twentieth century, and that speech sparked an idea in her head. Eve's "Behind the Veil" project would last two years and take her deep into the Arab world of Afghanistan, Egypt, and the United Arab Emirates.

87. Anouk Aimée on the set of the film *Justine*, 1968

What do you hang on the walls of your mind?
When I became a photographer I began,
assiduously, to collect favorite images which I filed
away in my imagination to bring out and examine
during moments of stress and moments of quiet. [113]

4. AT HOME IN THE WORLD

The more Eve's work took her on the road—sometimes for three or four months at a stretch—the more she came to value her rich life in England. "Coming back to London felt like settling into a velvet-lined womb," she wrote to a friend in January 1968, after a long assignment in America.[114]

She could spend time with Frank during his holidays; Magnum and the *Sunday Times* kept her busy and anchored; and her routines were sustaining. There was the tiny apartment, which she loved (and for which she had somehow managed to buy the lease), and the pub across the street where she'd go for smoked salmon sandwiches. There were the friendships she'd made with everyone from John Huston (fig. 89) to her cleaning lady. Her address book was packed with writers, painters, artists, actors, and politicians. Paloma Picasso quipped to Isabella Rossellini that she'd once found it impossible to get noticed at a chic party because "everyone wanted to talk to Eve!"[115]

Above all, there was her work schedule, with the apartment as its hub. Over breakfast at her kitchen table, she plotted out projects with her new agent, Ed Victor. Victor was something of a celebrity himself. An urbane, well-connected American expatriate, he was one of the first agents to make a lot of money for his famous clients. He recalls being fascinated by Eve the moment he met her. "We became instant friends," he says. "We were just very compatible; we just kind of fell in love with each other."[116]

After breakfast she would go to work with her assistants—loyal, hardworking young women whom she nurtured and befriended. Beeban Kidron had been one of the first who was invited to show Eve her photographs

88. Eve Arnold in Spain, 1969.
Photo: Pierluigi Praturlon

when she was just fourteen. She remembers arriving breathless and red-faced at the top of the five flights of stairs to be greeted by a woman of "great presence, little height and the longest hair I had ever seen." In her low, raspy voice, Eve said, "If you want to be a photographer, you'll have to be fitter than that."[117]

At sixteen, Kidron began working for Eve, and years later she remembered what it was like. "Before she went on trips, Eve would fill notebook after notebook with research and thoughts. . . . [H]er packing covered every eventuality from monsoon to heat wave, from potential illness to royal invite. . . . Her return would be a whirlwind of developing, sorting and printing—never jet-lagged, she would often work into the night."[118] Kidron went on to become a movie director but kept in touch; another assistant, Linni Campbell, stayed close to Eve for forty years as a devoted helper and friend.

Frank had met Campbell at the Glastonbury music festival, and he told her that his mother needed an assistant. Despite being a little intimidated by this "tiny gruff American," she took the job and began working for her a few days a week, doing errands and generally helping out. "I was really like her daughter, more than an assistant," Campbell says. "Most of the time, she treated me beautifully—I would have done anything she asked. She was so very generous. But a hard taskmaster—she did not suffer fools and she would be right on it. . . . [S]he could be unpleasant . . . she *had* to be."[119]

Campbell arrived just when Eve was deep into her "Behind the Veil" project (figs. 90–99). Every day Campbell would be dispatched to the School of Oriental and African Studies to do research. "I went off in the morning with a basket," Campbell recalls. "And I would come back [with the basket] stuffed with books, with articles, with things for Eve to read. We would go over them together. Then we would sit down for a proper lunch. With Eve, you always had a proper lunch, no matter what."[120]

Indeed, those Mount Street lunches were almost as legendary as the dinners. Eve would prepare them for her assistants and any guests using

89. John Huston with his dogs at home in St. Clarens, Ireland, 1968

ingredients Campbell had purchased from Fortnum and Mason, Selfridges, Marks and Spencer, or Allens of Mayfair, the posh traditional butcher across the street. As Campbell remembers it, the food was sophisticated—French bread, chicken livers, mascarpone, the salad bowl rubbed with garlic and salt, and good coffee, which was unheard of in London at that time. The table would be elegantly set with linen napkins and silver. (Even on picnics, Eve liked champagne and lobster sandwiches.) The spirited conversation flowed, and after lunch, the work would begin again.[121]

"Behind the Veil" mushroomed from a simple idea into a mammoth undertaking. There were roughly 500 million Muslims around the world at that time, living in societies with a wide range of practices regarding women and the veil. In Afghanistan, a country going through massive change, women were coming out of the burka and wearing miniskirts. In the United Arab Emirates (then known as the Trucial States), women were rarely seen. Then there was Egypt, Palestine, Jordan, Lebanon, and, if she wanted to venture to Asia—Indonesia, the most populous nation with a Muslim majority.

Eve spent months reading and ruminating. She wrote on index cards and filled notebooks. She studied maps. She talked to other writers and photographers about the countries where she could gain access, shoot, and move freely. It became clear to both Eve and her editor at the *Sunday Times* that the story needed the help of a writer who was familiar with the Muslim world. They agreed on Lesley Blanch, whose successful book *The Wilder Shores of Love* (1954) was a biography of four nineteenth-century European women who went to the desert to find adventure and romance.

They were an interesting pair: "She was a romantic," Eve wrote, "I a realist."[122] Blanch was flamboyant and demanding, but she was a game soul who was more than willing to travel across the Hindu Kush, eat strange food, and brush her teeth in Coca Cola. Eve stoically managed the money, the schedule, and the travel arrangements of getting from A to B. What they shared was an abundance of energy, sharp intelligence, and curiosity.

It was 1969, and they decided to begin in Afghanistan because Blanch had a contact who could get them to the king and also act as their interpreter. Eve was thrilled by the beauty of the landscape and the people; she called her time there "three of the happiest months of my working life."[123] The three women started out at the king's birthday celebration, then traveled across the country. Using a portrait lens and moving in close, Eve photographed the ruggedly handsome men as they walked in the streets, somehow managing to put them at ease. The women were more of a problem.

While the veil had been outlawed a decade earlier, most women still wore voluminous chadors covering their entire bodies, their eyes barely

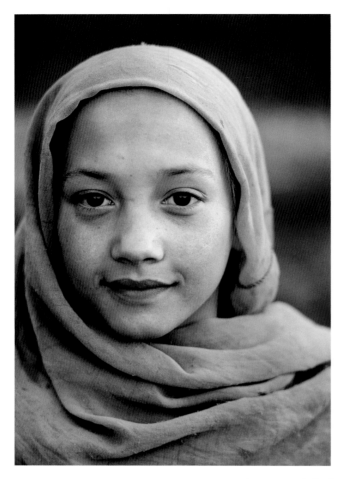

90. Portrait of a young girl, Kabul, Afghanistan, 1969

showing through a strip of lattice-patterned cloth. They were shy and reluctant to be photographed, but as they got to know Eve, they became intrigued, even protective. Eve was her usual intrepid self. She sought out, and found, a nomad wedding in the desert, only to be chased by a pack of wild dogs as she ran to photograph a group of dancing women. When she made it into the bride's tent, shaking, she was rewarded with a glorious sight. The young bride, dressed in red silk and adorned with jewels, stood in a shaft of sunlight with her eyes closed as she awaited her bridegroom.

Back home in London, Eve and Blanch began to plan for the following year's Egypt trip. Egypt was the leader of the Arab world, and in 1920 it had been the first Muslim country to remove the veil, so they decided to focus on strong women whose portraits could symbolize the changes in society. Their list included a pilot, a lawyer, an editor, and a seventy-year-old singer so adored that men would carry her away from the concerts in a chariot on their shoulders.

Because Eve had overspent her budget in Afghanistan, this second trip had to be short. It also turned out to be stressful. At every turn she faced an obstructive bureaucracy, interminable haggling, and, since Egypt was at war with Israel, a suspicious populace eyeing photographers as possible spies. But in three weeks of shooting, she got the pictures she was after, and she was able to move on to the United Arab Emirates, home of the Muslim world's most heavily veiled women.

In these seven states, women lived in harems in *purdah* (seclusion), and they wore burkas over their chadors. Somehow, Eve won their trust and photographed them in their daily lives. She made a crucial connection with the powerful and accomplished Sheikha Sana, niece of the ruler of Dubai, who invited her to lunch at her oasis. Over a dish of sheep's brains—the ultimate delicacy—the two became friends and talked for hours. They met for a second time when Sana visited London, and Eve entertained her and her entourage outdoors at an inn on the River Thames. In an expansive mood, Sana promised Eve that in the event of a family wedding, she would give her access to the celebrations.

"Behind the Veil" ran as two cover stories in the *Sunday Times Magazine*, and it created a stir. As British journalist Jon Snow described it,

WEDDING BREAKFAST

Wedding Cake - 1 metre 80 high. Gum drops, crystalised fruits, creme caramel, jello with tinned mixed fruit. 3 smaller wedding cakes, 24" in diameter, single layers bearing inscriptions 'Le Chef Patissier Francais de Carlton Hotel - vous souhaite de Bons Voeux de Bonheur'. Huntley & Palmers biscuits, traditional roast lamb (the one the English call mutton grab; a whole lamb eviscerated, the cavity stuffed with its own head with a large pancake, lentils and the whole covered with a large pancake. Mutton brain is the delicacy, usually removed and handed to the guest of honour. Camel milk. Irish biscuits. Honeyed pastries from Lebanon. Jordan almonds. Makintosha' toffees. Lebanese rice pudding made with honey, rose water, nuts and coconut and decorated with spices. Rahab halgum (a middle eastern gum sweet). Flowers - gladiolii, tulips, roses a gift from Lebanese singer (?) Simira. A camel had been killed the day before and there was camel meat and goat meat.

91. Menu for wedding breakfast, Jordan, 1971

92. Bill from the Winter Palace Hotel in Luxor, Egypt, for Eve Arnold's stay while shooting *Behind the Veil*, 1970

93. Spread from "The Seven Veils of Islam—Afghanistan," with text by Lesley Blanch, *Sunday Times Magazine*, 1969

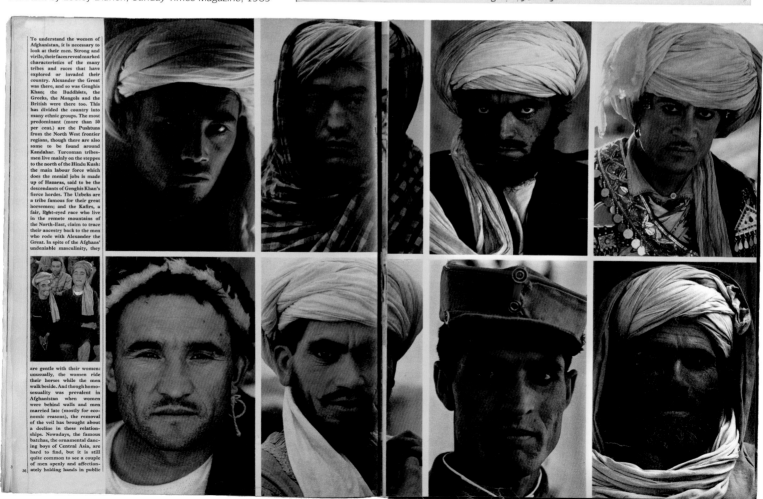

To understand the women of Afghanistan, it is necessary to look at their men. Strong and virile, their faces reveal marked characteristics of the many tribes and races that have explored or invaded their country. Alexander the Great was there, and so was Genghis Khan; the Buddhists, the Greeks, the Mongols and the British were there too. This has divided the country into many ethnic groups. The most predominant (more than 50 per cent) are the Pushtuns from the North West frontier regions, though there are also some to be found around Kandahar. Turcoman tribesmen live mainly on the steppes to the north of the Hindu Kush; the main labour force which does the menial jobs is made up of Hazaras, said to be the descendants of Genghis Khan's fierce hordes. The Uzbeks are a tribe famous for their great horsemen; and the Kafirs, a fair, light-eyed race who live in the remote mountains of the North-East, claim to trace their ancestry back to the men who rode with Alexander the Great. In spite of the Afghans' undeniable masculinity, they are gentle with their women: unusually, the women ride their horses while the men walk beside. And though homosexuality was prevalent in Afghanistan when women were behind walls and men married late (mostly for economic reasons), the removal of the veil has brought about a decline in these relationships. Nowadays, the famous batchas, the ornamental dancing boys of Central Asia, are hard to find, but it is still quite common to see a couple of men openly and affectionately holding hands in public

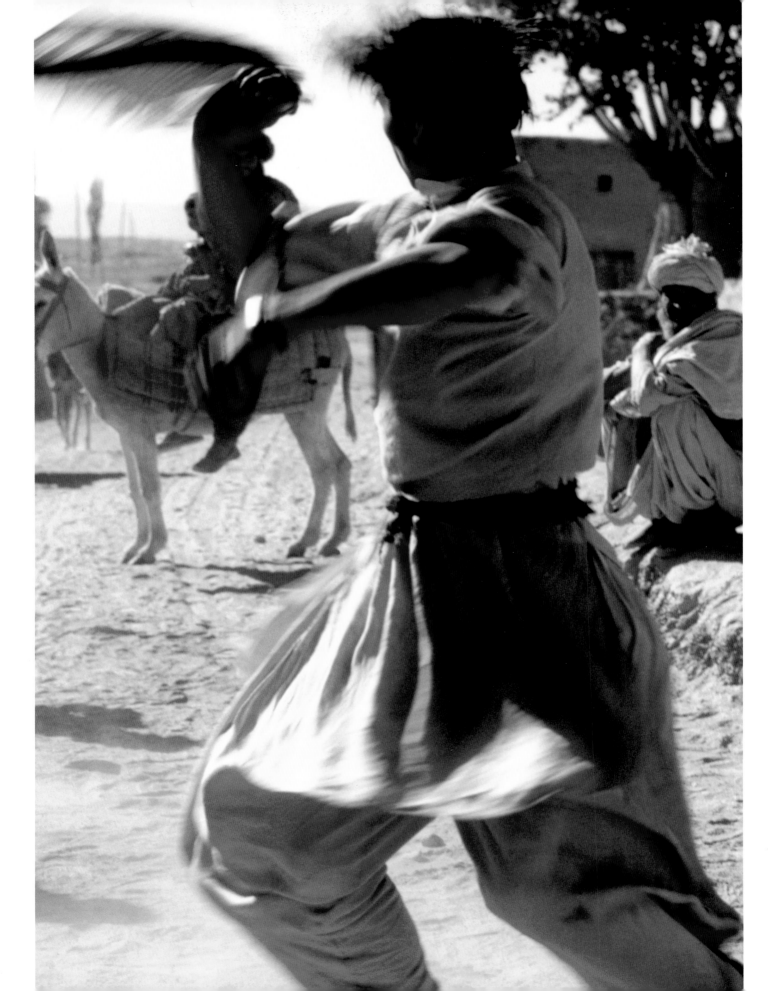

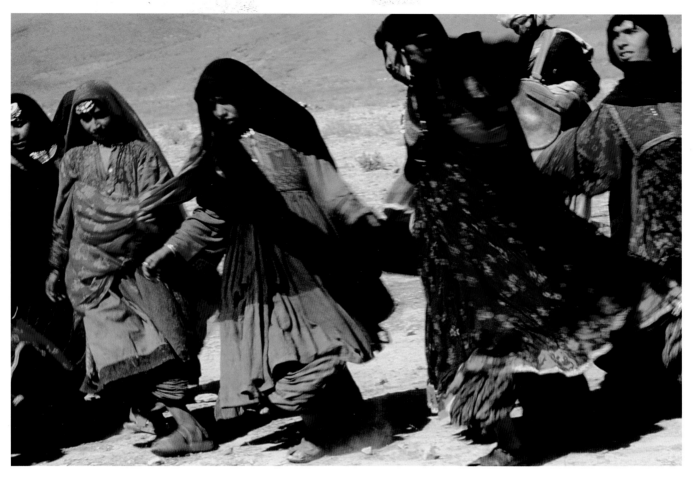

94. Women dancing at Kuchi wedding, Herat, Afghanistan, 1969

Eve had succeeded in two ways. She had documented Muslim women's daily life in a "matter-of-fact" fashion; they were hidden inside their fabric shrouds but striding in the sunlight, dancing, working in the market. She had also won their confidence to the extent that they let her photograph them at home in the harem, relaxed, smoking a cigarette, and draped in jewels and gloriously detailed fabrics. The images that resulted were, according to Snow, "some of the most intimate portraits of veiled women anyone has achieved."[124] The day after the harem story ran in the *Sunday Times*, NBC and the BBC approached Eve and asked her to make a documentary based on it.

While Eve had been the photographer on many film sets, she had no previous experience with film, and the new challenge worried her as much as it intrigued her. Still, she accepted the BBC's offer. "She was someone who was intensely self-critical in her life and her work," Frank Arnold recalls of his mother, but he says her doubts never stopped her. "She would think about her problems and act on them."[125]

There were major problems involved in the shift from photography to film. Instead of making her usual notes on index cards, Eve had to create

95. Atlan dancers on their way to Kuchi wedding, Herat, Afghanistan, 1969

a storyboard that everyone could use. She was a loner, used to having total control, but now, instead of working at her own pace, she would have to wait for the crew and equipment to arrive. Then she would have to take everyone's problems and opinions into consideration. She had to be a manager. In a letter to a friend, she wrote: "I feel confused and unsettled. . . . I have been asked by BBC and NBC to do things for them but I do not feel like I can make the impossible work . . . nor to accept an easier or lesser project. . . . I feel like the packhorse who [as long as he] is pulling the load can keep going, but as soon as he finds rest will find it impossible to [get] going again."[126] She did not give up on the index cards. The archive contains one with a delightful list of the items that were needed for a Jordanian wedding breakfast, including English toffees (fig. 91).[127]

Eve had wanted an all-female crew, which would make it easier to work inside harems. That turned out to be impossible, but in the end the lone male on the crew, a lighting cameraman, was finally allowed in because he was not an Arab and therefore not considered a threat to the women.

97. Egyptian woman, Valley of the Kings, Egypt, 1970

While immersed in the intricacies of preparation, Eve received the invitation that made everything come together—privileged access to the preparation for the wedding celebrations of Sana's daughter Alia and the crown prince of Dubai, the future Sheikh Maktoum bin Rashid Al Maktoum. The shoot was on, complete with dancing in the desert, camel racing, and a raucous party featuring all four wives of one of the sheikhs (figs. 98, 99). Eve used the idea of *One Thousand and One Nights* as her narrative thread, and she picked Noura, a handmaiden to the groom's father, as the Scheherazade who would guide her through the world of women.

She arrived back home with a wealth of material, more than enough to edit down into a fifty-minute documentary. The film, shot in intense colors, is part visual anthropology, part diary, with evocative images that include a dancer smoking during a break in the celebration and Hint bin Maktoum, the groom's little sister, with her brother and her pet gazelle in the harem. With its exotic aura and South African actress Janet Suzman

96. Family having tea on the stairs, Egypt, 1970

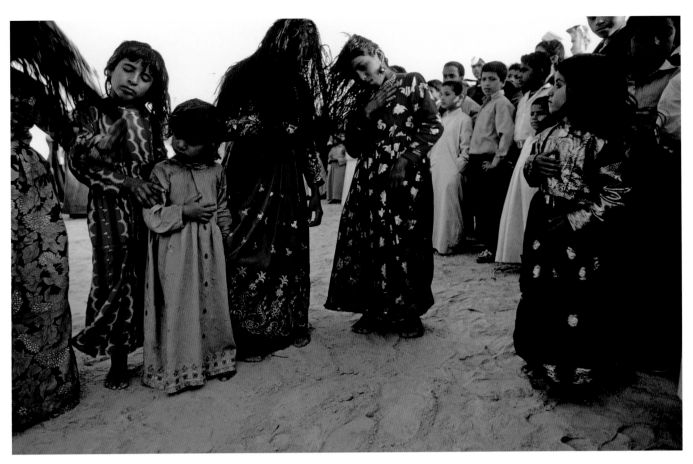

98. Bedouin girls dancing at wedding celebration, Dubai, 1971. Their hair is washed in camel urine to make it beautiful and vermin-free

supplying Noura's voice, the film was well received, and the BBC offered Eve a contract to make more films about women—adding the inducement of an all-female crew.

She anguished over the offer for months, trying to visualize her potential role. She had found moving from "the opaque silent flat page" to the juxtaposition of "luminosity, sound and motion" absorbing. Whereas she had once thought of film as thousands of still images put together, she now realized that those images were designed to be three-dimensional, as opposed to two-dimensional photographs that are framed against a horizon. Her "skills of seeing" were transferable to this new medium, but she had to accept that other people would come between her and the final, edited film. As she reluctantly realized, "I was a couple of decades too early for the new, light, handheld video and sound equipment."[128]

Even if such equipment had been available, Eve would probably not have been an early adopter. From her earliest days, she took great pride in working with the simplest tools available. As Chris Angeloglou, the *Sunday Times* photo editor, remembers, "She was not a great technical person, she wasn't mad about having the latest gear. She used Pentax and Nikon, never Leica—and I used to rib her about that."[129]

In the end, she decided against the time-consuming ensemble work of film. "I love the chance for personal expression and spontaneity photography gives me," she wrote about her decision. "I love the idea that I can go off with a single camera and a few rolls of film unencumbered and find instant response to a mood, a need."[130]

The film *Behind the Veil* had lasting significance. At a time when photography and journalism were dominated by men, it inspired a generation of women photographers and cemented Arnold's status as a pioneering visual commentator. It also contributed to Islamic history. Eve was in the United Arab Emirates at a moment of transformation and gave lasting insight into women's lives at a critical time in that culture.

While she was in New York, doing some final dubbing on the movie, Eve got word that her mother, Bessie, was very ill. She rushed to see her in the assisted-living facility in Philadelphia where she was living with a brother and sister. In her early nineties (her actual age was unclear), Bessie

99. Wedding celebration, Dubai, 1971

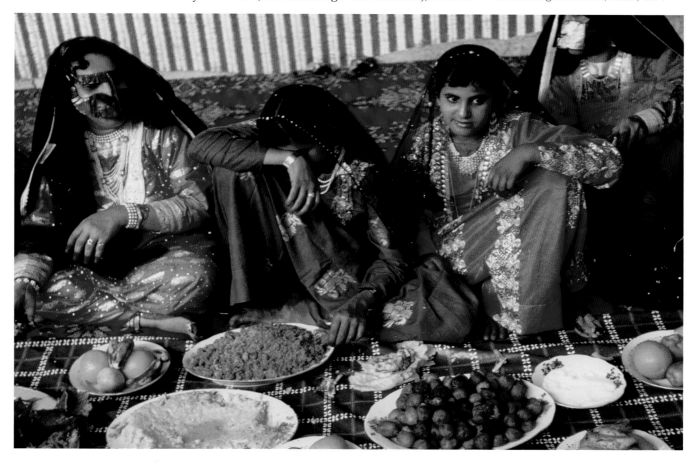

was still lucid and spirited as ever, and once the crisis passed, the two women were able to spend a few days together.

Their relationship had always been "adversarial," to use Eve's word. Both strong and opinionated, they could never agree on a woman's proper role. Bessie felt that Eve should have a comfortable, middle-class life, supported by her husband. She was shocked at Eve's ambition and unimpressed by her achievements, at least initially. When Eve showed her the issue of *Life* that contained her story "A Baby's Momentous First Five Minutes," Bessie said, "What's to be proud of?"[131] When Eve told her that she had an assignment to photograph First Lady of the United States Mamie Eisenhower, she said, in Yiddish, "Pauper, where are you crawling?"[132]

Over the years, their relationship mellowed, largely due to Eve's persistence. On her travels, she wrote many letters to her mother about her assignments, her worries, her son, her hopes and dreams. Even if Bessie did not always understand her daughter's work—or the world she was operating in—she became proud of her. "Eventually, she accepted what I did," recalled Arnold, "but grudgingly."[133]

As they parted, Bessie told her daughter that she need not return. "Do not grieve for me," she said. "I have lived a good life." On the plane home to London, Eve wrote her mother a loving letter of good-bye, probably the one that survives in the archive, dated December 1970. Eve wrote: "You are truly remarkable and an object lesson to us all in what the human spirit can be at its very best. I am proud to be your daughter. I just want to make sure that it's on the record. I love you very much. . . . You still make the best knishes I ever tasted."[134]

Six months after the visit, Bessie died. Eve was still grieving in 1972 when her brother asked her to come to the unveiling of Bessie's tomb, and she declined. "I find that even thinking of returning sets up a misery in me that makes it extremely difficult," she wrote. "I like to think that my work is a monument to our Mother."[135] Four years later when she published her book *The Unretouched Woman*, her dedication read, "For Bessie, my mother, whom I loved and fought and am only now beginning to understand."

In September 1972 Eve went to Munich to write and shoot the making of the first Olympic documentary. It was to be an extravaganza. She would be shadowing directors like John Schlesinger, Milos Forman, and Arthur Penn, and she imagined a hectic but fascinating experience. The first night, Eve checked into her hotel at the Olympic village, went to bed, and woke up to the news that Arab terrorists had penetrated the village, killed two Israelis, and taken nine others hostage.

For the next few days, everyone at the village lived in a state of anxiety and confusion. They were in a news bubble, with the world's attention focused on them, but with no clear idea of what was going on. However, the work continued, and Eve felt intense guilt that she was holding a camera at a moment when people's lives were hanging by a thread. She remembered a passionate discussion at Magnum during the 1956 Hungarian uprising about the ethics of photographing men as they were lined up and shot. Cartier-Bresson had said, "At the moment of death and the moment of love, one should turn away." When she found out that all the hostages had been killed, she wept, "for the dead, Arab, Jew and German, and for us, the living, who had stood by so helplessly."[136] She wrote to her brother Bob that she came away "in a state of black despair that I had difficulty losing."[137]

Back home again, Eve decided to return to advertising. The climate had changed greatly since the days of her dreary assignment for Simplicity Patterns. In the sixties, British advertising had become creative and exciting, and photojournalists like Eve were happy to do the work as a way to finance their other projects. At Magnum, this tended to be a contentious issue. The agency could not stay afloat without the income that commercial work provided, but some members felt that this undermined its original purpose. Eve still held to her original view that advertising presented a useful opportunity to learn.

She put it succinctly: "If one regarded each advertisement as a problem to solve and as a healthy fee to bank, it just broadened the area of photography in which to operate."[138] In a 1972 letter to her sister-in-law, Gert Cohen, she described her situation in saltier terms. "Life is a bit fraught at the moment—divided into almost equal halves between the difficult and not so rewarding advertising—bare asses on bare beaches to promote sun tan lotion (where to go now that November is almost here and London pissing with rain—Senegal, the Seychelles—I had hoped Mexico, but no, says the client), and plans for an African editorial junket for the *Sunday Times*—Can we sell Anti-Apartheid. I wake up with the feeling I'm living in the middle of a scrap yard—Can grey-haired Eve Arnold find happiness (can she survive is more to the point) on this see-saw. Tune in next week."[139]

100. Insured Savings and Loan ad, 1970s

101. Pretty Polly ad, London, 1969

102. Sharwood's curry powder ad, 1970s

She worked out of a splendid studio that the *Sunday Times* owned on Pimlico Road, renting space by the day. It had been designed by a fellow photographer, Lord Snowdon, and a friend of hers ran it. She shot by daylight or using state-of-the-art lamps, either exclusively or as boosters. "I learned a great deal about photographic illumination in that studio," she noted.[140] She brought her unique sensibility to the layouts she was given, with great success. She won two art director's awards—one for Pretty Polly tights, illustrated by the sensual image of a woman's leg on a motorbike (fig. 101), and the second for a sepia-toned "Victorian" image she created for Sharwood's curry powder (fig. 102).

Eve had ethical concerns that kept her from working with, say, a company that manufactured mines,[141] but otherwise she was open to everything from hair products to insurance, only calling the work "the nasties" when she was feeling exasperated with the balancing act. In a 1975 letter to Frank's girlfriend, she wrote, "I have been asked to go to California for a week's work to do—exhale that smoke from your lungs before I continue—yet another cigarette campaign. If I can do this cigarette campaign I can then afford to do my book on the Fifties—from Joe McCarthy to Malcolm X—or perhaps start a new book on the state of Britain at the moment, or using my

'Loving Look at the British' as a base, go out and do some nasties to fill it in."[142] Her work with cigarettes was irksome. After a shoot when she had smoke blown over her for an unconscionable length of time, she tried to quit smoking (according to Frank, she never inhaled), and she never worked on another cigarette campaign.

Between advertising and her various assignments, Eve was busy, but it was time for another big project, something absorbing. In 1973, Magnus Linklater, the editor of the *Sunday Times*, suggested a visit to South Africa. What was it like to be black under the system of apartheid? Linklater asked. Could she find a way to illustrate such a tragic and explosive situation?

Determined to do it, she began to make arrangements. Although she knew there would be months of bureaucratic maneuvering ahead, she was not prepared for the degree of resistance she met. The first step was easy: Eve told the consul at the South African embassy that she wanted to photograph animals and people, figuring that she would be admitted as just another photographer looking to go on safari. Within two days she had her visa.

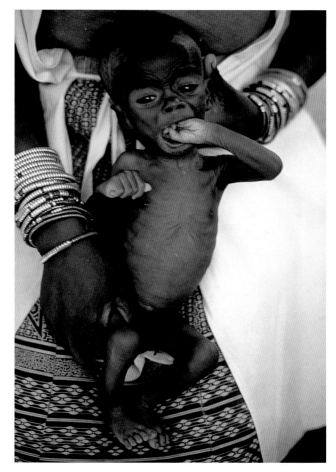

103. Child suffering from malnutrition, Charles Johnson Memorial Hospital, Nqutu, Zululand, South Africa, 1973

Once there, she was stuck. Photographers or journalists who wanted to see how blacks lived in their "homelands," which were areas segregated from whites, had to apply for permission in the capitol, Pretoria. This process could take weeks or months, and it was clearly designed to discourage reporters from going at all. Eve waited it out, traveling and learning about the workings of the country, photographing whatever she could.

When her permits came through, she went to several homelands, where she was supposed to check in with the police every day. By working outside police hours, she managed to avoid their surveillance and went about her business, photographing inside a public hospital where, she reasoned, none of her subjects could be blamed for allowing themselves to be photographed. She photographed children who were starving (fig. 103) and malnourished pregnant women receiving only the most primitive medical care (figs. 104, 105), but she could not accomplish what she had set out to do.

Her idea had been to document the life of one black family under apartheid. Although she had often worked on grim stories, she had never found herself faced with such systematic cruelty, where families were deliberately

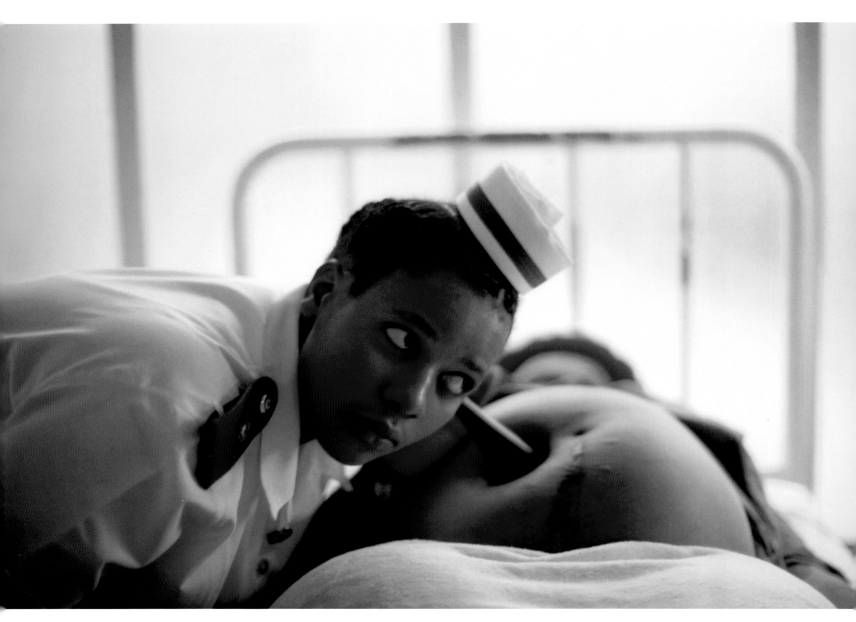

104. A nurse listens to a fetal heartbeat,
Zululand, South Africa, 1973

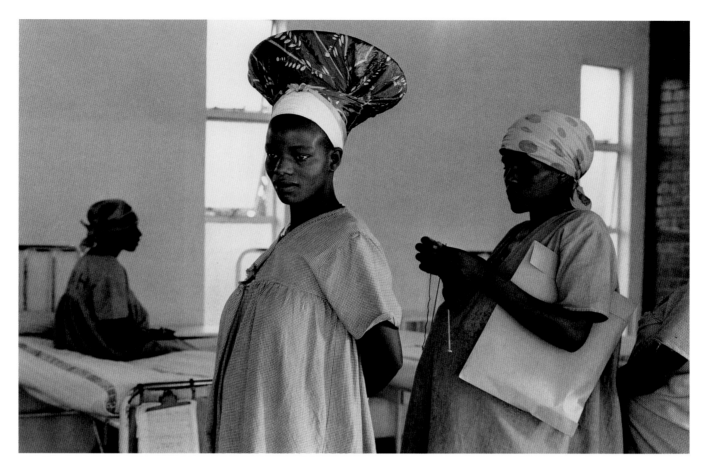

105. Pregnant women at Charles Johnson
Memorial Hospital, Nqutu, Zululand,
South Africa, 1973

split apart. The men were sent away to work in the cities or the mines, often thousands of miles away from their families, for a salary that was about forty-five cents a month. Meanwhile, wives were left alone to raise the children. When the men returned once a year for a visit, they would impregnate the women, and the cycle would start again.

Eve brooded about the men laboring in terrible conditions far from home and the unskilled, often illiterate young women doomed to poverty and sorrow. "What would the life of a young wife be whose husband might be away for 40 years?" she wondered.[143]

Thwarted by the distances and bureaucracy, she never got the chance to document this story through the experience of one family. Instead she had to do two separate pieces—one about men working in a gold mine and living in a barracks (figs. 106, 107), and one about the women and children in a Zulu homeland. It was an uneasy time for her, and her anxiety was compounded by the news that her London flat had been broken into while she was away. Frank had come in to find a window smashed and papers scattered around. The culprit was never found.

After three months of work, it was time to go home, but the night she was due to travel Eve was sick, feverish. The hotel doctor diagnosed tick fever

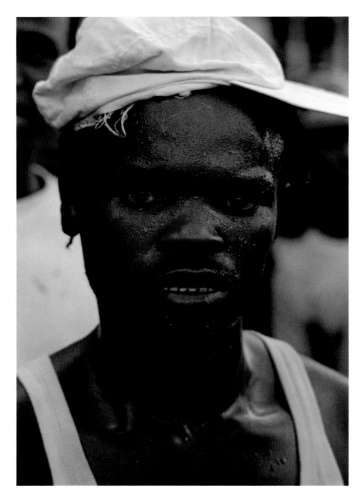

106. Valreef gold mine, South Africa, 1973

107. Gold miner after a grueling day of work, Valreef gold mine, South Africa, 1973

and gave her medication. She remained sick on arrival in England. For months, she endured chest pains, lethargy, and disorientation, but doctors found no evidence of heart trouble or exotic disease. Eve wrote to her sister Charlotte Walsh: "My mind is a morass of sad and shocking images of starving children, and my ears were filled with words spoken by oppressed people. I have never been so distressed and so sad at anything I have witnessed anywhere else in the world that I have worked.... I've had enormous difficulty sorting out what I saw and what I felt, and I'm having a hell of a tough time trying to write accurately without becoming over-emotional and so over-balance. Forgive my going on in this depressed way, but the experience went deep and is hard to accept."[144]

Although Eve's feverish symptoms finally ebbed, the heartache never left her for long. In her last years she still talked about that shoot and how much it had taken out of her. "All I need to do is think of the people I met and the conditions I saw at the time, look at the photographs or think of the worm in the apple in that beautiful Paradise and the pain is back again."[145]

After all the work and frustration, all the heartache, the story that resulted was a disappointment. When Eve left South Africa, she had given all her material to a writer and introduced him to her sources, but the piece he finally turned in, months late, was all about the daily lives of white South Africans. Bitterly disappointed and still recovering, Eve struggled to rewrite the text herself and realized that it was full of holes. She had protected the people who trusted her enough to talk by deciding not to photograph them. Incomplete as it was, the story ran in the *Sunday Times* in 1974; in a letter to John Schlesinger, Eve called it "probably the most important assignment I've ever had."[146]

It was a dismal time to be back in England. Political unrest, a miners' strike, and a gasoline shortage led to power cuts and a three-day workweek. She rewrote the *Sunday Times* piece by candlelight, huddled in sweaters. Physically debilitated and anxious, she received a communication from her husband. Alarmed by the convulsions of the sixties and the Vietnam War, Arnold had moved his family back to England for a fresh start and he suggested a meeting.

In a reply, she wrote, "I do not see that there is anything to be gained by our seeing each other at this time. . . . My stay for the first three months of 1973 in South Africa kept me one step ahead of the police . . . a nasty experience which left me with a dose of tick bite fever. Which brings with it a kind of brain fever and disorientation. It was while I was recovering from this that your troubles started. I was glad to be able to help but I am still feeling the shock. I am deeply sympathetic and deeply troubled by what happened. I am unhappy about it—cry easily and get angry easily. I do not want to see you in this state."[147] "The troubles" Eve mentioned probably alluded to Arnold's persistent money problems. She had subsidized him over the years, and Frank did the same when he could, but Arnold was, in Frank's estimation, never psychologically well enough for a stable life, despite his talents.[148]

Far from capitulating to the bitterness and disillusion around her, Eve, now in her sixties, decided to embark on a radically new venture. She was going to publish her first book. It would contain her photographs of women, and she would write the accompanying text. Her agent, Ed Victor, connected her with Bob Gottlieb, editor in chief at the prestigious Alfred A. Knopf publishing house in New York. An enthusiast with a keen eye and brilliant instincts, Gottlieb was perfectly attuned to Eve's sensibility. He would go on to publish six of her books and become one of her most beloved friends. In a 1976 letter to him, she wrote, "What can I say after I've said you're wonderful? I say that I've never known that an editor could be that perceptive, that intelligent and that sympathetic."[149]

The Unretouched Woman took shape over many trips between New York and London. Eve set up a darkroom in her apartment and toiled for twelve hours a day. As she later put it, she was "lost in a wood of black-and-white negatives, a wilderness of contact sheets, a jungle of work prints"[150] that spanned twenty-five years of photographing women around the world, from movie stars and nuns to migrant workers and schoolgirls.

As she pondered and sifted through the material, she realized that while she was in the thick of it all, she might as well mine the material for more books. With Knopf on board, she committed herself to writing two books over the coming years: *Flashback! The 50s* and *In Britain* (published in America as *The Great British*), an affectionate tribute to her adopted home.

By now, Eve's reputation was so distinguished that she could pick her projects, and as always, she thrived on variety. In addition to organizing the material for her three books, she churned through a prodigious amount of work: assorted advertising shoots, many journalistic stories, and trips to Ireland to shoot the filming of *The Great Train Robbery* and Morocco for *The Man Who Would Be King*, directed by her old friend John Huston.

YVES SAINT LAURENT

108. Spread on Yves Saint Laurent from "Regard sur les Collections de l'hiver 1977" by Eve Arnold and Joseph Losey, *Vogue Paris*, no. 1570, 1977

From 1976 to 1978, she photographed the Democratic National Convention, Indira Gandhi campaigning in India, Margaret Thatcher on the trail in England, the Paris collections for French *Vogue* (figs. 108, 109), and celebrations for the Bicentennial in America and the Queen's Silver Jubilee in London.

However, this creative flurry could not insulate her from the turbulence around her. One evening in 1975, as she sat on her sofa at home trying to write the first sentence of *The Unretouched Woman*, an IRA-set bomb went off in her favorite Italian restaurant across the street. The impact threw her to the floor; for hours her phone rang with calls: some wanted her to race over with her camera to film the wreckage, while friends and family wanted to know if she was all right. Although she was shaken, she kept up appearances, writing to Gert Cohen, "The news here (London bombing) was strong enough to overshadow the announcement of attempt on Ford's life. Maybe that is just as well that lady assassin wasn't quick enough. Rockefeller is not much of a replacement."[151]

She found satisfaction in the creation of her book *The Unretouched Woman*. With Gottlieb at her side, she mulled over the images, designed layouts, monitored the actual printing at the press, and learned that this was the way she wanted to work. The book gave her a way to reflect, and in so doing

PIERRE CARDIN

Pierre Cardin photographié pendant son défilé
qui eut lieu à Lyon à l'aéroport de Satolas.
Ce fut une première. On retrouve là le novateur
Pierre Cardin, qui a entraîné avec lui 200
journalistes internationaux. De gauche à droite, les
mannequins s'habillent dans les coulisses :
pull-chasuble en tricot à côtes, avec une
capuche bordée de fourrure; robe de mariée en
dentelle blanche de Huret; robe chemise en voile
de laine imprimé de minuscules marguerites.
Coiffures et maquillages Carita.

66 (suite de la page 265) quelques petits jeux. Voici d'abord, les règles du jeu : les photos qui suivent ont été choisies parmi 4 000 par Eve Arnold et moi-même, parce que nous avons soit adoré, soit détesté, les vêtements qu'elles montrent. Pas de compromis. Eve et moi, nous avons presque toujours été d'accord sur ce que nous n'aimions pas — pas toujours sur ce que nous aimions. Mais ce que nous avions en commun, c'est le désir de faire des photos franches, sans aucune tricherie, et nous espérons que, pour une fois, nous avons réussi à montrer les vêtements tels qu'ils sont, même lorsque c'est une atmosphère que nous montrons. Maintenant, si vous voulez jouer à notre petit jeu, je vais vous donner diverses combinaisons d'adjectifs ou de phrases, qui peuvent toutes, s'appliquer à une ou plusieurs des collections que nous avons vues. Pour jouer, il vous suffit de choisir les mots qui collent avec les photos, et de leur appliquer les adjectifs correspondants. Je ne vais pas le faire, sauf pour un ou deux cas. (suite page 272). **99**

109. Spread on Pierre Cardin from
"Regard sur les Collections de l'hiver
1977," *Vogue Paris*, no. 1570, 1977

she showed herself to be that rare talent—a photographer as gifted with language as with images. As she wrote, "The worry that I had been nursing about whether to have someone else write text for the book or do it myself seemed to solve itself. Since I had been at the scene, why not tell it myself? Why a second-hand view?"[152] She told an interviewer, "You don't work in a vacuum when you're working. There's always something going on that needs words."

Setting the book aside, Eve traveled to Russia to spend two difficult weeks documenting a British Airways flight, the first non-Russian tourist flight to be permitted inside the country. Exhausted from the trip and still jittery after the bomb scare, she took herself off to Mexico to spend Christmas with relatives. Sitting on a veranda in Cuernavaca, she thought about the women she had seen and photographed around the world, and she wrote the entire text for her book. Asked later how she felt about the process of writing, she said simply, "It seems to be flowing out . . . as though all these years I've prepared for this."[153]

Eve wrote in the book's introduction: "Themes recur again and again in my work. I have been poor and I wanted to document poverty; I had lost a child and I was obsessed with birth; I was interested in politics and I wanted to know how it affected our lives; I am a woman and I wanted to know about women."[154]

The Unretouched Woman was published in America in late 1976 and a few months later in Britain. With its range of images, which were "unretouched for the most part, unposed and unembellished," it attracted considerable attention. Interviews, reviews, TV coverage, and excerpts in the *Sunday Times Magazine*—all the fuss gave Eve a new confidence about her capabilities and bore out what she had written a year earlier when starting the book: "Looking at it as a document it is pretty great seen from one dame's eyes and one dame's camera, it sure was a long road I travelled."[155]

The only negative response came from South Africa, where a magazine excerpt from the book was banned as obscene because it featured a picture of Vanessa Redgrave's bare bottom (she was getting dressed for her role in *A Man for All Seasons*). Asked for a response by the South African press, Eve called the ban "sheer lunacy," adding, with her customary briskness, "My book, which contains the same picture, is on sale in South Africa—unbanned. But in that book, in the South African section, there are pictures of children dying of kwashiorkor. Now those photographs are *really obscene*."[156]

Two years later, in 1978, *Flashback! The 50s* was published. It was a very different proposition, in which Eve looked back after sixteen years of living abroad to what she called "a decade of disillusionment." She was nervous, for Bob Gottlieb at Knopf had suggested that she write the text for this one, too. She wrote to Lee Jones at Magnum, "I'm not quite sure how I can handle it. I break out in all kinds of cold sweats when I think about writing."[157] However, she did it, and then applied herself with relief to the book's production and the exhibition for its launch.

The collection received excellent notices. The *New Republic* reviewer described it as "sharp-eyed, unpretentious photojournalism at its best." In *Newsweek*, Douglas Davis called the images "so faithful to the pace and rhythm of the decade that they exert an irresistible nostalgic attraction."[158] For Eve, the work helped her remember the glory days of the picture magazines like *Life* and *Look*. "What I knew in America in the '50s was free and adventurous, both in the use of the instrument and in the scope it gave the photographer to range the world in search of subject matter."[159] The coming of television had curtailed that freedom, but Eve was not to be deterred.

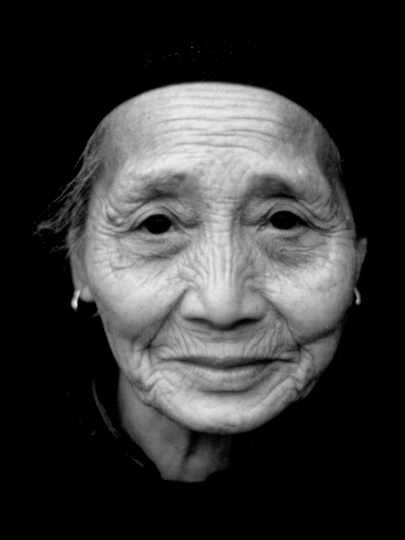

I must look at China in her own perspective, remembering her history, trying to understand her character and being totally aware of her needs. . . . I must try and not judge by my Western eyes but must try and think in Chinese, look in Chinese, while still retaining my own point of view.[160]

5. THINK IN CHINESE, LOOK IN CHINESE

Through all the years of activity and achievement, Eve persisted in her attempts to get to China, "that fabled land." Magnum photographers had worked there before—Capa and Cartier-Bresson in the thirties and Marc Riboud in the fifties—but for years it had been impossible to gain access. Asked later why China was so important to her, Eve said, "I had worked in so many places in the world and it seemed like the next obvious place, as though, if one couldn't get there, it was even more important to get there!"[161]

She was quite clear about what she wanted to accomplish through her photographs. "Not the ubiquitous blue suits and bicycles we had been seeing pictures of for so many years, but the lives of the people. I wanted to try to penetrate to their humanity, to try to get a sense of the sustaining character beneath the surface."[162]

For fifteen years, throughout the Cultural Revolution, Eve and her editors at the *Sunday Times* had been vainly petitioning for access. For the same amount of time she had been reading and researching. "I was filled with anecdotes, images of paintings and drawings and scrolls and land-scapes," she said, "so I already had a sense of what it would be like." One particular book resonated with her: *Away with All Pests* by Joshua Horn, an English physician. This was his account of working in China—where he had moved with his family in the fifties—in order to train peasant vol-unteers as "barefoot doctors" so that they could go out into the villages to treat common diseases and administer basic drugs. Eve stayed up all night reading it. She was so moved that at dawn she sat down and wrote Horn a

110. Retired woman, China, 1979

letter—her first fan letter. He replied, and they eventually met, starting a relationship that became important to both.

One of Eve's typed-up index cards contains what seems to be a reference to Horn. An excerpt from a letter to Gert Cohen, it reads, "If things work as planned I should go to China with a rather marvelous man, who was a doctor in China for 15 years, speaks the language, got the Chinese ambassador to Britain enthusiastic about going, and it looks like a chance to see freshly, without having to go the same tired route as most journalists have."[163]

Some of Eve's intimates, and her son, Frank, believe that the two were lovers and that Horn asked her to marry him, but wanting to keep her independence, Eve declined. However, as always, Eve's private life remained private. None of the correspondence in her archive reveals deep attachments beyond those to her family and close friends, and her friends often said that kind of sustained connection would have been impossible.

That did not mean she lacked for male attention. Her good friend Hanan al-Shaykh said she had admirers. "She would say, very frankly, that she was invited here and there and men pursued her." However, she was not prepared to put her work in second place. Al-Shaykh remembered a time when she told Eve of her anxiety about leaving her children behind when she went on a work trip, and Eve said, "You have to. You will get a babysitter, and she will stay with the children, and you will go for your work. Work is very important. Like your children. Your work has to be maintained. Promise me you will go."[164]

In al-Shaykh's view, there was no way Eve could have had a husband. Her work was her partner. She said, "People thought, because she left her husband and her son was in a boarding school that she was selfish. But I used to think she was the least selfish person ever . . . the human love she carried. . . . [S]he would really care for anyone . . . whether young, old, men, women. . . . [A]nything would stop her . . . anything would make her take a moment and stop and think."[165]

Whatever the relationship was between Joshua Horn and Eve, he opened doors for her and gave her access to diplomatic channels. In London she met his son's wife, Sirin, a young Thai woman who had been raised by Zhou Enlai, China's premier from 1949 to 1976; Sirin had suffered grievously during the Cultural Revolution after Zhou Enlai died and fell out of favor, and she was sent to London, where she taught piano. Sirin and Eve became good friends, and one day in 1979, just after President Nixon normalized diplomatic relations with China, Sirin called Eve from Beijing to say that there was a visa waiting for her at the Chinese Embassy in London.

111. Television, China, 1979

Most of the visas being issued during this initial period of openness were for three weeks; Eve's was for three months. After ten years of waiting, she had five days to get herself to Peking.

She frantically prepared—gathering letters from acquaintances that would introduce her to Chinese officials and consulting with her editors

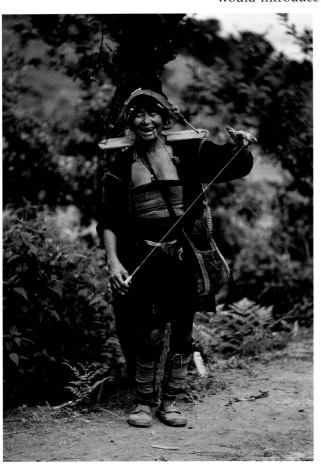

112. Tribal woman in Hsishuang, China, 1979

about subjects to shoot. (One of them jokingly suggested Peking duck, and on her last day in China, she took him at his word, photographing a grand feast.) Since she planned to be traveling down the Yangtze River through a bitter winter, she packed warm heavy clothes. As always she brought gifts for the people she was photographing—toys for children, books for adults—and she asked Sirin for advice about this because she wanted some of her gifts to smooth the way for a second trip. Sirin suggested beef and dolcelatte cheese for Vice Chairman Liao Chengzhi; he had lived in America for many years and hankered after them. So Eve rushed to her Mayfair butcher and had the meat frozen and packed, and she bought the cheese from Harrods.

She picked up her advance money from the *Sunday Times* and set up a book deal with Bob Gottlieb at Knopf. When she asked him to describe his vision for the book, he said he hoped it would show people a hundred years hence how the Chinese had lived a century earlier. Excited, nervous, she took the night flight. On January 31, 1979, at the age of sixty-seven, Eve embarked on what she called the "ultimate assignment," as China's closed society began, cautiously, to open to the world.

It was freezing cold on that first morning in Beijing, and although she had traveled for nearly twenty-four hours and barely slept, Eve rose at 6 am, wrapped herself up in her warm coat, and went out to shoot people doing their Tai Chi in the public square. From that moment on, her schedule, prepared by her government hosts, was packed every day from morning until night, except for a short lunch break to eat and then rest. There was no point in trying to pace herself—her interpreters and hosts were anxious to show her everything, and she knew she had miles to cover. In the end, she logged forty thousand miles over two trips, each nearly three months long.

Looking back, Eve wrote, "I traveled by plane, by ship, by train, by car, by air-conditioned bus, by jeep and on foot. I walked on the 'roof of

the world' in the rarefied air of the 13,000 Tibetan Plateau; hand-held by a Tibetan lama to steady me as we climbed to the top of the gold-covered Potala Palace. In Sinkiang, I descended to the Turfan depression—426 feet below sea level—the lowest spot in China. I roasted in the Gobi in July and froze in the snow in Peking in February; was soaked by the monsoon in Hsishuang Panna; and was almost blown off my feet in a predawn gale on a boat on the Yangtze while waiting for sunrise over the Three Gorges. A water buffalo I was photographing tried to charge me because he did not like the smell of my perfume, and a yak that was being milked by a Tibetan maiden grew restless because she did not like the click of my camera."[166]

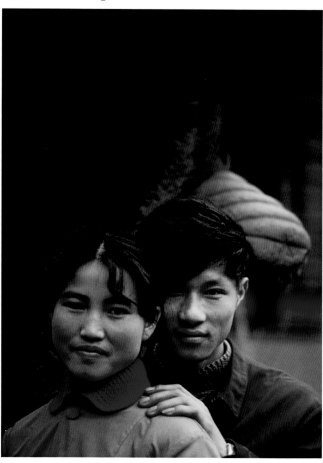

The first trip took her to Canton, Shanghai, Beijing, Suzhou, Guilin, and Hangzhou, and everywhere she went, she attracted interested bystanders and, always, a clutch of photographers. The photographers were there at the request of Vice Chairman Liao, Sirin's friend, with whom Eve had lunched on her first day. Thrilled with the beef and cheese Eve had brought, the vice chairman was also vastly impressed with her photographic technique, complimenting her on her decision to work without a flash. He had asked if she would allow Chinese photographers to accompany her so that they could learn to use minimal equipment and available light.

At first the swarm of students did not bother her, and she organized them like a workshop, with question-and-answer sessions before each shoot. Before long, she was rattled. "You are always looking, searching, and having a lot of people trying to get as close to you as possible does not help!" They got in her way, pestered her with questions and were always surprised by her choice of subject. "I didn't have time to explain," she said. "I just pulled them along with me."[167]

113. Friends, China, 1979

Part of her irritation resulted from her firm belief that some things cannot be taught: "Without the seeing eye, the student can learn nothing from a teacher." To her, technique was far less important than using your intelligence and your eyes, responding to the moment, being deeply interested in your subject. She once said, "My techniques belong to me and you won't find them in any handbook. . . . It's all intuition. . . . I just concentrate on seeing. . . . I can't analyze the technique. . . . [T]here is nothing except me."[168]

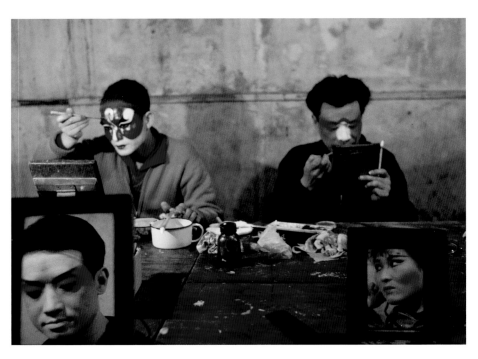

114. Actors applying makeup for an opera performance, China, 1979

Her method was straightforward and elegant. Unlike the Chinese students, who were encumbered by flash and Rolleiflex cameras similar to the cheap camera she had used in the fifties, Eve worked with a Pentax or a Nikon and shot with 35mm film in available light, whenever possible. For the first time, she was also working exclusively in color, what picture editor Angeloglou called her "lovely slow Kodachrome."[169]

During the first decade of her work, she had used mostly black-and-white. "I shoot for form and content, but not for color," she told an interviewer.[170] It was easier for her to think in monochrome. When she compiled the images for her book *Flashback! The 50s*, she realized that the square black-and-white format had been perfect stylistically for the buttoned-up look of the day. She had been suspicious of color, feeling that because it was so pleasing to the eye, it romanticized the subject, made it part of "the great soap opera of life." In the sixties, however, she was energized by the *Sunday Times*'s pioneering journalistic use of black-and-white combined with color. Now, color made absolute sense. "What we had seen for 30 years were Mao-suited, almost unrecognizable groups. . . . [P]eople seemed to look alike. But I wanted them to come through as themselves."[171]

As for the images, she visited "communes and factories, hospitals and schools, theatres and film studios in cities and in the countryside." As always with Eve, it was all about the people: Buddhist monks studying sutras; city workers and shopkeepers; government officials and peasants; babies and ancients. The contours of the faces fascinated her; "their varied physiognomies kept me in a state of bewilderment."[172]

James Fox, a photo editor at Magnum, was Eve's point person during the trip, but they could only keep in touch via telex, which proved worrisome when Eve became very ill with pneumonia. "We got a message that her life had been saved because of a young Chinese doctor," Fox later recalled.[173] The enforced week of medication and rest had a happy outcome. On one of her first tentative trips outdoors, bundled up against the freezing cold, she came across an elderly woman peeking from a shadowed doorway. The two exchanged curious glances, and turning to Eve's interpreter, the woman pointed to Eve and said, "What a strange-looking woman she is!"

For her part, Eve knew instantly that the woman's face was magnificent, with "seams like the pleats on a Fortuny dress." She lifted the camera and caught the moment—an old woman who had seldom, if ever, been photographed, assessing the small, gray-haired foreign woman who was taking

115. Equestrian acrobats rehearsing, Inner Mongolia, China, 1979

her picture. Even though the photograph is in color, the range of tones is limited: the woman's expressive face seems to float against the dark background of her clothes and the shadows. Her gold earrings gleam; her eyes are black; her gaze is mysterious. A whole life story is hinted at in the spare and haunting image (fig. 110). Eve was ecstatic when she saw it. "There's a kind of emotional content in the picture which expresses what she is."[174] She sent the interpreter back to get some kind of identification, but all she received was "retired worker." The interpreter had thought it rude to ask her age.

When it came time to choose the cover for the book, it was Eve's agent, Ed Victor, who guided her to the image of the old woman. "I knew it was the one," he said. Eve was not sure—she had wanted a pretty young girl—but when Victor pushed, she relented. After the book was published, she tried to send the woman a copy, thinking it would please her to know that her face had been seen around the world, but she could not be found.

Despite the thrill of the trip, the routine was punishing for a sixty-seven-year-old—up at 5 am with a thermos of tea by her bed to get her going, traveling thousands of miles, trying to communicate with people whose language she could not speak. It was a relief to be back in London with her haul of images, but she felt uneasy, not sure that her work was done. Her editor, Bob Gottlieb, confirmed her doubts. Together, they looked through her material and concluded that, while she had amply documented familiar places and everyday situations, the collection still lacked images of "the unexpected, the rare and the exotic."[175] She wrote to the authorities, and to her joy she received a new three-month visa.

This trip was easier. It was summer, and Eve was healthy and more accustomed to the ways of the country. Her interpreter, Liu Fen, the wife of a photographer and herself a journalist, brought her to Tibet, to Inner Mongolia, to Xinjiang, all places that were barely accessible to foreigners. The two developed a rapport that served them well. "For three months we lived together," Liu Fen wrote in an article for *China Popular Photography,* describing their rapid progress as "looking at a flower from the back of a galloping horse."[176]

Liu made a wealth of observations about Eve, noting that she always carried three cameras, and "because she pressed the shutter release every day, every moment, her fingers came out hard skin.... Mrs. Arnold's eyes were very sharp—especially when she covered news or took pictures.... She always sat beside the driver and looked carefully at everything that happened outside the car. She frequently asked the driver to come to an abrupt halt and then she would walk off 'into the countryside.'"[177]

Liu was amazed at the range of Eve's interests. Instead of sticking to one topic—sport, for example, or the arts—she wanted to shoot everything. When the women went to a dance opera about the Silk Road, Eve worked her way backstage and captured the actors making themselves up (fig. 114) and, later, in their sleeping quarters. The morning after, she shifted focus, wanting to take pictures of "buildings, snack bars and also of students studying to take their examinations."

This second trip presented its own problems. Because foreigners were a rarity in the remote regions where she was working, Eve was swarmed. "I had more followers than the Pied Piper of Hamelin," she wrote, "except that they did not follow—they surrounded and hemmed me in and cut me off, making work impossible. And if my hosts did manage room for me, there would be hundreds of voices calling 'XIAO, XIAO'—smile, smile—and that would be the end of the picture, the subject self-conscious, the photographer even more so."[178]

In all her interactions, Eve was dogged by her eager interpreter. James Fox remembered Eve telling him how frustrated she was by Liu's insistence on being somewhere in the photograph. "It was a real disaster," Fox said. "That woman kept getting in her shot!"[179] As the trip wore on, and the women worked from dawn until night, there were moments of tension. Liu became more assertive, resisting the idea of photographing people in their shabby everyday clothes. Eve wearied of her chatter and longed for some privacy. They squabbled and made up, and the work continued.

116. Child getting a permanent wave, China, 1979

Her final task in China was to give a speech to the news agency, Hsinhua, about her work. She typed it for Liu to translate and read aloud for her. "Comrades," it began, "I appreciate your coming this morning to join me in a discussion about photography." After explaining who she was and what she had done in China, she said, "I now want to list 10 fundamental rules that I have worked out for myself—which I used on this trip. I know they are simple basic rules, but I thought they might interest you."

1. Focus on the eyes.
2. Do not be afraid of slow speeds and wide open apertures.

117. Chongqing Sunday, China, 1979

118. Art class, Chongquing, China, 1979

119. Chongqing school play, China, 1979

3. The maximum sharpness of a lens is usually between 4:5 & 5:6—so the myth about everything being sharpest at 16 or 22 is a myth.

4. The idea of shooting in brilliant sun should be questioned—unless you want particular contrast. For portraits it produces squints and harsh shadows.

5. For color shadowless lighting is very often best. Wait for the cloud going across the sun—generally I shoot outdoors for both portraiture and landscape—very early day and very late day.

 I love landscape done at dawn and at dusk.

6. Do not be afraid to shoot in the shadows. For instance the subject in a doorway with the light from the street or indoors using the window light.

7. The difference between a fine portrait and an ordinary photograph can be a single gesture, the movement of a hand, the flicker of an eye. Watch for the gesture and use it.

8. Very often an interesting street photograph is the sheer accident of the photographer being in the right place at the right time. Train your reflexes to move at speed. The difference between the fine photographer and the hack is that the good one knows how to take advantage of the accident.

9. To avoid self-consciousness on the part of the sitter, set a situation. Give the subject something to do. For instance, if you are photographing a doctor, follow him on his rounds. Of course if it is Chairman Mao you are shooting, it is more difficult. I solved the problem of the Queen of England by following her around for a day on tour, and when I did a story on Mrs. Ghandi [sic] I followed her on an election campaign for 2 weeks.

10. Ask yourself constantly what it is you are trying to say—Do you love what you see—then say it with love. Your picture should reflect what you believe. If it is war, poverty, disaster—you are photographing, and you loathe it, then say it with hate.

 Remember it is the photographer and not the camera that is the instrument.[180]

It had been a lonely time. Eve hated to be away from home for so long, separated from her son, her three-year-old grandson, Michael, her friends, and the comfort of her flat. She said that, before she boarded the plane at Heathrow for the second trip, she had locked herself in a restroom and cried. However, years later, remembering those trips, she wistfully reminisced about her adventures shooting such an enormous story so dear to her heart.

120. Horse training for the militia, Inner Mongolia, China, 1979

121. "Faces of an Unexpected China" cover, *Life*, October 1980

122. "Girls on Film" cover, *Post Magazine*, September 27, 2001

123. Cover of *GEO*, German edition, March 1, 2006

In Inner Mongolia, she took a picture of the girl lying on the grass to train her horse for the militia (fig. 120). It captures great tenderness in the intimate relationship between the horse and the girl: in this moment of repose, she caresses the horse's flank. The curve of the horse's back repeats the curve of the hill in the background. The image uses just a few colors— the light blue of the sky and the girl's headscarf, the deep green of the grass, the red of the girl's dress, and the horse's gleaming white. While shooting there, Eve had her own tent, ate the inner pads of camel hooves for breakfast, and she said, "We had to walk ten miles to get toilet paper."[181]

At the Great Wall of China, she came upon Pierre Cardin posing chiffon-clad models as they twirled in the snow. From a doctor who was checking up on her pneumonia, she received a traditional treatment (acupuncture, heat with herbs, cupping) that banished for seven years the chronic backache she'd endured from carrying camera equipment. Eve felt that the China experience and the pictures that resulted were the apex of her career. "I loved it," she said simply. "I think I was nearly at my happiest."[182]

The photographs were seen all over the world. While Eve's original contract had been with the *Sunday Times*, which ran stories over two issues, her membership in Magnum enabled her pictures to be subsequently

published in *Life* (fig. 121) and *Paris Match* and in a sixteen-page spread in *Stern*. Under the agency's distribution system, an editor at one of the Magnum offices in London, Paris, or New York would make a selection from the vast number of negatives that the photographers turned in, after any embargo from the first publication, and then circulate their "distro" of selected images to multiple agents across the world (more than twenty at the height of the 1990s), who would then try to place them in newspapers and magazines where they had connections. The result was a reliable source of income for the photographers and Magnum, and if the pictures were so popular that they were repeatedly reused (as, for instance, Eve's pictures of Marilyn Monroe), they could earn substantial sums over the years.

After laboring over the text, design, and production of the book, Eve and her team at Knopf published *In China* at the end of 1980 to considerable acclaim. Eve had fulfilled her editor's wish, capturing a world that in one hundred years' time would show what life had been like in China, in all its vast variety and on the cusp of tremendous change.

Translated into Japanese, French, and German, *In China* had several foreign editions, a rare occurrence then for a lavish picture book, and it won awards, including an American Book Award for the year's best-designed book of the year. The American Society of Magazine Photographers gave her a lifetime achievement award, and at the presentation dinner, John Huston said of her, "She is an adornment to this earth." Quoting the words in her memoir, Eve wrote, "Even now I blush when I think of it."[183]

Tied into the book launch, the Brooklyn Museum organized an exhibition, the first ever of Eve's work. Gene Baro, curator of the exhibition, wrote, "The best photojournalism transcends its subject and gives us images that have a timeless quality, so acute visually that no other explanation is needed finally. The art is in what remains when the occasion has faded."[184] Critic Daniel Pettus said, "Arnold's photographs from China bring Baro's definition to life. The expressions on children's faces at a cotton mill nursery, the intimate details shown from a child receiving a permanent wave and the juxtaposition of two extremely different aged women's . . . eyes present the viewer with a faded occasion that will now last as long as the photograph. Arnold was a master at illuminating the intimate."[185]

Over the next two years, the exhibition traveled to major cities around the United States. *In China* was groundbreaking work. It brought Eve a new level of international recognition, and it made her proud, but she was ready for something new. Afterward, she wanted something more substantial than her former diet of British stories, advertising, and work on movie sets, and Bob Gottlieb supplied it when he suggested a book on America.

124. Tabernacle Choir, from the essay
"In America," Salt Lake City, 1984

Eve had moved to England twenty years earlier. Although she had done so to settle Frank in boarding school, she had been glad to leave America. Between the McCarthy hearings and her time with the Black Muslims, she had found herself frightened for her country at a time of "political darkness and fear."[186] She crossed the Atlantic many times in the intervening years, for work and to see her family, but England had become home, the place where she had created the life and career she wanted.

Gottlieb's idea was both intriguing and challenging. Despite Eve's long absences, America was undeniably a place she knew in her bones. However, being able to speak the language and understand its culture deprived her of the bracing outsider's perspective that had worked to her advantage around the world. In China, she wrote, a poster had looked beautiful because she had not known that the calligraphy read "Lucky Cola." The equivalent in America would have been just a poster for Coke. How could she bring a fresh eye to a country that was so well known, so well documented? She felt it was "too difficult, too familiar."[187] As usual, she worked to conquer her doubts, and after months of exhaustive research, Eve figured out how to tackle the vastness of the project. Instead of traveling to each state, she would divide the book into the nine regions specified in the US census. Her journeys in 1981 and 1982 took her to thirty-six states.

Traveling across her homeland at the age of seventy, she found the country's social and political climate troubling in new ways. Encountering rampant homelessness, the AIDS epidemic, mortgage foreclosures, and inner-city desolation, she abandoned the idea of photographing anything in black-and-white, fearing that it would make the images too bleak. Gottlieb helped her find a way into her subject by taking her to unassuming neighborhoods in Queens and New Jersey to clear her head. In so doing, he steered her toward a balanced view in which the downtrodden, the privileged, and the people in between would mesh to form a picture of life in America that was neither grim nor rosy, but everyday and true.

Eve's extraordinary journey began in the Southwest, where she visited the Navajo Nation and was permitted to witness an all-night peyote ceremony (but was denied permission to photograph it). Then for two years she traveled, photographing miners and strippers, construction workers and prisoners, church choirs and shopping malls, philanthropists and immigrants, parades

125. Prisoners, from the essay "In America," Sugarland, Texas, 1982

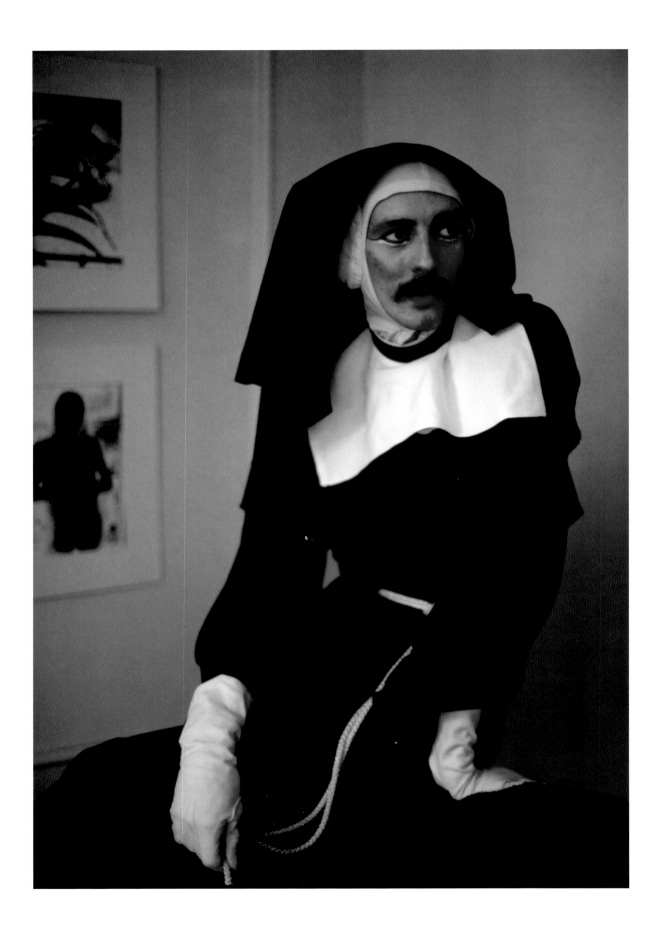

127. Guardian Angels, from the essay "In America," New York City, 1984

and demonstrations. Her worst experience, what she called "the most terrible (next to the McCarthy period of terror) days of my professional life"[188] came when she visited the Texas compound of the Ku Klux Klan and listened in horror as the Imperial Wizard spewed hatred. Her oddest experience had to be the time she spent in San Francisco with the Sisters of Perpetual Indulgence, an antic group of queer transvestite nuns fighting for social justice (fig. 126).

In the end, she was satisfied that she had enough solid material for the book, but later, looking back, she said that, unlike in China, she had never felt the excitement of working on something special. She wished that *In America* could have been a valentine to America, but what she had seen and photographed left her disquieted about the future of the country.

She wrote in the book's introduction: "Through the lives of ordinary people I sought to show my America and found that the ordinary does not exist; each person's ordinary story emerges as extraordinary. I have tried to tell it all in pictures and in words with the dignity and respect it deserves." A perfect summary of Eve's method and her achievement, these words could have signaled her graceful exit from professional photography at the age of seventy-one. However, she was far from finished.

126. Member of the order of the Sisters of Perpetual Indulgence, from the essay "In America," San Francisco, 1981

6. A BROAD SENSE OF LIFE

A John Huston project in an exotic locale—that was the perfect antidote to the emotional exhaustion Eve felt after the 1983 publication of *In America.* This time, Huston was in Mexico, filming Malcolm Lowry's classic novel *Under the Volcano,* and because of logistical problems, Eve found herself not just photographing, but unexpectedly directing a scene in a bar with a cast list that included "eighteen whores, a dwarf and a transvestite."[190]

Working with Huston was the usual chaotic, exhilarating experience, and afterward Eve felt unable to settle quietly in London, so she flew to India, on assignment to photograph the royal family of Gwalior. This experience was also chaotic, but in an unfortunate way—stolen equipment, troubled text, and a story that ultimately did not run—and she returned to her sustaining, London-based life of varied assignments and time spent with friends and family.

At an age when most people start to scale back, Eve remained wide open to new people and ideas, and in 1984, at the age of seventy-two, she made professional contacts that would turn into lasting friendships. Assigned to shoot stills for Taylor Hackford's movie *White Nights,* she spent time with the cast and developed close relationships with Isabella Rossellini, Mikhail Baryshnikov, and Gregory Hines. In the end, she called it "the most enjoyable film I ever worked on."[191]

Rossellini had long played an invented game with David Lynch (the movie director and her former lover) that involved picking different parents than one's own and inventing conversations with them. Lynch always chose Ingrid Bergman (Rossellini's mother), and Rossellini had always chosen Eve Arnold. It made sense. As a model and actress, Rossellini had a sophisticated understanding of, and appreciation for, people who work with cameras, and her mother and Robert Capa had been lovers. "And then

128. Eve Arnold shooting through window with long lens to avoid crowds, China, ca. 1979. Photo: Pang Yulin

129. Spread from "The Importance of Being Bergman," *Vogue*, 1983

130. Isabella Rossellini studying her lines for the film *Blue Velvet*, Massachusetts, 1985

one day I met Eve in person, in flesh and bone, in front of me, and we became friends."[192]

After filming the movie, Eve continued to photograph Rossellini for a profile in *Life*, following her around as she shot ads for Lancôme and filmed Lynch's *Blue Velvet* (fig. 130). Rossellini was in awe of Eve's approach. "Her subjects are relaxed and spontaneous in front of her lens. How did she do it? How did she conquer the trust of such revered people? I knew that answer as soon as I met her. She loves life and human beings. With her compassionate eyes and her sense of humor she is there pointing her lens to take the picture of a human being behind the star, behind the politician, behind the destitute, and behind the child."[193]

Over the ensuing years, the two spent a great deal of time together—a decade later, in her eighties, Eve was still photographing the actress. Rossellini said, "I saw Eve often, as often as I could," and they talked about everything from children to politics. Eve sent her many prints, including one of Chinese babies lined up "on the potty" when Rossellini's son was born, with a note that read: "Welcome to this mad, impossible world . . ." Rossellini wrote, "In this sentence, I saw the essence of her philosophy which is reflected in her photos."[194]

Eve's friendship with Baryshnikov led her to a new book, *Private View*, about his life and work at the American Ballet Theatre in 1987. As always,

she was less interested in the breathtaking moment, the perfect leap, than in capturing the reality of the dancers and the grueling work involved (figs. 131, 132). Or, as she later recalled, the "sweat, intense hard work, concentration, pulled tendons and pain that go on behind the scenes."[195] Since she was not the writer this time—John Fraser wrote the text for the book—she was able to focus simply on getting the honest shots she wanted without jeopardizing a relationship that was important to her. She succeeded; while "Misha" had the right of picture approval for the book, he shared her feel for which images worked, and she said, the process brought them even closer.

In her later years, Eve spent more and more time with Frank and his growing brood. After Eve finished work on *White Nights* in 1984, Frank took her and his six-year-old son, Michael, to Brighton for a traditional British seaside holiday. Calling the trip "delicious," Eve later wrote, "Grandma found that Tibet, Afghanistan, India and the Caucasus paled by comparison. None of the others had Michael in them."[196] More grandchildren arrived: in 1989, Sarah Jane was born, and two years later, David. After each birth, Eve traveled to Manchester, where Frank's family was living, for a portraiture session. Frank describes her as a doting grandmother and "incredibly generous," rolling up at Christmas with a pile of presents and showering the children with love, advice, and attention.[197]

As Eve increasingly reflected on her life and work, she revisited subjects that remained important to her. Russia was at the top of her list. She had last visited in 1975 and was eager to see how perestroika and glasnost were changing the country she had found so poignant. To her dismay, the trip never happened. She had picked writer Bruce Chatwin, a good friend who had accompanied her on the first India trip, to go with her, but after a long illness Chatwin died in January 1989. In her distress, Eve lost all enthusiasm for the project.

Eve still got to Russia, albeit in a very different way. She had been phasing out her magazine work, but in 1988, *Condé Nast Traveler* asked her to accompany a group of American tourists on a cruise up the River Volga. The article's writer was to be Jessica Mitford, a brilliant, doughty British aristocrat known for her wit and her Communist sympathies, and Eve could not refuse. The two spirited ladies of a certain age must have made quite a pair as they cruised on the *Maxim Gorki*, engulfed by a raucous and genial crowd that Eve later described as "a Rotary Club afloat on vodka."[198] Surreal as it was, the trip resulted in a scintillating new friendship, and it also got Eve thinking about her family's roots in Ukraine.

Just before she left, Eve had received a letter from her brother Michael, asking for memories of their parents that he could share with his family and

131. Ballet shoes ready for opening night, American Ballet Theatre on tour in Illinois, 1987

wondering if she could do any research into their early lives while she was in Russia. On the last day of her trip, Eve sat down to write what she could remember of their father, William, and painfully realized how little she and her siblings had ever been told about their origins. The urge to learn more persisted—a few years later, at the age of eighty, she began a real attempt to retrace her family history.

As she continued to assess her body of work, Eve became an expert archivist, annotating shot lists, retyping notes, and organizing her thousands of pictures—and that led her to create more books. In 1987 she published a portfolio of her Marilyn Monroe images (*Marilyn Monroe: An Appreciation*), partly out of irritation at the misguided people who pontificated about a woman whom she had known so well and wanted to protect.

Starting in on the project, she wrote to a friend, "For years it has niggled at me—at first I did not want to rush into print, I did not want to turn my pictures into money. . . . Now I feel ready and anxious to do it, for my own reasons—namely: much of what was written about her was done by people who did not know her—over a period of a decade I photographed her frequently and intimately; the people who wrote about her were for the most part men—and I think a woman's point of view might be interesting. Also much that was done is from my observation inaccurate—and I would like to help set the record straight. Also I think that a quarter century after her death she would have liked still to be the provocative figure she was in her life. So—I have embarked on my venture and I am on a 'high' at the moment."[199]

By 1989 Eve was working on three books simultaneously. *All in a Day's Work* contained, as the title indicated, pictures of people working, taken over thirty-five years, and because they were all single images shot for her own pleasure, she found the task of arranging them relatively stress-free. The second book, *The Great British*, intended as a loving tribute to Britain and her people, turned out to be a more substantial proposition and would take a couple of years to complete. She had so much to say: "The more I examined the visuals, the more memories they called up, and the more I wrote, the more pictures my mind conjured up."[200]

The most challenging project of all, "the big book," was to be a retrospective of her entire life's work over four decades. She found the prospect unsettling and fretted about the many decisions she had to make. Her son, Frank, likes to say that his mother possessed all the qualities that would have made her a great doctor, had she pursued that original dream: discipline, methodical research, and determination.[201] Those skills had served her well in her career, and she needed them now for the rigors of compiling this final collection, which would become *In Retrospect*.

Meanwhile, Eve had Magnum business to conduct. Through all the years in Britain, she had kept up her commitment to the cooperative, which she enduringly believed to be an "exalted spot,"[202] even as it was plagued by clashing egos and disorganization. The *Sunday Times Magazine* had provided her and her fellow Magnum photographers with a ready market for their work, and inevitably, in 1987, Magnum decided to open a London office to complement those in Paris and New York. The London work had previously been handled from Paris, and as a result of the change there were delicate relationships to soothe, territorial disputes to resolve, complex negotiations about assignments, and archives to manage.

At seventy-five, Eve played an important diplomatic role. A link to Capa, she was able to bridge the generations. Outspoken and generous, she reminded everyone of the cooperative's lasting value, reassuring the older members, encouraging the restive young talent, and buoying Magnum's women.

A decade earlier, she had advocated strongly for the inclusion of Susan Meiselas and Marilyn Silverstone.[203] In 1981, a researcher for feminist writer Germaine Greer wrote to ask Eve to name the "most remarkable women photographers" for a book Greer was planning, and Eve replied, "There are now some fine young women emerging with insight and commitment—Mary Ellen Mark with her pictures of Bombay prostitutes published by Alfred A. Knopf, called *Falkland Road*; Martine Franck with her gentle insight into old age and her beautiful, sensitive portraits; and Susan [Meiselas] with her repeated assignments of revolutions in Nicaragua and El Salvador."[204] Whenever Magnum came together for its annual general meetings, the women would have a festive dinner together. Meiselas recalls these occasions as inspiring rather than explicitly feminist: "It was always sharing, more about a broad sense of life, to live one's life by what one believes, to strive for a distinctive voice, to not be inhibited."[205]

Eve was a stalwart advisor to any young women who shared or understood her obsession with her work, training her especially acute and understanding gaze on them as they dealt with the issues of love and family

132. Mikhail Baryshnikov in rehearsal for the show *Japon*, 1987

that she had faced all her professional life. She gently warned Meiselas, whose companion was feeling abandoned by her long absences, "Watch out, most Magnum photographers end up getting divorced."[206] She told a war correspondent returning from Chechnya that she had better get on with the issue of childbearing if she did not want to miss the boat, but she also took her to lunch whenever she was back from assignment, to listen and advise without lecturing. She also nurtured strong friendships with Inge Morath and Martine Franck.

Eve was deeply involved with the commemoration of Magnum's fortieth anniversary, which coincided with the opening of the London office, and she worked on the committee that, after two years of intense negotiations in London, Paris, and New York, produced *In Our Time*, a book celebrating the work of all Magnum's members.

With her unique knowledge of film, she suggested a commemorative television project. She already had a connection with Rosie Bowen-Jones at the BBC, who had just filmed an interview with her about her relationship

133. Queen Elizabeth, the Queen Mother, with Prince Charles as Colonel-in-Chief of the Welsh Guards during the Queen's Jubilee, London, 1977

with Marilyn Monroe, timed to coincide with the publication of Eve's Monroe book. According to Bowen-Jones, Eve was initially wary about the BBC project, since she did not have total control, but after a number of "enjoyable and civilized meetings" at Eve's home, Eve agreed to the interview and overcame her reluctance to discussing questions of mutual exploitation by subject and photographer.[207]

Shortly thereafter, Eve put forward her Magnum idea. The BBC responded enthusiastically, and after several meetings, Eve brought Magnum's London office on board. She worked hard behind the scenes to bring in the Paris and New York offices, and largely as a result of her efforts, the BBC and Magnum signed a coproducing contract in January 1989 and toasted it one month later with celebratory drinks at Eve's. Bowen-Jones noted that Eve was "intimately involved, tireless and generous in the way she made crucial introductions and smoothed the path for us, helping us navigate around the politics and egos."[208] Susan Meiselas says, "It was the first time Magnum did anything as a full collective, and it took a lot of courage."[209] Filmed with Magnum photojournalists in Europe, the United States, and China, the three-part series finally aired later that year.

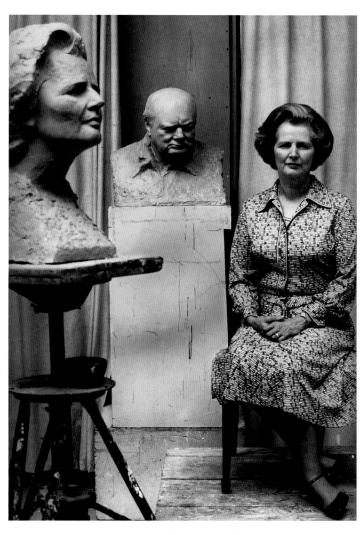

134. Margaret Thatcher standing near a bust of Winston Churchill, in the London studio of Oscar Nemon, 1977

Still the work kept coming. In 1991 *The Great British* was published, first in America and then in London, with an appropriate fanfare of publicity and an exhibition at the National Portrait Gallery. The gallery hosted an opening-night celebratory dinner with forty friends in attendance from London, New York, and Paris. Eve reveled in the fuss. By now, the tiny, elegant woman with the white chignon had become a beloved institution, and the *Sunday Times* recognized this when they asked her to shoot a cover story for the magazine on John Major, the British prime minister in 1992.

Eve was used to working with the British establishment. When she photographed the royal family at their ceremonial duties, she was a face in the crowd, and she reveled in the excitement of the spectacle. Posing prime ministers was more of a challenge. While she had persuaded Alec Douglas-Home and Edward Heath to act naturally, she found the imperious Margaret Thatcher infuriating because she "hijacked every situation

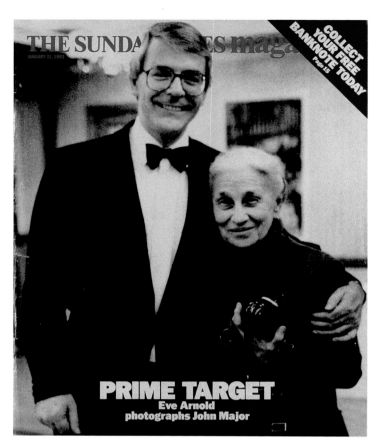

135. "Prime Target: Eve Arnold Photographs John Major" cover, *Sunday Times Magazine*, January 31,1993

by telling me where to stand,"[210]) and Eve disliked the rigid look of the picture that resulted (fig. 134). Major was her fourth, and possibly her most frustrating, prime minister. A guarded, low-key man, he was not the type to respond to the camera. What made the story memorable was a photograph that Eve did not take. At a cocktail party, Major announced that he wanted to have his picture taken with her. He put his arm around her, Eve's assistant took the picture, and that image of the two of them ended up on the cover of the magazine (fig. 135). Eve was embarrassed but mollified when her editor told her it was "an affectionate tribute."[211] Indeed, it was her last cover story.

The *Sunday Times* years felt like a gift. Years later, she said in an interview, "I would call up and say I wanted to do a story on women and wind up working on it for years. . . . Going to Afghanistan and Egypt and the Arab Emirates . . . you know, like forty pages! Going to Russia thirty, forty pages. . . . They were my ideas and they let me do them and keep and own the copyright. Where could you get anything like that today?"[212]

Eve increasingly found it hard to dismiss the physical problems of aging, especially with regard to work and its pressures. Her books had led to exhibitions, the exhibitions led to print sales, and the print sales freed her from the financial need to take on advertising assignments. However, some projects were irresistible. In 1990, at the age of seventy-eight, she took on an advertising campaign for British Rail (six enticing images for a very generous amount of money). Mid-shoot, and without warning, she was blinded by a cataract in her right eye.

Ever-resourceful, she put her unknowing assistant in charge of the shoot; afterward, she took herself to a doctor whom Frank recommended, was operated on, and several weeks later was back at work. However, she also had chronic back pain after many years of carrying camera equipment; by her mid-eighties, the pain could be intense. "Just when I think I have reached a plateau of tolerance," she wrote, "it gets worse."[213] She never complained publicly about the pain, or about the vertiginous climb to her Mount Street flat, but she was, inevitably, scaling back.

Despite this unwelcome fragility, Eve was active and appreciative as ever in her engagement with friends, colleagues, and the world. Chris

Angeloglou recalls, "She was a tremendously kind, gentle person. She was very supportive. If one had problems at Magnum, she was the first person you would go to."[214] Susan Meiselas recalls splendid tea parties at Eve's walkup salon. "It was elegant, like going to your great-aunt's."[215] Many friends or people she had photographed had died, including Marcia Panama, her close friend for twenty-five years, but her circle kept expanding, and now included Jessica Mitford and Zelda Cheatle, whose gallery on Mount Street was the first to show and sell Eve's work. "She was alive," Gert Cohen says. "She was generous—whether she had it or not. There was joy in her life. She worked very hard—but there were so many friends."[216]

She often went out to a pub with her friend Hanan al-Shaykh, the Lebanese writer who lived near her in Grosvenor Square, and the two spent hours discussing the turbulent events in the Middle East, which was still, twenty years after "Behind the Veil," very much on Eve's mind. "Everything Eve thought about was connected to humanity," al-Shaykh recalls, "what was happening to people. We used to have a dialogue all the time about what was happening—politics, mainly. Then we would talk about films, about art." Despite Eve's age, she was "everything modern, not at all like an old woman. She was very contemporary."[217]

Somehow, in her early eighties, Eve was managing to pull off the trick of living simultaneously in the past and the present. As she sorted through her memories for the "big book" that would become *In Retrospect*, she felt compelled to pick up the project that had been haunting her—the search for her roots. For this, she needed help from someone based in Ukraine, and in 1992 she enlisted James Hill, a young photographer living in Kiev, who would go on to do award-winning work for the *New York Times*. "It was very important to her, this question of her roots," Hill said.[218]

Fluent in Russian, Hill knew how to work the Soviet bureaucracy, and he went looking for Eve's family's village. The results were disappointing (figs. 136, 137). "I did two trips," he recalled, "but a lot of villages in the Ukraine have the same name. I took pictures and brought them back to England. But she had very imprecise information."

Despite the lack of success, Hill was grateful for the opportunity to work with Eve. "I remember when I first met her," he said in an interview. "I am really big and she is really small. And her house was full of filing cabinets. I was a nobody and she was this great Magnum photographer. She was sharp, but she was charming."[219]

As always, Eve was eager to boost a young photographer. She grilled him on his work—how was he finding it, was it difficult to start out, and how did he manage to be a freelancer in a tight market. "She said one thing

Flat 22,
Mihailovsky Pereyulok,
Kiev,
UKRAINE.

Tel. 010 7 044 228 8331

14 September 1992

Dear Eve,

I have been so busy that it's only been this week that I have at last been able to visit Novo Grebli, but I hope that what I have found will tell you what you want to know.

1. Novo Grebli
The village is situated about 20km south-east of Zashkov, and about 20km north-east of Sokolivka. It is a small village with a population of about 1,100 people built in a typical Ukrainian style.

Today there are no Jews living in the village and there hasn't been for a long time. All Jewish remains have been destroyed and the centre where the Jewish quarter was situated has been rebuilt with the village soviet, school, shop and war memorial in its place. Apparently, it was traditional for the Jewish area to be in the centre, their houses often built tightly together, with the Ukrainians surrounding them. There was, in effect, a mini ghetto in every village.

The Jewish area was also the trading centre because Jews were usually forbidden to own land or to work on the farms which meant that there was little else for them to do except trade. But in Novo Grebli today there are no traces of this history.

2. Sokolivka
There are at least some remains of the Jewish past in Sokolivka within the cemetary and its hebrew tombstones. But there is nothing else besides.

The village of Sokolivka, as I mentioned in the letter I typed in London, was joined together with another village to the north of it called Justingrad. This happened in 1950, and you can see how they were before on Alan's old Austrian map. But it seems that Justingrad was in fact the Jewish part, and the old Sokolivka Ukrainian/Christian. It would be interesting to know which part your mother was living in.

Last time I visited Sokolivka, I found a Leshchinyer in Zashkov who, I am certain was no relation, but who said that she believed there to be another Leshchinyer living in a village to the east of Zashkov, called Vinograd. I went there to check with the local council but they said that there had never been anyone of that name living there.

I have also been looking into the possibilities of finding out some more definite information about your parents but this seems likely to prove unfruitful for various reasons.
i) I spoke to the main Jewish body here in Kiev who said that they couldn't help much in this case because the rubinical books from the synagogues had been destroyed and without them it was very hard to do any tracing.
ii) Novo Grebli was previously in a district that was dissolved in the 1950's and no-one from the village council seems to know what happened to the records from before that time, and if are still existing where they are now kept.

I am going to contact the Zashkov Oblast Soviet and see if they can be of any help, but I guess that the records needed are so old that it would be an amazing stroke of luck to find them. But it is worth inquiring.

There are two films enclosed, Nos 1-22 on the first cassette are of Sokolivka, showing the Jewish cemetary, an old Jewish house and the village as it stands today. The rest of the pictures are of Novo Grebli showing the village and the modern centre where the Jewish part used to be.

I will be in touch, hopefully before this arrives, to tell you about everything and to find out if you need anything else done at this stage.

Yours,

James

I never forgot," Hill said, "and that other young photographers would surely appreciate. She told me: 'Whatever you do, concentrate on long-term projects.'" He took her advice. "Because of that, I stayed in the Ukraine for four years," he said. "I moved to Russia after that. And what I am most satisfied [with] is the legacy Eve gave me, those long-term projects."[220]

Her own long-term project, *In Retrospect*, was still a few years away from fruition, but it was much on her mind when she invited her grandson Michael to Mount Street for lunch and a photography session to mark his sixteenth birthday in 1993. She had been giving him lessons in photography for the past two years. This time he was to sit for her and experience what it was like to be the subject, then they would trade places. All the time, they talked, discussing questions of time and light, but Eve focused on the heart of the process—the relationship between the subject and the

camera and, more importantly, between the two of them. "I wanted to call upon the intimacy built up between us as grandmother and grandson," she wrote.[221] That feeling of intimacy with Michael extended from him through all the people she had photographed over the years, all the way back to her beginnings.

Eve recognized how lucky she had been to come of age in the heyday of picture journalism. "There was an innocence in our approach, especially in the fifties and sixties when we naively believed that by holding a mirror up to the world we could help—no matter how little—to make people aware of the human condition."[222] She was realizing that her days as a professional photographer were coming to a close—not that she wanted to stop taking pictures, but the old techniques were outworn, and the new technologies might be too daunting to master at her age.

For *In Retrospect,* Eve had been asked to write a ten-thousand-word essay to accompany her images, but by 1993 she was up to a hundred thousand words and not finished. When the book was finally published in America in 1995, and in Britain a year later, it was a major event. The BBC aired a documentary produced and directed by Beeban Kidron, Eve's former protégée, with appearances by Anjelica Huston and Isabella Rossellini, as well as Eve's family. There were accompanying exhibitions at the Barbican Center in London, at the International Center of Photography (ICP) in New York, and fifteen other venues.

Mary McCartney, a young British photographer (and daughter of photographer Linda Eastman McCartney), met Eve for the first time at the 1996 opening of *In Retrospect* in Bradford, England. She was immediately captivated by Eve's "naughty twinkle" and moved by the humanity of the pictures, writing later, "Eve's informal approach to photography really helped to pioneer a new wave in portraiture. . . . [H]er subjects seemed to have confidence to allow her into their private moments, as they could sense she would not take advantage of them."[223]

At eighty-six, Eve was still closely engaged with Magnum. At the end of 1997 she placed a call to the BBC's Patricia Wheatley, with whom she had worked on the Magnum documentary. Wheatley had always longed to make a documentary on Henri Cartier-Bresson, but famously averse to publicity, he had turned down her requests for ten years. Eve said to Wheatley, "Do you still want to make that film about Henri? If you do, he's ready!" Cartier-Bresson was about to have three exhibitions in London, and Eve had taken the opportunity to nudge him toward some appropriate publicity. Wheatley says, "Heaven knows what persuasive powers she used, and she had plenty of those, but he said yes!"[224]

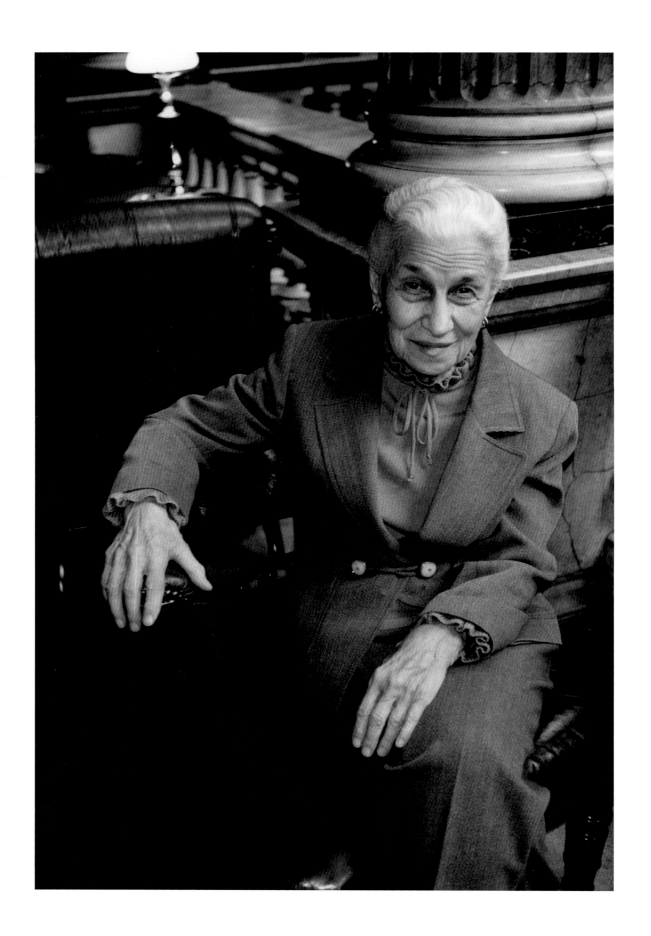

There was a mad dash to make the film and air it in time for the exhibitions, and Eve was actively involved. Wheatley says, "I have footage of her and Henri at the Reform Club, one of her favorite haunts in London. Henri, who said he had given up photography, whipped out an instant pocket Leica and snapped Eve. The flash went off—Henri was horrified and disgusted with the camera's misbehavior! Eve laughed delightedly and said she was sure it would be fine. And it was—he sent it to me some weeks later, very tickled that the flash had known better than he."

Wheatley remembers that Eve was essential to the project. "She was the perfect mediator for us with Magnum and for me with Henri—understanding both our need to get inside the story and her fellow Magnum members' nervousness at having the tables turned—the documenters documented. We owe her a great deal."[225]

Eve had two more shows on the road, a portfolio of her Marilyn Monroe pictures and, in Japan, a joint show called *Women to Women* with longtime Magnum colleague Inge Morath. Her pictures were beginning to sell for high prices at auction. Clearly, the world was ready to celebrate her remarkable career, and the honors rolled in. She was made a fellow of the Royal Photographic Society and named "master photographer" by the ICP. Universities bestowed honorary degrees; she received the lifetime achievement award of the American Society of Magazine Photographers and, in her nineties, the Order of the British Empire (OBE).

By the late 1990s, Eve felt she was done with traveling, but there was one loose end left to tie up. She needed to return to Cuba. In 1954, on one of her first magazine assignments abroad, she had become close to a Havana couple who had asked her to adopt their little girl, Juana, to save her from a life of poverty. Unable to do so, Eve had returned home grief-stricken. Forty-three years later she went back, and she discovered that, not only was Juana alive and well, she was a grandmother who still remembered Eve's original visit (figs. 139, 140). Juana was delighted to see the pictures of herself as a girl, and Eve's worries and fears for her were finally alleviated.

The next year, in 1998, *The Times* of London asked the eighty-six-year-old photographer to cover the Algerian "Dirty War" from the point of view of the women freedom fighters. Flattered, Eve gave it careful thought, discussing it with her loyal assistant, Linni Campbell, but she turned it down, saying that her health was not strong enough to travel through the so-called "Triangle of Death." "I don't think I will be able to run fast enough," she wrote to Isabella Rossellini.[226]

That same year, her career received its capstone with a book and exhibition titled *Magna Brava.* It had been Eve's idea to celebrate Magnum's

138. Eve Arnold, 1998.
Photo: Henri Cartier-Bresson

139. Juana Chambrot as lookout in a game she plays on the beach, Cayo Carenero, Cuba, 1954

140. Juana Chambrot sitting in the same tree she climbed when photographed by Eve Arnold forty-three years before, Cayo Carenero, Cuba, 1997

women photographers, and despite disapproving rumblings from members who felt it inappropriate to single out the women, she prevailed. The project showcased the work of Eve, Inge Morath, Martine Franck, Marilyn Silverstone, and associate member Lise Sarfati. Their portfolios from China, Ireland, Central America, New York, India, Tibet, and Pakistan documented, as Magnum said, issues of global and local importance, all of them focused on the lives of the people involved.

Eve had helped open the door for women to a previously closed world. Others had also contributed, particularly Margaret Bourke-White, Dorothea Lange, Sara Facio, Gisèle Freund, Lee Miller, Lisette Model, and Marion Post Wolcott. But despite the extraordinary work of these women, photojournalism, by the time Eve arrived, remained dominated by men, none more high profile than the four men who cofounded the Magnum agency. Eve made a difference. With her Pentax, her long braid, and her tireless curiosity, she traveled the world alone, and she became a role model to the legion of women photographers who came after her. Most never met her, many only saw some of her work, but all knew of her and were inspired by her example.

On April 21, 2002, and in a flurry of activity, Eve Arnold turned ninety—it was, apparently, the first time she had decided to acknowledge

her real age. Fond messages, drawings, and faxes arrived from all over the world, so many that Eve compiled a book of them. "This counting of years is absurd," Cartier-Bresson wrote to her. "Friendship, love and wariness of power are the only things that matter and the space you occupy (in this) is huge. With all my heart. Henri."[227] Frank said, "She was so happy to see she was not only remembered, but loved."[228]

After Eve underwent a series of small strokes, her family and friends decided that it was too difficult for her to live alone in the Mount Street walkup that she loved so much. She moved to a nursing home, St. George's in Pimlico, where she had a flat of her own—with a sitting room that she filled with books, notebooks, and memories—as well as full-time care. Even though her salon days were over, she was still excited to see her family, friends, and admirers. Anjelica Huston came to visit and asked if she still took pictures. Eve replied with her typical lack of sentimentality, "That's over. I can't hold a camera anymore." Instead, she said, she spent most of her time reading—Dostoyevsky, Thomas Mann, Tolstoy.[229]

In 2007, the *In China* exhibition was brought back to Asia House in London. For the opening night, Eve dressed in one of her red Chinese silk jackets and walked out with her beloved assistant, Linni Campbell, to see the photographs that she had worked so hard to get. Even years later, talking about that China trip made her glow. "It was hard," she said, "and it was lonely. But it was worth it. All of it."[230]

Eve tried to keep working—signing prints for sale and preparing for her next book, which was to be a celebration of her hundredth birthday, with pictures from her own collection dating back to the earliest days. Her friend journalist Liz Jobey wrote that she "fixed a beady eye" on Stuart Smith, the book's designer, when she met him for the first time and said, "Is he good with his letters?" When Smith asked if she would like any specific color for the book's binding, she replied, "Rose." The book was published the week she died, with rose-colored endpapers.[231]

Chris Angeloglou was a faithful visitor. "At the beginning, she could move around and entertain," he said, "but gradually, over the years—and we are talking ten years—she was less able to do things."[232] The periods of sleep or confusion grew longer, and curled up in her bed, she seemed tinier than ever. Hanan al-Shaykh wrote a poem in preparation for Eve's hundredth birthday. "Get up Eve and braid your long silver hair / Let's go down to Mount Street / And eat smoked salmon / On buttered brown bread / With slices of cucumber / Fragile as rose petals . . ."[233]

The celebration never happened. Eve died on January 4, 2012. She was ninety-nine years and nine months old. Her fifty-year career began

with the flowering of color photography (even though her heart had always belonged to black-and-white), spanned the glory days of photojournalism, and ended as the digital era created a new paradigm for photography.

Through it all, one thing remained a constant: her passionate interest in people—all kinds of people—both learning about them and capturing their essence. Asked by an interviewer if she saw a distinction between ordinary and extraordinary people, she said, "No! Everybody is extraordinary, I think, within the framework of their own background and their own personalities. . . . I see them simply as people in front of my lens." The interviewer then asked, "How do you know the sort of person you want to have in front of your lens?" Eve replied, "You don't really know until you've done it, do you?"[234]

A few days after Eve's death, her friend Zelda Cheatle, the gallerist, was showing some of Eve's vintage prints to Gaby Wood, who was writing Eve's obituary for the *Daily Telegraph*. Wood wrote, "As Zelda Cheatle returned Arnold's photographs to their boxes, she asked me if I'd been in London when Arnold died. A little perplexed by the question, I said I had. 'Did you hear the storm that night? That was Eve, going.'"[235]

EVE ARNOLD — 1964 STORIES

No.	Title	Source		#Rolls	Neg size
64-1	Personal		Eve.	3 Rolls	35 mm
64-2	John Bloom	Sunday Times	N.Y	20 Rolls	35 mm
64-3	Sir Alec Home	Sunday Times	N.Y	14 Rolls	35 mm
64-4	Women Keeping Fit	Elle	N.Y	5? Rolls	35 mm
64-5	Color Whiskey Ads	Reach —McClinton			
64-6	The Living Theater			2 Rolls	35 mm
64-7	Lycee			18 Rolls	35 mm
64-8	Royal Societies	Sunday Times	Eve	8 Rolls	35 mm
64-9	Producers, England	Sunday Times	N.Y	5 Rolls	35 mm
64-10	New Statesman	Sunday Times	N.Y	14 Rolls	35 mm
64-11	Baseball Game	Personal	Eve	1 Roll	35 mm
64-12	Royal Society of St. George	Sunday Times	Eve	4 Rolls	35 mm
64-13	Fringe Religions, Engl.	Sunday Times	Eve	11 Rolls	35 mm
64-14	Opening of Museum	Museum of Modern Art		3 Rolls	35 mm
64-15	Amer. Writing Scene	Sunday Times	N.Y	2 Rolls	35 mm
64-16	Mrs. DeVita & Grand Daughter	I.P.		1 Roll	35 mm
64-17	Producers, USA	Sunday Times	N.Y	33/20 Rolls	35 mm
64-18	Teenagers in Washington	Elle			
64-19	Mrs. Price	Seventeen	N.Y	4 Rolls	35 mm
64-20	Fringe Religions, USA	Sunday Times 34	N.Y	3? Rolls	35 mm
64-21	Goldwater	Sunday Times	N.Y	25 Rolls	35 mm
64-22	Republican Convention		N.Y	9 Rolls	35 mm
64-23	Ritchel House in Carmel	I.P.			
64-24	Alan Bates	Vogue	N.Y	4 Rolls	35 mm
64-25	Robert Kennedy	Magnum X	N.Y	3 Rolls	35 mm
64-26	Kingman Brewster of Yale	Newsweek			
64-27	Negro Aristocracy	Sunday Times	N.Y	5 Rolls	35 mm
64-28	Marion Spottiswoode	I.P.			
64-29	Dr. Leonard Kramer	Medical Issues	N.Y	4 Rolls	35 mm
64-30	Auerbach, Pollak & Richardson	Auerbach, Pollak & Rich.		9	35
64-31	Barbra Streisand & Curtis Taylor	Seventeen	N.Y	4 Rolls	35 mm
64-32	Henry Jones	Holiday — Youth			
64-33	Delmer True	Holiday — Youth			
64-34	Andy Warhol	I.P.	N.Y	13 Rolls	35 mm

put 64-9 & 64-17 together

1961 STORIES — EVE ARNOLD

No.	Title		#Rolls	Neg size
61-1	Adlai Stevenson at the U.N.	N.Y.	3 Rolls	35 mm
61-2	Linda Emmet — GLAMOUR			
61-3	Harvey Schmidt — PLAYBOY	N.Y	5 Rolls	35 mm
61-4	Lessing in Pilgrim Land	N.Y	7 Rolls	35 mm
61-5	Lessing in Pumpkin Land	N.Y	9 Rolls	35 mm
61-6	Muslims +1 Blank Roll	N.Y		
61-7	Toy Testing	N.Y	9 Rolls	35 mm
61-8	Core Benefit	N.Y	9 Rolls	35 mm
61-9	Marilyn Monroe & Kenneth — GOOD HOUSEKEEPING		3 Rolls	35 mm
61-10	Danny Kaye at Tanglewood — SHOW	N.Y	38 Rolls	35 mm + 9 Blank
61-11	African Nationalist Rally — LIFE	N.Y	2 Rolls	35 mm
61-12	Lomax — Harlem Misc.	N.Y	5 Rolls	35 mm
61-13	Cancer Story — SEP	N.Y	5 Rolls	35 mm
61-14				
61-15				
61-16	Stravinski	N.Y	6 Rolls	35 mm

LONDON STORIES:

No.	Title		#Rolls	Neg size
61-17	Cheltenham Ladies College — SUNDAY TIMES	N.Y	11 Rolls	35 mm + 3 strips called E
61-18	Wycombe Abbey Girls School — SUNDAY TIMES	N.Y	10 Rolls	35 mm (2 color 6 Black&white)
61-19	Heathfield Girls School — SUNDAY TIMES	N.Y	26 Rolls	35 mm
61-20	Cranborne Chase Girls School — SUNDAY TIMES		22 Rolls	35 mm 17 Black&white 5 colour
61-21	Vicar Needing Funds — QUEEN	N.Y	25 Rolls	35 mm
61-22	Widow Needing Companion — QUEEN	N.Y	20 Rolls	35 mm
61-23	Dog Needing Owner — QUEEN	N.Y	13 Rolls	35 mm
61-24	Girls Sharing Apartment — QUEEN	N.Y	19 Rolls	35 mm
61-25	The Marquis of Bath at Longleat — QUEEN	N.Y	24 Rolls	35 mm
61-26	Crockford's Club — FREE		2 Rolls	35 mm
61-27	Joseph C. Harsch of NBC — McCANN-ERICKSON		6 Rolls	35 mm

+ 61-6A MUSLIMS USA 3 Rolls 35 mm
* 67-10 No. 2,3 & 40-39 - 23 BLANK
* 61-19 - Roll 108 strip 8 missing
61-25 No#143

INTO THE ARCHIVE

"My Own Mad Conscientiousness"

TESSA HITE

In box 137, there is a worn black notebook with a tattered label that reads "Magnum Master File: Eve Arnold" (fig. 143). In this notebook, Arnold has chronicled every photo story that she completed from her first assignment in 1950 to her last in 1997. Toward the end of her life, in 2003, Arnold placed this file—and her entire archive—at the Beinecke Rare Book and Manuscript Library at Yale University. Comprising 194 boxes of correspondence, journals, tearsheets, negatives, contact sheets, photographs, audiovisual material, and ephemera, these documents represent a legacy that Arnold curated for herself.[236]

The contents of Arnold's archive, the records she herself chose to save, can be characterized as largely professional; personal items are noticeably scarce. However, close study of the material reveals the ways in which her professional activities permeated her personal life, and vice versa, and provides a new understanding of her accomplishments. Contact sheets enable one to view unpublished and unprinted images, tearsheets display how her work was published and read, journals contain notes on her experiences, and letters reveal details of her daily working life and expose her excitements, frustrations, and sensitivities. Whereas Arnold's photographs as reproduced in numerous publications appear extracted from the time in which they were made, the archive allows for recontextualization of the work.

The story list in the worn black notebook is a sort of codex with which to decipher the archive. Employing Magnum's numbering system, Arnold listed the year, story title, format of film, and number of rolls shot for each assignment (figs. 141, 142). The story number leads to the corresponding contact sheets, negatives, and tearsheets in the Beinecke archive. With

143. Cover of Eve Arnold's Master File, 1950

141, 142. Pages from Eve Arnold's story book of the 1960s

```
EVE ARNOLD

COUNTRIES IN WHICH I PHOTOGRAPHED:

The United States          1950 through 1985 (off and on)
Jamaica                    1953 - 3 weeks
Cuba                       1954 - 1 month
Haiti                      1954, 1956 - 6 weeks
Eleuthra                   1960 - 2 weeks
England                    1961 through until present day
Malta                      1963 - 1 week
Ireland                    1963, 1968, 1974 - 1 month
France                     1964, 1966, 1968, 1973, 1974, 1977 -
                           2 months
Italy                      1965 - 3 months
Spain                      1966, 1966, 1969 - 2 months
U.S.S.R.                   1965, 1966, 1975 - 8 months
Tunisia                    1968 - 1 month
Austria                    1968 - 6 weeks
Puerto Rico                1968 - 3 weeks
Afghanistan                1969 - 4 months
Egypt                      1970 - 3 weeks
Muscat Oman                1971 - 1 week
Arab Emirates              1970, 1971 - 3 months
Northern Ireland           1971 - 2 weeks
Germany                    1972 - 3 weeks
South Africa               1973 - 3 months
Switzerland                1974, 1975 - 2 weeks
Morrocco                   1975 - 2 weeks
Mexico                     1976 - 2 weeks
India                      1978, 1984 - 3 months
China                      1979 - 2 trips, 6 months
Holland                    1979 - 1 month
Hungary                    1980 - 1 week
Yugoslavia                 1985 - 3 weeks
Finland                    1985 - 1 week
Portugal                   1985 - 1 week
```

144. "Countries in which I photographed" story list

over six hundred stories listed, the sheer volume of Arnold's accomplishments is remarkable. Titles such as "Women Working in Aircraft Plant" (1952), "Clinical Death" (1966), and "Puerto Rico and the Pill" (1968) entice one to investigate her lesser-known stories. One can also use these titles as search tools to mine the extensive online collection of images in the Magnum Photos digital database.[237]

Arnold's story list can also be read as a flight map charting her whereabouts as she explored in an increasingly widening orbit. On one page in the story list, headed "Countries in Which I Photographed," Arnold listed the year and duration of her photographic trips (fig. 144). The

time spent in each country—four months in Afghanistan, six months in China, eight months in Russia—shows that she did not merely chase stories but lived them. She was propelled by a curiosity to learn about and convey the character of a country by picturing the daily lives of its diverse inhabitants. She first employed this approach in England in the 1960s and then repeated it in many of the countries listed. In a 1963 letter to photographer Wayne Miller, then director of Magnum's New York office, she referred to her methodical and immersive working method as "my own mad conscientiousness."[238]

For each project Arnold completed, she photographed profusely. In the archive, heavy three-ring binders brim with contact sheets. The contact sheets from the beginning of her career, in the early 1950s, show twelve 2¼-inch negatives per page, as they were shot with a square-format Rolleicord; by the end of that decade, she had switched to a 35mm camera. The contact sheets not only allow one to see the moments before and after her well-known photographs, but they also give clues to her editing process and show images that were never published or printed. The contact sheets may be read like a dance pattern, tracing Arnold's steps through each photographic encounter. By looking at a contact sheet from her early 1950s migrant labor camp series, which featured potato pickers near her home in Brookhaven, Long Island, one can easily envision Arnold walking from the side of the house where the children are gathered into the barn where a man stacks heavy bags of potatoes (see fig. 26).[239] The circles on the sheets, made with a china marker, indicate the images that Arnold chose to print. She did not select the photograph of the white man and his son but instead honed in on the physical prowess of the laboring black man. She sometimes cropped photographs for printing. On another contact sheet showing migrant women toiling in the field, red rectangles delineate the portion of the negative she wanted to print (see fig. 20).[240] The archive also has several Kodachrome color slides from this series. Arnold sometimes shot color and black-and-white simultaneously; on an index card titled "Color and Monochrome," she typed, "I am greedy, I want both."[241] For later stories, too, like one depicting pregnant women and babies dying of malnourishment in 1973 at Charles Johnson Memorial Hospital in Nqutu, South Africa, Arnold shot identical frame-for-frame images in both black-and-white and color.[242] She was likely motivated by both aesthetic and editorial concerns. Her article "Black in South Africa," published subsequently in the *Sunday Times*, ran entirely in color, but in later monographs, she reproduced the Nqutu hospital images in black-and-white (see figs. 102–4).

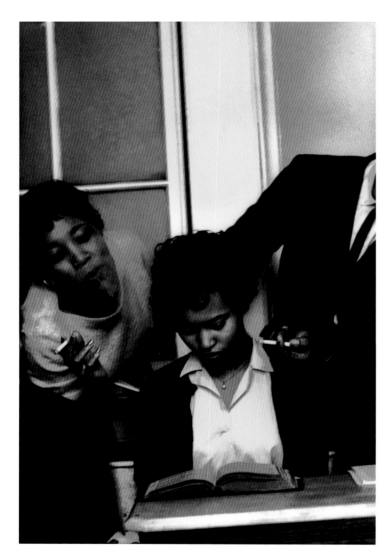

145. Passive-resistance training for sit-ins, in which African American youth are taught not to hit back when harassed by whites, Petersburg, Virginia, 1960

146. Verso of 1960 print showing explanatory caption typed by Eve Arnold or Magnum staff

In the publication of her photographic stories, images would be edited first by Arnold and next by Magnum's editors, who would create and send a distribution selection, or "distro," to more than twenty international agents. Each magazine would then make its own edit of the material for print. In thirteen boxes at Beinecke and in an additional collection at Magnum, New York, are pages torn from magazines showing Arnold's stories as published in *Life*, *Look*, *Esquire*, *Queen*, *Picture Post*, the *Sunday Times*, and many additional international magazines. These tearsheets show how Arnold's photographs were disseminated to and consumed by contemporary audiences. They also provide the opportunity to study the relationship between image and text. Though Arnold authored accompanying articles whenever possible, she often collaborated with journalists. In an interview found on audiocassette in the archive, she explains that "there is always something going on that needs words [to] complement or

supplement the picture."[243] This reciprocity is readily apparent in her photographs of a passive-resistance training program in Virginia for a story called "School for Sit-ins," published in *Look* on August 30, 1960.[244] The photographs show Priscilla Washington, a young African American girl, getting her hair pulled and being taunted with cigarettes by older African American students. To see these images alone, or even within the context of a contact sheet, is initially startling (fig. 145). But on the back of a photograph one finds a lengthy explanatory caption typed either by Arnold or someone at Magnum (fig. 146), and the *Look* magazine article offers further details of Priscilla's training. *Look*'s circulation at this time was six million copies. This vast readership, and that of the other magazines to which Arnold contributed, demonstrates the expansive reach of her photographs. For her contemporaries, Arnold's images acted as mirrors reflecting the political, social, and cultural climate in which they lived.

Arnold, a prolific writer, authored text for more than a dozen books during her lifetime, with editions published worldwide. The archive contains many notebooks filled with heavily annotated manuscripts for such projects, showing Arnold's tenacious self-editing process as she built her own narratives. Perplexingly, the pages of these notebooks have been crossed out as though she did not want anyone to publish her nascent thoughts. Her diaries from her 1979 trips to China, however, read as fresh and impromptu recordings of her day-to-day experiences. In a softly worn paper journal, one fantastical musing, an entry left tantalizingly incomplete from June 30, 1979, reads, "Today I walked on the roof of the world hand in hand with a Tibetan monk" (figs. 147, 148).[245] Once Arnold returned home from China, Arnold's assistant, Linni Campbell, typed up her journals; Arnold then highlighted sections to be typed once more onto notecards that she could reference while assembling her book *In China* (1980).

Additional notecards, found in two long narrow boxes in the archive, bear research notes, story ideas, quotes, and excerpts from letters. The cards have been sorted by theme and project and are tied in small groupings with white ribbon. One set of cards displays the extensive research Arnold conducted in preparation for "Behind the Veil," a photographic essay on veiled women in Egypt, the United Arab Emirates, and Afghanistan for the *Sunday Times* (October and November 1970) and a subsequent 1971 film, which Arnold wrote and directed for BBC and NBC. In hopes of familiarizing herself with various cultures, she dutifully lists Bedouin expressions of greeting, customs, and even poems (fig. 149).[246] Other notecards bear Arnold's mantra, "The job of the photographer is to show something one would not have seen if the photographer hadn't shown it," and her perennial question,

147, 148. Cover and entry of June 30, 1979, travel journal from China

"What do you hang on the walls of your mind?" (fig. 150).[247] Perhaps most surprising are the excerpts from Arnold's own letters that she had Campbell type onto index cards. One such notecard includes a portion of a May 22, 1972, letter to her sister-in-law Gertrude, written during Arnold's nearly decade-long struggle to obtain a visa to visit China:

> I seem to be in a state of *suspended animation*, unable to make anything happen for my Chinese trip and unwilling to settle for anything less.... This kind of *stagnation* comes every couple years and is apparently a need on the part of my psyche to slow me down, but I find it irksome.[248]

Such emotional candor is characteristic of her letters to Gert and her sister Charlotte, but the question of why these were retyped onto notecards remains unanswered. The poetic phrase "suspended animation" appears in other letters, too, such as one addressed to her son, Frank, in January 1963 about the freezing winter in London and the death of Hugh Gaitskell, leader of the Labour Party. She wrote: "People are walking around in a stupor . . . suffering from the same lack of leadership as the U.S., worried about

MOON *Mood* *Bedouins*

Then she unveiled her face, and I saw that she was like
the moon, and I stole a glance at her whose sight caused
me a thousand sighs, and my heart was captivated with love
of her.

 - 1001 Nights, tr, Burton

MANNERS AND CUSTOMS OF THE RWALA BEDOUINS - Musil

The Bedouin is most happy from the eighth to the
eighteenth night, for the moon in that period is still
alive at sunrise; these nights are called the white.
The Bedouin cannot then be discovered from afar; nor
suddenly attacked from near by, as he sees farther than
the rifle would carry. Beginning with the eighth night he
can sleep easily; from the tenth onwards, he need not
drive together the camels which lie here and there around
his tent.

January 31st 1979. *Images*

What do you hang on the walls of your mind?

When I became a photographer I began, assiduously, to collect favourite
images which I filed away in my imagination to bring out and examine
during moments of stress or moments of quiet.

It became a game of solitaire to be played during long trips abroad - a
form of meditation that kept me occupied during endless waits in
bureaucratic anterooms in the USSR, fly spattered hotels in India, risky
landrover rides in the Hindu Kush of Afghanistan, and sleepless breath-
catching moonlit nights in Zululand - to say nothing of unnumbered hours
of flying time back and forth to London.

What were the pictures?

(note: write about George Rodger's *africa)* Nuba Wrestlers, Henri C.B.'s Children
in the rubble (Spain), Elliott's dogs etc.

Freelancing *Freelancing*

writing
work habits

Feel bereft when a project ends. Like all the attention

and concentration is gone like a child that has grown

up and gone away and suddenly you are alone - write on

freelancing.

149. Index card with research notes for
Behind the Veil, 1970s

150. "What do you hang on the walls of
your mind?" index card, January 31, 1979

151. "Freelancing," *In Retrospect* notes,
date unknown

the need to go forward, and still caught in an almost state of suspended animation."[249] Not only images but also words seem to have hung on the walls of her mind.

Perhaps the gems of the archive are the two boxes of correspondence that begin in the early 1960s after Arnold moved to London. Grouped in folders by decade are carbon copies of typed letters she mailed to confidants and colleagues. This correspondence exposes unpublished details of stories and reveals Arnold's passions and aggravations as well as details of her daily life as a photojournalist. Noticeably absent from her archive are letters dated before the 1960s and letters that are strictly personal in nature. There are also far more copies of letters she wrote to others than those that were sent to her. One can only speculate today, but it seems that Arnold, an intensely private person, wanted to protect parts of her life from scrutiny. The letters in the archive therefore represent only a selection of her correspondence during these decades, and each piece that survives was deliberately chosen to be saved. She annotated the typed letters with pencil or red pen, bracketing paragraphs she found noteworthy and topping the pages with headings that identify the story or project to which each letter pertained. It is unclear at what point each letter was marked, but Campbell suggests that it was a continual process, not one undertaken retroactively toward the end of her life.[250]

The intersection of Arnold's personal and professional life is evident in three letters written to her husband, Arnold Arnold, in November 1961, shortly before the couple separated.[251] Though she may have had other romantic relationships after their separation, traces of these are scant in the archive. In these early letters to her husband, Arnold shares details about her first assignments from London: photographs of girls' schools for a story in the *Sunday Times* and a five-part series for *Queen* of people who placed personal ads in the magazine. She writes of the exhaustion of the shooting schedules at the schools, the young female flatmates from a personal ad who kept her up gossiping until midnight, and the scramble to replace the Earl of Bristol, who had to be dropped from the personal ad story because he was involved—as Arnold put it—in a "nastybit of business," the murder of a jeweler.[252] The paragraphs pertaining to these stories are bracketed, suggesting that the professional content is the reason the letters were saved. But toward the end of the letters are Arnold's pleas of concern, asking her husband to explain the distant tone in his voice. After this series of letters, correspondence to Arnold Arnold is cordial but scarce. She wrote prolifically, however, to her son, Frank, recounting many details of life on the job: the "charge" she got from her "Black Bourgeoisie" story,

the boredom of waiting for rain to clear on the Noah's ark set of John Huston's film *The Bible*, and her annoyance when editors turned her story on Princess Grace into a "flowery piece of praise and nonsense" (see figs. 162, 164).[253] For a researcher, the letters to Frank—replete with Arnold's candid expressions of how she felt about her stories—are a treasure trove ripe for further exploration.

Arnold's relationship with her second family, Magnum, is also exposed in the boxes of correspondence. A stream of letters follows her four-month trip to Russia in 1966, illustrating the complexity of her working relationships. On January 16, 1967, she submitted a package of her Russian photographs to Lee Jones, Magnum's editorial director in New York, with a letter declaring: "Herewith my Russian Opus. I feel as though I have never done a story before in my life, nor will I ever again. It is though I have always worked on this."[254] Jones replied, though her letter was not saved, and apparently asked for additional color material and negatives. To this, on January 31, Arnold sent an angry response. She was outraged, expressing bitter dismay because she believed Jones had not reviewed her submitted material carefully enough.[255] On February 6, Jones asked how she could say such things, but then praised Arnold's work: "You have managed to imbue [the photographs] with a sense of relaxation, of friendliness, of person-to-person intimacy which I have never seen before out of Russia."[256] Arnold wrote back to Jones, apologizing for blowing "a gasket."[257] She explained that she was deeply paranoid about the Russian material because, while in Russia, she felt that she was under surveillance by the KGB and feared that the political climate was such that her stories might be quashed. Arnold also sent a letter to Magnum's Paris bureau chief, Russ Melcher, with a half-hearted apology: "I am sorry this [has] all been such a 'kuffeffel' [*sic*] but that's the way the caviar tastes."[258] This exchange seems to illustrate Magnum's complex family dynamics.

On one scrap of paper in the archive Arnold typed, "a story is made first in the camera then in editing."[259] Indeed, she used both her camera and her wits to create and edit her own story as she transformed herself from a Long Island housewife into a global photojournalist. Arnold's archive represents a curated legacy, and it cannot be known what might have been revealed in the materials she withheld from the archive. Yet what remains is incredibly rich; the contact sheets, letters, and notes accompanying her stories shed light on what Arnold saw and felt. In her most candid voice, the archive allows Arnold to speak for herself.

CHRONOLOGY COMPILED BY TESSA HITE

1912

Eve Cohen is born April 21 in Philadelphia to parents William Cohen (born Velvel Sklarski) and Bessie (Bosya Laschiner).

1940s

Works in a Philadelphia real estate management office by day and attends night school.

Receives her first camera, a medium-format Rolleicord, from a boyfriend.

1943

Meets new friends on a holiday cruise to Bermuda; they persuade her to move to New York.

Takes a job at Stanbi Photos, a photo-processing plant in Hoboken, New Jersey. Works there for five years, first as a supervisor in charge of cutting and inspecting pictures, then as a plant manager. Organizes photographic studios in army camps in the American South and sets up a new plant in Chicago.

Marries Arnold Arnold.

1948

Gives birth to Francis, nicknamed Frank, on August 14.

Leaves job at Stanbi Photos to care for her son.

1950s

Attends a six-week program with *Harper's Bazaar* art director Alexey Brodovitch at the New School for Social Research in Manhattan.

Ventures to Harlem to photograph fashion shows.

152. Eve Arnold, London, England, 1992

All dates are derived from materials in the Eve Arnold Papers of the Beinecke Rare Book and Manuscript Library, Yale University.

153. Hubert's Museum, New York, 1950

154. Woman working in aircraft factory,
Long Island, New York, 1952

155. Juana Chambrot in school built by
parents, Caya Carenero, Cuba, 1954

Picture Post runs Harlem photographs—her first publication.

Receives first editorial assignments: an opening night at the Metropolitan Opera and 42nd Street by night. Photographs a peep show and a flea circus at Hubert's Museum, Times Square (fig. 153).

1951

Becomes associate member of Magnum.

With her husband and son, spends several summers on Long Island. Photographs potato pickers and child laborers at a migrant labor camp near their summer home.

1952

Photographs women working in an aircraft factory on Long Island (fig. 154)

Photographs a recording studio session with Marlene Dietrich at Columbia Records.

Photographs the Republican National Convention in Chicago.

Photographs the birth of her niece, Jane Walsh. Would continue to photograph births throughout her career (see 1959).

Photographs Mamie Eisenhower. Would continue to photograph wives of politicians, including Jacqueline Kennedy, "Lady Bird" Johnson, "Pat" Nixon, Lady Spencer-Churchill, and Nina Petrovna Kukharchuk (wife of Nikita Khrushchev).

1953

Moves to Brookhaven Township, Long Island, with husband and son.

On first foreign assignment, travels to Jamaica to photograph the young Queen Elizabeth II for *Picture Post*.

With a local comedian ("The Charlie Chaplin of Jamaica") and journalist Kathleen McColgan, ventures to Trenchtown to photograph Rastas.

1954

Travels to Haiti and photographs the country's first female doctor, Yvonne Sylvain, as well as patients in an asylum.

Photographs Havana, Cuba, for an *Esquire* article entitled "The Sexiest City in the World." In Cayo Carenero, photographs a young girl named Juana Chambrot, whom she considers adopting (fig. 155). (Returns in 1997; see entry.)

Photographs Senator Joseph McCarthy in Washington, DC.

Meets Marilyn Monroe at a party for John Huston.

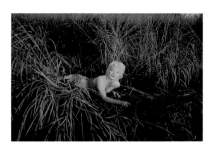

156. Marilyn Monroe, Mount Sinai, Long Island, New York, 1955

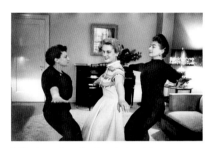

157. Joan Crawford and daughter Christina during a workout with Susan Strasberg, New York, 1956

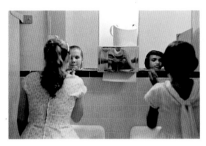

158. A party to introduce blacks to whites during civil rights strike, Virginia, 1958

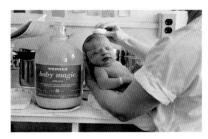

159. Birth, Port Jefferson, Long Island, 1959

1955

Becomes a full member of Magnum.

Photographs Marilyn Monroe on a playground, rolling in the marshes of Mount Sinai, Long Island (fig. 156) and on a publicity stint in Bement, Illinois.

Photographs Paul Newman in the Actor's Studio.

1956

Photographs Marilyn Monroe in *The Prince and the Showgirl* with Laurence Olivier.

Photographs faith healer Oral Roberts.

Photographs Joan Crawford and her daughter Christina on a trip to New York for *Woman's Home Companion* (fig. 157).

1957

Advertising work includes fashion assignments for Grey Advertising and Simplicity Patterns. Also photographs for El Al Airlines.

Photographs William Carlos Williams.

1958

For three months, documents daily lives of Italian Americans in Hoboken, New Jersey.

During integration crisis, photographs Thurgood Marshall, then chief counsel for the National Association for the Advancement of Colored People (NAACP) in Washington, DC. Also photographs a party in Virginia in which white students are introduced to African American students (fig. 158).

Photographs the Davis family and other members of her Brookhaven, Long Island, community. Pitches a story of Brookhaven as quintessential American town.

1959

In deep depression after a miscarriage, photographs births at Mather Hospital in Port Jefferson, Long Island (fig. 159).

Life runs the six-page story "A Baby's Momentous First Five Minutes." The final image of a baby clinging to a mother's hand is reused in numerous advertisements.

Spends a month photographing Joan Crawford in Hollywood for *Life*. At the actress's request, photographs Crawford getting her legs waxed and hair and eyebrows colored.

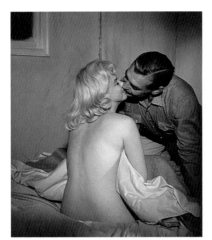

160. Marilyn Monroe and Clark Gable,
The Misfits, 1960

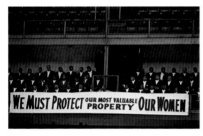

161. Nation of Islam meeting, Washington,
DC, 1961

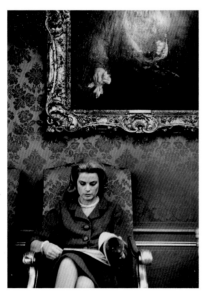

162. Princess Grace, Monaco, 1962

1960s

1960

In Virginia, photographs African American students training in passive-resistance tactics for school sit-ins.

Photographs Marilyn Monroe, Clark Gable, and Montgomery Clift during filming of *The Misfits* in Nevada (fig. 160). Throughout her career, would photograph stills for thirty-five films.

Befriends *Misfits* director John Huston. Over the years, photographs several Huston film productions, visits Huston's home in Ireland, and photographs his daughter, Anjelica Huston.

1961

During 1961 and 1962, photographs Malcolm X and Black Muslims for *Life*, which then declines to publish the story. Story is later published in *Esquire* in 1963 and syndicated internationally (fig. 161).

Moves to England and enrolls her son, Frank, in boarding school. Months later, separates from Arnold Arnold.

Begins work for the *Sunday Times*, photographing several girls' schools in England.

For *Queen* story on personal ads, photographs a widow, a vicar, a Scottish terrier, the Marquis of Bath, and three young female flatmates searching for a fourth.

1962

Photographs Grace Kelly in Monaco (fig. 162). Does her first European television shoot of Princess Grace showing the palace.

Photographs the Salvation Army.

1963

Signs ten-year contract with the *Sunday Times* and becomes contributor to their recently launched *Colour Magazine*.

Photographs the Church of England.

1964

Portrait subjects include Prime Minister Alec Douglas-Home, actor Sir Alan Bates, Barbra Streisand, and Andy Warhol.

163. The Royal Toxophilite Society, founded in 1781, posing in a disused cemetery behind Albion Mews, London, England, 1964

164. Two giraffes in John Huston's film *The Bible*, Rome, Italy, 1965

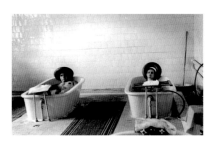

165. Hydrotherapy for political prisoners, psychiatric hospital, Moscow, 1966

Photographs British Royal Societies, including the Royal Academy (painting), Royal Photographic Society, and Royal Toxophilite Society (fig. 163).

Photographs for *Sunday Times* story entitled "The Black Bourgeoisie."

1965

Photographs production of John Huston's film *The Bible* in Italy (fig. 164).

Photographs female soldiers, divorcées, abandoned women, lesbians, and nuns for a *Sunday Times* essay titled "Women without Men." Images of nuns are subsequently published in Germany, France, Italy, and Japan.

In the Caucasus Mountains of Georgia, Soviet Union, photographs the oldest men in the world.

While in village of Telavi, falls of a porch, breaking three front teeth and hurting jaw.

1966

Photographs Vanessa Redgrave in Orson Welles's film *A Man for All Seasons*, Sophia Loren and Marlon Brando in Charles Chaplin's *A Countess from Hong Kong,* and Simone Signoret in Sidney Lumet's *The Deadly Affair.*

Photographs Prince Phillip at Windsor Great Park, Windsor, Berkshire, England.

Spends four months in Russia with the Russian-speaking American journalist George Feifer. Shoots twenty-nine stories. Subjects include a hospital psychiatric ward (fig. 165), advertisements, jazz, a circus school, fashion, movie stars, divorce court, Tolstoy's oldest grandson, and clinical death trials (in which animals were bled to death and then resurrected).

1967

Documents the Vatican. Photographs rituals, confirmations, confessions, marriages, ordinations, and other daily activities. Works with Vatican newspaper *L'Osservatore Romano* and publishes "How the Vatican Works" in the *Sunday Times.* Proposes a book on the topic, but it is never made.

In Majorca, photographs production for the film *The Magus*, starring Michael Caine, Candice Bergen, and Anthony Quinn, as well as for the film *Salt and Pepper* with Sammy Davis Jr. and Peter Lawford.

Photographs US Marine combat training in an elaborately constructed Vietnam village in North Carolina. (Later photographs wounded Marines in 1971.)

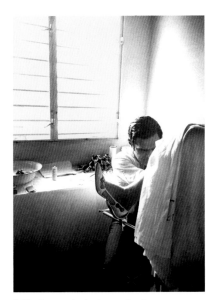

166. Gynecological examination,
Puerto Rico, 1968

167. Egypt veiled women, 1970

1968

Photographs Audrey Hepburn interviewing Moroccan refugees in Paris.

Photographs anti-Vietnam protest in London; the "Peace-In" ends in riots.

Photographs Anjelica Huston with her father, John Huston, in Ireland; with her mother in London; and on set of *A Walk with Love and Death*, directed by John Huston, in Austria.

In Tunisia, photographs Anouk Aimée in title role of the film *Justine.*

At a Tunisian rally, the president's call for Muslim women to come out from behind the veil inspires the project, "Behind the Veil," 1969–71.

Photographs "Drop City," a hippy commune in New Mexico.

Photographs for and authors the *Sunday Times* article "Black Is Beautiful"; subjects include musician James Brown, model Arlene Hawkins, and actress Cicely Tyson.

Shoots a story on the birth-control pill in Puerto Rico, where the drug was first tested in the 1950s (fig. 166).

Photographs women giving birth with the Lamaze method in London.

1969

For "Behind the Veil" project, spends four months traveling through Afghanistan with writer Lesley Blanch. Stops include Herat, Kandahar, Kabul, Bamyan, Jalalabad, Tashqurghan (Khulm/Kholm), Mazar-i-Sharif, and Ghazni. Also visits Pakistan and Turkmenistan. Subjects include nomadic tribes and weddings, gender-segregated classrooms, bazaars, and men and women of various social classes (fig. 167).

For continuing advertising work, casts with modeling agencies. Favors an agency called *Ugly* that features what Arnold calls "ordinary people."

1970s

1970

For three weeks, photographs veiled women in Egypt and in harems throughout the United Arab Emirates. "Behind the Veil" is published in the *Sunday Times* in October and November 1970.

Photographs Mia Farrow in London.

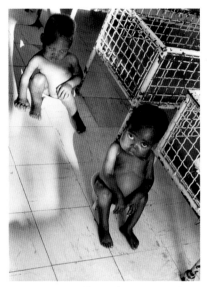

168. Children suffering from malnutrition, Johannesburg, South Africa, 1973

169. Sean Connery, Michael Caine, and Christopher Plummer discuss the script for *The Man Who Would Be King*, Morocco, 1975

170. Cover, *The Unretouched Woman*, 1976

1971

Writes and directs *Behind the Veil*, a one-hour film for the BBC featuring a harem in Dubai and the wedding of the Crown Prince of Dubai. Also uses footage for a half-hour film on harems in the United Arab Emirates for NBC.

1972

Travels to Germany for Munich Olympics to document the making of the official Olympic film, which continues despite Palestinian terrorist attack on the Olympic village.

1973

Spends three months in South Africa to photograph, and later authors, *Sunday Times* article "Black in South Africa." Subjects include students in literacy classes, workers in gold mines and factories, a witch doctor, and Chief Gatsha Buthelezi, the Zulu prime minister. Visits Charles Johnson Hospital at Nqutu and photographs mothers and babies dying of kwashiorkor (malnourishment) (fig. 168).

1974

For Irish tourist board, photographs Aran Islands, Glencar, and Killarney.

Prepares materials for upcoming publications, and sets up a small darkroom in London flat; spends six days a week printing.

1975

In Russia, documents the first non-Russian (British Airways) tourist flight.

Shoots cigarette ads in Switzerland.

In Morocco, photographs John Huston film *The Man Who Would Be King* (fig. 169).

1976

Travels to Mexico. Writes text for *The Unretouched Woman* while sitting on a veranda in Cuernavaca (fig. 170). Makes twenty-five minute film with BBC to promote the book's publication that year.

Photographs Democratic National Convention, Madison Square Garden, New York.

Advertising assignments include the Avon Lady, Air India, and testing of Olympus camera on go-go dancers.

1977

Shoots Yves Saint Laurent and the Paris collections for French *Vogue*.

Photographs Margaret Thatcher with busts of herself and Winston Churchill in the studio of sculptor Oscar Nemon, London (fig. 171).

1978

Photographs painter Francis Bacon.

In India, photographs Indira Gandhi on campaign trail for prime minister (fig. 172), travels with journalist Bruce Chatwin, and photographs people in Madras (Chennai) and Cochin (Kochi).

Publishes book *Flashback! The 50s*.

1979

Takes two trips to China, three months each, covering forty thousand miles. First trip includes stops in Chongqing, Shanghai, Beijing, Suzhou, Hangzhou, Guilin, Fuzhou, and Canton. Photographs schools, factories, markets, film studios, hospitals, peasants, city dwellers, and government officials. Destinations for second trip include Tibet, Inner Mongolia, Xi'an and Ürümqi, Xishuangbanna (near Burmese border), and a return visit to the Yangtze River.

Contracts pneumonia during travels in China.

1980s

1980

Publishes book *In China*, which is printed in United States, England, France, Germany, Australia, Canada, Japan, and New Zealand and is plagiarized in Taiwan.

Receives National Book Award for *In China* and lifetime achievement award from the American Society of Magazine Photographers.

Has first museum exhibition at the Brooklyn Museum (*In China: Photographs by Eve Arnold*, November 15, 1980–January 11, 1981). Exhibition travels through February 1983 to cities including Pittsburgh; Seattle; Denver; Houston; San Francisco; Portland, Oregon; Milton, Massachusetts; and Champaign, Illinois.

1981–82

Spends two years crisscrossing the United States, photographing in thirty-six states. Attends a peyote ceremony on Navajo reservation, rides subways with Guardian Angels

171. Margaret Thatcher before her election as prime minister, London, England, 1977

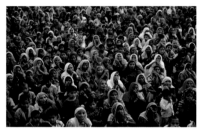

172. Audience for an Indira Gandhi rally, Uttar Pradesh, India, 1978

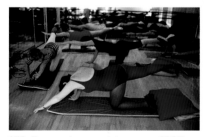

173. Texas prisoners doing yoga, 1982

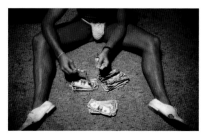

174. Male stripper at Sneaky Pete's, New Jersey, 1982

175. Cover of *In America*, published 1983

176. Cover of *Marilyn Monroe: An Appreciation*, published 1987

in New York and Sukkot-mobiles with Hasidic Lubavitch in Brooklyn. Photographs wine tasters, migrant grape pickers, and llama ranchers in California; nursing homes and recovering addicts in the South; Asian immigrants learning English in the Pacific Northwest; queer transvestite nuns, the Sisters of Perpetual Indulgence, in San Francisco; women at gun ranges; erotic dancers in New Jersey (fig. 174); and mothers and children everywhere.

1983

Publishes book *In America* (fig. 175).

In Mexico, photographs John Huston film *Under the Volcano.*

1984

In India, travels to Delhi, Gwalior, Bombay (Mumbai), Shivpuri, and Jaipur. Photographs the Scindia family—the Rajmata and Maharaja of Gwalior.

Photographs film *White Nights* in Finland, England, and Portugal, with actors Isabella Rossellini, Mikhail Baryshnikov, and Gregory Hines.

Photographs a replica of a Nairobi village in South Carolina.

1985

Photographs Isabella Rossellini for *Life* magazine covers, Lancôme ads, and on the set of the David Lynch film *Blue Velvet.*

Photographs the Miracle in Medjugorje—six children who see the Virgin Mary daily in Yugoslavia (Bosnia and Herzegovina).

1986

Photographs John Huston on the set of *Mister Corbett's Ghost*, directed by Huston's son, Danny.

1987

Publishes book *Marilyn Monroe: An Appreciation* (fig. 176).

Photographs Mikhail Baryshnikov and the American Ballet Theatre.

1988

Publishes book *Private View: Inside Baryshnikov's American Ballet Theatre.*

Returns to Russia to photograph a cruise of 150 American tourists on the River Volga.

177. Cover of *In Britain*, published 1991

178. Eve Arnold's grandson, Michael Arnold, age sixteen, London, England, 1993

1989

Publishes book *All in a Day's Work*, a collection of photographs that span thirty-five years and various countries, such as China, South Africa, Pakistan, and the United States. Photographic subjects include miners, factory and field workers, craftsmen and cooks, actors, athletes and equestrian acrobats, photographers and filmmakers, models, marines and market vendors, vicars and nuns, housewives, doctors, veterinarians, and yak herders.

1990s

1980

While shooting an advertisement for British Rail in Perth, Scotland, suffers temporary blindness in her right eye. Without mentioning her ailment, hands camera to assistant and playfully takes director role.

After a successful cataract surgery and several weeks' recovery is able to photograph with her right eye again.

1991

Publishes book *The Great British*, titled *In Britain* in the United Kingdom (fig. 177). Photographs span from her arrival in London in 1961 to her Margaret Thatcher shoot in 1977.

Exhibition *The Great British* at the National Portrait Gallery, London (November 1991–February 1992).

1992

Photographs Prime Minister John Major.

1993

Has photography lesson with grandson Michael on his sixteenth birthday (fig. 178).

1995

Publishes book *Eve Arnold: In Retrospect*.

Photographs Isabella Rossellini modeling Betsey Johnson in BBC film shoot.

Named master photographer by the International Center of Photography, New York, and fellow of the Royal Photographic Society, United Kingdom.

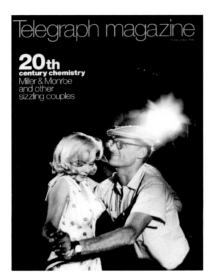

179. Cover of *Telegraph* magazine, 1999

1996

Exhibition *In Retrospect* tours sixteen venues in New York, Houston, Austin, London, Birmingham, Bradford, Edinburgh, Dublin, Milan, and Australia.

Receives Kraszna-Krausz Book Award for *In Retrospect*.

Participates in *Women to Women* exhibition with Inge Morath in Tokyo.

1997

Awarded honorary degrees Doctor of Letters from Staffordshire University, Stoke-on-Trent, UK; Doctor of Science from the University of St. Andrews, UK; and Doctor of Humanities from Richmond, the American International University in London.

Named a member of the advisory committee of the National Museum of Photography, Film, and Television, Bradford, UK.

In Cuba, photographs Juana Chambrot, whom she had met (and considered adopting) forty-three years earlier (see 1954).

2000s

2002

Publishes book *Film Journal.*

2003

Receives high honor of Order of the British Empire (OBE), United Kingdom.

Acquisition of Eve Arnold archives by Beinecke Rare Book and Manuscript Library, Yale University.

2004

Publishes book *Handbook (with Footnotes).*

2005

Publishes book *Marilyn Monroe.*

2012

Passes away on January 4 at age ninety-nine.

180. Eve Arnold's obituary published in the *Independent*, January 6, 2012

NOTES

Chapter 1: Born Poor in America

1. Eve Arnold, *Eve Arnold: In Retrospect* (New York: Alfred A. Knopf, 1995), p. 9.
2. Interview with Gertrude Cohen, 2013, Magnum Foundation Archive, New York (hereafter Magnum Archive).
3. Arnold, *In Retrospect*, p. 265.
4. Tim Adams, "Eve Arnold: Stars in Her Eyes," *Observer* (London), July 6, 2002.
5. Information from notebook created at Cohen family reunion in 1990s. Access courtesy of Gert Cohen.
6. Eve Arnold, interview by John Tusa, BBC3, November 5, 2000.
7. Arnold, *In Retrospect*, p. 11.
8. Eve Arnold, *The Unretouched Woman* (New York: Alfred A. Knopf, 1976), p. 8.
9. Marguerite Arnold, obituary of Arnold Arnold, Bedales Association and *Old Bedalian Newsletter*, 2013.
10. Frank Arnold, various interviews, 2008–14, Magnum Archive.
11. Ibid.
12. Marguerite Arnold, obituary of Arnold Arnold, Bedales Association and *Old Bedalian Newsletter*, 2013.
13. Alexey Brodovitch, February 1964, cited in *Creative Camera*, February 1972.
14. Eve Arnold, "Notes from a photographer's diary," date unknown, index card, box 10, Arnold Papers.
15. Interview with Eve Arnold, August 28, 1990, audiotape entitled "Five Masters of Photography," box 60, Eve Arnold Papers, Beinecke Rare Book and Manuscript Library, Yale University, New Haven (hereafter Arnold Papers).
16. Eve Arnold, *The Unretouched Woman* (New York: Alfred A. Knopf, 1976), p. 8.
17. Eve Arnold, "Notes from a photographer's diary," date unknown, index card, box 10, Arnold Papers.
18. Interview with Eve Arnold, August 28, 1990, audiotape entitled "Five Masters of Photography," box 60, Arnold Papers.
19. Arnold, *In Retrospect*, p. 4.
20. Liz Jobey, "What Eve Arnold Saw," *FT Magazine*, March 2, 2012.
21. Val Williams, Eve Arnold obituary, *Independent*, January 6, 2012.
22. Arnold, *In Retrospect*, p. 17.
23. Liz Jobey, "What Eve Arnold Saw."
24. Arnold, *In Retrospect*, p. 6.
25. Ibid.
26. Inge Bondi, email message to James Fox, January 5, 2012, interviews file (included in document dated July 3, 2013), Arnold Papers.

Chapter 2: A Passionate Personal Approach

27. Arnold, *In Retrospect*, p. 13.
28. Elliott Erwitt, in Brigitte Lardinois, ed., *Eve Arnold's People* (London: Thames & Hudson, 2009), p. 16.
29. Peter Silverton, "Eve Arnold Profile," *Professional Photographer*, July 21, 2010,
30. Eve Arnold, interview by Russell Miller, 1987, Magnum Archive.
31. Eve Arnold, interview by Janine di Giovanni, 2009.
32. Frank Arnold, various interviews, 2008–14, Magnum Archive.
33. Russell Miller, *Magnum: Fifty Years at the Front Line of History*, (New York: Grove Press, 1997), p. 95.
34. Arnold, *In Retrospect*, p. 15.
35. Eve Arnold, interview by Russell Miller, 1987, Magnum Archive.
36. Arnold, *In Retrospect*, p. 27.
37. Amanda Hopkinson, "Eve Arnold Obituary," *Guardian*, January, 5, 2012, http://www.theguardian.com/artanddesign/2012/jan/05/eve-arnold.
38. Arnold, *In Retrospect*, p. 33.
39. Eve Arnold, "A Cuban Childhood," *Gourmet*, April 2000.
40. Arnold, *In Retrospect*, p. 38.
41. Ibid.
42. Ibid., p. 24.
43. Peter Lennon, "Moments of Truth," *Guardian*, October 31, 2000, http://www.theguardian.com/culture/2000/nov/01/artsfeatures.44. Arnold, *In Retrospect*, p. 24.
45. Eve Arnold, *Flashback! The 50s* (New York: Alfred A. Knopf, 1978), p. 78.
46. Eve Arnold, interview by Russell Miller, 1987, Magnum Archive.
47. Arnold, *In Retrospect*, p. 53.
48. Beeban Kidron, in "All about Eve" by James Rampton, *Independent*, May 10, 1996, press file, Arnold Papers.
49. James Hill, interview by Janine di Giovanni, Summer 2013.
50. Eve Arnold, interview by John Tusa, "Eve Arnold," *BBC3 Radio*, November 5, 2000, press file, Arnold Papers; access at http://www.bbc.co.uk/programmes/p00nc1bw.
51. Eve Arnold, interview by Russell Miller, 1987, Magnum Archive.
52. Frank Arnold, various interviews, 2008–14, Magnum Archive.
53. Eve Arnold, interview by Russell Miller, 1987, Magnum Archive.
54. Ibid.
55. Frank Arnold, various interviews, 2008–14, Magnum Archive.
56. Eve Arnold, interview by Russell Miller, 1987, Magnum Archive.
57. Ibid.
58. Tim Adams, "Eve Arnold: Stars in Her Eyes," *Observer* (London), July 6, 2002.
59. Eve Arnold, interview by Russell Miller, 1987, Magnum Archive.
60. Eve Arnold, *Marilyn Monroe: An Appreciation* (New York: Alfred A. Knopf, 1987), p. 10.

61. Ibid., p. 26.
62. Eve Arnold, interview by Russell Miller, 1987, Magnum Archive.
63. Eve Arnold, "From a letter to Gertrude Cohen, 22nd May 1972," index card, date unknown, box 10, Arnold Papers.
64. Arnold, *In Retrospect*, p. 83.
65. Frank Arnold, various interviews, 2008–14, Magnum Archive.
66. Ibid.
67. Frank Arnold, school essay, 1958, box 12, Arnold Archive.
68. Arnold, *In Retrospect*, p. 17.
69. Ibid.
70. Ibid., p. 20.
71. Mary Panzer, "Surprising Insights," *Wall Street Journal*, January 12, 2012, http://online.wsj.com/news/articles/SB10001424052970204257504577150641295316770.
72. Arnold, *In Retrospect*, p. 63.
73. Ibid., p. 62.
74. Eve Arnold, interview by Russell Miller, 1987, Magnum Archive.
75. Ibid.

Chapter Three: A New Life in London
76. Eve Arnold, *The Great British* (New York: Alfred A. Knopf, 1991), p. 1.
77. Marguerite Arnold, obituary of Arnold Arnold, Bedales Association and *Old Bedalian Newsletter*, 2013.
78. Frank Arnold, various interviews, 2008–14, Magnum Archive.
79. Ibid.
80. Arnold, *In Retrospect*, p. 72.
81. Gert Cohen, interview by Janine di Giovanni, June 2013.
82. Eve Arnold, "A Very Personal View of the British: Three Girls in Search of a Fourth," *Queen,* March 6, 1962, tearsheet, box 23, Arnold Papers.
83. Eve Arnold to Wayne Miller, letter, July 24, 1963, box 1, Arnold Papers.
84. Ibid.
85. Eve Arnold to Wayne Miller, letter, July 24, 1963, box 1, Arnold Papers.
86. Arnold, *In Retrospect*, p. 76.
87. Ibid.
88. Eve Arnold to Lee Jones, letter, April 24, 1966, box 1, Arnold Papers.
89. Eve Arnold, interview by Val Williams, October 22, 1991, audiotape, box 60, Arnold Papers.
90. Ibid.
91. Eve Arnold to Frank Arnold, letter, November 20, 1964, box 1, Arnold Papers.
92. Chris Angeloglou, interview by Janine di Giovanni, 2013.
93. Eve Arnold, index card, date unknown, Arnold Papers.
94. Arnold, *Great British*, p. 1.
95. Eve Arnold, interview by Val Williams, October 22, 1991, audiotape, box 60, Arnold Papers.
96. Eve Arnold to Arnold Arnold, letter, November 21, 1961, box 2, Arnold Papers.
97. Frank Arnold, various interviews, 2008–14, Magnum Archive.
98. Beeban Kidron, "Eve Arnold Apprentice: She Taught Me How to Pack a Suitcase," *Guardian* (London), January 5, 2012, http://www.theguardian.com/artanddesign/2012/jan/05/eve-arnold-photographer-died-99.
99. Frank Arnold, various interviews, 2008–14, Magnum Archive.

100. Ibid.
101. Eve Arnold to Frank Arnold, letter, September 28, 1962, box 1, Arnold Papers.
102. Frank Arnold to Eve Arnold, letter, 1961, box 2, Arnold Papers.
103. Eve Arnold to Marcia Panama, letter, date unknown, box 2, Arnold Papers.
104. Anjelica Huston, in Lardinois, *Eve Arnold's People,* p. 8.
105. Eve Arnold to Bessie Cohen, letter, 1965, box 2, Arnold Papers.
106. Eve Arnold to Arnold Arnold, letter, 1965, box 2, Arnold Papers.
107. Eve Arnold, interview by Val Williams, October 22, 1991, audiotape, box 60, Arnold Papers.
108. Eve Arnold, *Sunday Times*, January 31, 1993.
109. Arnold, *In Retrospect*, p. 103.
110. Ibid., p. 107.
111. Sean O'Hagan, "All About Eve: The Photography of Eve Arnold," *Observer*, March 3, 2012, http://www.theguardian.com/artanddesign/2012/mar/04/all-about-eve-arnold-review.
112. Eve Arnold to Bessie Cohen, letter, 1965, box 2, Arnold Papers.

Chapter 4: At Home in the World
113. Eve Arnold, index card, January 31, 1979, box 9, Arnold Papers.
114. Eve Arnold to Dora, letter, January 8, 1968, box 1, Arnold Papers.
115. Isabella Rossellini, letter, recipient and date unknown, box 2, Arnold Papers.
116. Ed Victor, interview by Janine di Giovanni, 2013.
117. Beeban Kidron, in Lardinois, *Eve Arnold's People,* p. 120.
118. Ibid, p. 121.
119. Linni Campbell, various interviews, 2008–12, Magnum Archive.
120. Ibid.
121. Ibid.
122. Arnold, *In Retrospect*, p. 151.
123. Ibid.
124. Jon Snow, in Lardinois, *Eve Arnold's People,* p. 116.
125. Frank Arnold, various interviews, 2008–14, Magnum Archive.
126. Eve Arnold to Monica Menil, letter, 1972, excerpt on index card, box 10, Arnold Papers.
127. Eve Arnold, index card, date unknown, box 9, Arnold Papers.
128. Arnold, *In Retrospect*, p. 151.
129. Chris Angeloglou, interview by Janine di Giovanni, July 2013.
130. Arnold, *In Retrospect*, p. 151.
131. Yvonne Roberts, "At Least Eve Arnold Had the Chance to Break the Mould," *Observer*, January 7, 2012, http://www.theguardian.com/commentisfree/2012/jan/08/yvonne-roberts-eve-arnold-education.
132. Arnold, *In Retrospect*, p. 280.
133. Amanda Hopkinson, "Eve Arnold Obituary," *Guardian*, January, 5, 2012, http://www.theguardian.com/artanddesign/2012/jan/05/eve-arnold.
134. Eve Arnold to Bessie Cohen, letter, December 1970, box 2, Arnold Papers.
135. Eve Arnold to Bob Cohen, letter, November 13, 1972, box 2, Arnold Papers.
136. Eve Arnold to Frank Arnold, letter, 1972, box 1, Arnold Papers.
137. Eve Arnold to Bob Cohen, letter, October 4, 1972, excerpt on index card, box 9, Arnold Papers.

138. Arnold, *In Retrospect*, p. 128.
139. Eve Arnold to Gert Cohen, letter, October 27, 1972, excerpt on index card, box 10, Arnold Papers.
140. Arnold, *In Retrospect*, p. 130.
141. Frank Arnold, various interviews, 2008–14, Magnum Archive.
142. Eve Arnold to Frank Arnold's girlfriend, letter, November 27, 1975, box 2, Arnold Papers.
143. Arnold, *In Retrospect*, p. 160.
144. Eve Arnold to Charlotte Walsh, letter, May 11, 1973, box 1, Arnold Papers.
145. Arnold, *In Retrospect*, p. 165.
146. Eve Arnold to John Schlesinger, letter, May 11, 1973, box 2, Arnold Papers.
147. Eve Arnold to Arnold Arnold, letter, 1973, box "misc," Arnold Papers.
148. Frank Arnold, various interviews, 2008–14, Magnum Archive.
149. Eve Arnold to Bob Gottlieb, letter, September 20, 1976, box 1, Arnold Papers.
150. Arnold, *In Retrospect*, p. 172.
151. Eve Arnold to Gert Cohen, letter, 1975, box 2, Arnold Papers.
152. Arnold, *In Retrospect*, p. 174.
153. Eve Arnold, interview by Val Williams, October 22, 1991, audiotape, box 60, Arnold Papers.
154. Arnold, *The Unretouched Woman*, p. 1.
155. Eve Arnold to Frank Arnold's girlfriend, letter, April 1975, box 2, Arnold Papers.
156. Arnold, *In Retrospect*, p. 181.
157. Eve Arnold to Lee Jones, letter, May 7, 1977, box 1, Arnold Papers.
158. Magazine reviews from "A Brief History of Magnum," box 8, Arnold Papers.
159. Eve Arnold, *Flashback! The 50s* (New York: Alfred A. Knopf, 1978), p. 149.

Chapter 5: Think in Chinese, Look in Chinese

160. Eve Arnold, notebook, 1979, box 4, Arnold Papers.
161. Eve Arnold, interview by Terry Gross, *Fresh Air*, WHYY Philadelphia, audiotape, box 61, Arnold Papers.
162. Eve Arnold, *In China* (New York: Alfred A. Knopf, 1980), p. 8.
163. Eve Arnold to Gert Cohen, letter, December 27, 1972, excerpt on index card, box 10, Arnold Papers.
164. Hanan al-Shaykh, interview by Janine di Giovanni, July 2013, interviews file, Arnold Papers.
165. Ibid.
166. Arnold, *In China*, p. 9.
167. Pat Booth, "Eve Arnold: A Moment in Time," Modern Masters, *PhotoIcons* (2007), press box, Arnold Papers; see also http://www.photoicon.com/modern_masters/42/.
168. Ibid.
169. Chris Angeloglou, interview by Janine di Giovanni, 2013, interviews file, Arnold Papers.
170. Eve Arnold, interview by Val Williams, October 22, 1991, audiotape, box 60, Arnold Papers.

171. Interview with Eve Arnold, August 28, 1990, audiotape entitled "Five Masters of Photography," box 60, Arnold Papers.
172. Arnold, *In Retrospect*, p. 194.
173. James Fox, interview by Janine di Giovanni, 2013.
174. Eve Arnold quoted by Fox, ibid.
175. Arnold, *In Retrospect*, p. 204.
176. Liu Fen, quoted by Eve Arnold, *In China*, p. 10.
177. Liu Fen, article in *China Popular Photography*, 1980, index card, box 10, Arnold Papers.
178. Eve Arnold, "Photographing in China," index card, box 10, Arnold Papers.
179. James Fox, interview by Janine di Giovanni, 2013.
180. Eve Arnold, speech to the Hsinhua (now Xinhua) news agency, August 16, 1979, typed script, box 6, Arnold Papers.
181. Liu Fen, article in *China Popular Photography*, 1980, index card, box 10, Arnold Papers.
182. Pat Booth, "Eve Arnold: A Moment in Time," Modern Masters, *PhotoIcons* (2007), press box, Arnold Papers; see also http://www.photoicon.com/modern_masters/42/.
183. Arnold, *In Retrospect*, p. 212.
184. Gene Baro, draft of catalog introduction for *In China* exhibition, Brooklyn Museum, 1980, box 8, Arnold Papers.
185. Daniel Pettus, "Learning How to Rebel: In Her Own Eyes," bysuchandsuch.com, April 12, 2013, http://bysuchandsuch.com/2013/04/eve-arnold/.
186. Arnold, *The Great British*, p. 1.
187. Arnold, *In Retrospect*, p. 214.
188. Ibid., p. 247.

Chapter 6: A Broad Sense of Life

189. Arnold, *In Retrospect*, p. 284.
190. Ibid., p. 256.
191. Ibid., p. 258.
192. Isabella Rossellini, *Vogue* (France), July 1995.
193. Isabella Rossellini, in Lardinois, *Eve Arnold's People*, p. 11.
194. Isabella Rossellini, *Vogue* (France), July 1995.
195. Arnold, *In Retrospect*, p. 261.
196. Ibid., p. 258.
197. Frank Arnold, various interviews, 2008–14, Magnum Archive.
198. Arnold, *In Retrospect*, p. 264.
199. Eve Arnold to Lucy Kroll, letter, April 27, 1985, box 2, Arnold Papers.
200. Arnold, *In Retrospect*, p. 268.
201. Frank Arnold, various interviews, 2008–14, Magnum Archive.
202. Eve Arnold, interview by Val Williams, October 22, 1991, audiotape, box 60, Arnold Papers.
203. Eve Arnold to Susan Meiselas, letter, date unknown, box 11, Arnold Papers.
204. Eve Arnold to Germaine Greer, letter, July 16, 1981, box 1, Arnold Papers. According to Susan Meiselas, her trips to Nicaragua and El Salvador were self-assigned, not assignments: "I started to just go there on my own. It wasn't with an assignment, though eventually I got a few, nor was it a personal independent project exactly. I immersed myself in

an historical process, and as it evolved I stayed with it!" See note 197 for Meiselas source.

205. Susan Meiselas, interview by Janine di Giovanni, 2014.
206. Ibid.
207. Rosemary Bowen-Jones, email to Helen Rogan, April 6, 2014, Magnum Archive.
208. Ibid.
209. Susan Meiselas, interview by Janine di Giovanni, 2014.
210. Arnold, *In Retrospect,* p. 279.
211. Ibid.
212. Eve Arnold, interview by Russell Miller, 1987, interviews file, Arnold Papers.
213. Eve Arnold, letter, recipient and date unknown, Arnold Papers.
214. Chris Angeloglou, interview by Janine di Giovanni, 2013.
215. Susan Meiselas, interview by Janine di Giovanni, 2014.
216. Gert Cohen, interview by Janine di Giovanni, 2013.
217. Hanan al-Shaykh, interview by Janine di Giovanni, 2013.
218. James Hill, interview by Janine di Giovanni, 2013.
219. Ibid.
220. Ibid.
221. Arnold, *In Retrospect,* p. 284.
222. Eve Arnold, in Jobey, "What Eve Arnold Saw."
223. Mary McCartney, in Lardinois, *Eve Arnold's People,* p. 126.
224. Patricia Wheatley, email to Helen Rogan, April 6, 2014, Magnum Archive.
225. Ibid.
226. Eve Arnold to Isabella Rossellini, letter, 1998, box 1, Arnold Papers.
227. Henri Cartier-Bresson to Eve Arnold, fax, April 21, 2002, Arnold Papers.
228. Frank Arnold, various interviews, 2008–14, Magnum Archive.
229. Lardinois, *Eve Arnold's People,* p. 8.
230. Eve Arnold, interview by Janine di Giovanni, 2000.
231. Jobey, "What Eve Arnold Saw."
232. Chris Angeloglou, interview by Janine di Giovanni, 2013.
233. Hanan al-Shaykh, in Jobey, "What Eve Arnold Saw."
234. Interview with Eve Arnold, August 28, 1990, audiotape entitled "Five Masters of Photography," box 60, Arnold Papers.
235. Gaby Wood, "Eve Arnold: She Chased the Image that Told the Story," *Daily Telegraph,* January 20, 2012, http://www.telegraph.co.uk/culture/photography/9027868/Eve-Arnold-she-chased-the-image-that-told-the-story.html.

Into the Archive: "My Own Mad Conscientiousness"

236. The Eve Arnold Papers at Yale University consists of the following: two boxes of correspondence; three boxes of notebooks; three of research notes; two of index cards; thirteen of tearsheets; eighteen of photographs; twenty-seven of contact sheets; forty-nine of photographs, contacts, and captions for publications; twenty-two of negatives; twenty of slides; and numerous other boxes of audio and video material, posters, publicity, and ephemera.
237. Magnum Photos: magnumphotos.com.
238. Eve Arnold to Wayne Miller, letter, July 24, 1963, box 1, Arnold Papers.
239. "Migrant Workers," contact sheet, c. 1951, box 77, Arnold Papers.
240. "Migrant Workers," contact sheet, c. 1951, box 137, Arnold Papers.
241. Eve Arnold, "Color and Monochrome," index card, date unknown, box 10, Arnold Papers.
242. Charles Johnson Memorial Hospital in Nqutu, South Africa contact sheets and color slides, 1973, box 74, Arnold Papers.
243. Eve Arnold, interview by Val Williams, October 22, 1991, audiotape, box 60, Arnold Papers.
244. "School for Sit-ins," *Look,* August 30, 1960, tearsheet, box 30, Arnold Papers. In her story list, Arnold refers to this story as "Non-Violence in Virginia."
245. Eve Arnold, China 1979 diary, entry dated June 30, 1979, box 4, Arnold Papers.
246. Eve Arnold, "Moon," index card, 1970s, box 9, Arnold Papers.
247. Eve Arnold, "Function of the Photog [sic]," index card, date unknown, box 10, and "What do you hang on walls of your mind?" index card, January 31, 1979, box 9, Arnold Papers.
248. Eve Arnold, "From a letter to Gertrude Cohen, 22nd May 1972," index card, date unknown, box 10, Arnold Papers. Italicized words are highlighted in original.
249. Eve Arnold to Frank Arnold, letter, January 23, 1963, box 1, Arnold Papers.
250. Linni Campbell, interview by Tessa Hite, January 8, 2014.
251. Eve Arnold to Arnold Arnold, three letters, November 21, 1961; November 26, 1961; November 27, 1961; box 2, Arnold Papers.
252. Eve Arnold to Arnold Arnold, letter, Nov 26, 1961, box 2, Arnold Papers.
253. Eve Arnold to Frank Arnold, three letters, January 21, 1956; January 23, 1963; November 20, 1964; box 1, Arnold Papers. Note that most of Eve Arnold's letters to Frank are in a folder in box 1.
254. Eve Arnold to Lee Jones, letter, January 16, 1967, box 1, Arnold Papers.
255. Eve Arnold to Lee Jones, letter, January 31, 1967, box 1, Arnold Papers.
256. Lee Jones to Eve Arnold, letter, February 6, 1967, box 1, Arnold Papers.
257. Eve Arnold to Lee Jones, letter, February 13, 1967, box 1, Arnold Papers.
258. Eve Arnold to Russ Melcher, letter, February 13, 1967, box 1, Arnold Papers.
259. Eve Arnold, "Editing," *In Retrospect* notes, box 8, Arnold Papers.

ACKNOWLEDGMENTS

Thanks are due to Frank Arnold, Eve Arnold's son, for his cooperation and enthusiasm for this first volume. Susan Meiselas's keen eye and boundless energy make her a driving force behind this and every Magnum Foundation initiative. John P. Jacob, director of the Magnum Foundation Legacy Program, provided advice and helpful oversight every step of the way. Christopher Klatell provided invaluable counsel and insight. Janine di Giovanni, who had known and admired Eve, signed on to the project enthusiastically. Helen Rogan's contributions to the text were essential. Carole Naggar gave great editorial guidance and contributed in the selection of archival materials and photos. Tessa Hite did primary research in Arnold's archives and was masterful at resolving issues and inconsistencies. Laura Lindgren was able to incorporate all points of view during our many discussions and formulate a cohesive design for the series, while Nerissa Dominguez Vales expertly guided production. Our thanks to Anne Marie Menta and the staff at the Beinecke Library for their invaluable help during our research on this book. And finally, we would like to thank Karen Levine, Ryan Newbanks, and the entire team at Prestel for believing in and supporting this project.

—Andrew E. Lewin, Managing Editor
Magnum Legacy series

SUGGESTED FURTHER READING

BOOKS ON AND BY EVE ARNOLD

Arnold, Eve. *All in a Day's Work.* Toronto: Bantam Books, 1989.

———. *Eve Arnold: In Retrospect.* New York: Alfred A. Knopf, 1995.

———. *Flashback!: The 50s.* New York: Alfred A. Knopf, 1978.

———. *In China.* New York: Alfred A. Knopf, 1980.

———. *Marilyn Monroe.* New York: Harry Abrams, 2005.

———. *The Unretouched Woman.* New York: Alfred A. Knopf, 1976.

Arnold, Eve, and Mehmet Dalman. *All About Eve: The Photography of Eve Arnold.* Kempen, Germany: teNeues, 2012.

Lardinois, Brigitte, ed. *Eve Arnold's People.* London: Thames & Hudson, 2009.

Siben, Isabel, and Andrea Holzherr, eds. *Eve Arnold: Hommage.* Munich: Schirmer/Mosel, 2012.

BOOKS ABOUT MAGNUM

Boot, Chris, ed. *Magnum Stories.* London: Phaidon Press, 2004.

Lacouture, Jean, William Manchester, and Fred Ritchin. *In Our Time: The World as Seen by Magnum Photographers.* New York: W. W. Norton & Co., 1989.

Lubben, Kristen, ed. *Magnum Contact Sheets.* London: Thames & Hudson, 2011.

Miller, Russell. *Magnum: Fifty Years at the Front Line of History; The Story of the Legendary Photo Agency.* New York: Grove Press, 1997.

INDEX

Published by Prestel,
a member of Verlagsgruppe Random House GmbH

Prestel Verlag
Neumarkter Strasse 28
81673 Munich
Tel.: +49 89 41 36 0
Fax: +49 89 41 36 23 35

Prestel Publishing Ltd.
14–17 Wells Street
London W1T 3PD
Tel.: +44 (0)20 7323 5004
Fax: +44 (0)20 7323 0271

Prestel Publishing
900 Broadway, Suite 603
New York, NY 10003
Tel.: +1 212 995 2720
Fax: +1 212 995 2733
E-mail: sales@prestel-usa.com

www.prestel.com

Library of Congress Cataloging-in-Publication Data
Di Giovanni, Janine, 1961–
Eve Arnold : Magnum legacy / Janine di Giovanni, Magnum Foundation.
pages cm
Includes bibliographical references and index.
ISBN 978-3-7913-4963-3
1. Arnold, Eve. 2. Photographers—United States—Biography. 3. Photographers—Great Britain—Biography. 4. Magnum Photos. I. Magnum Photos. II. Title.
TR140.A76D53 2015
770.92—dc23
[B] 2014020329

For the Magnum Foundation:
Managing editor: Andrew E. Lewin
Series editor: Carole Naggar
Editorial assistant/researcher: Tessa Hite

For Prestel:
Editorial direction: Karen A. Levine
Managing editor: Ryan Newbanks
Design: Laura Lindgren
Copyediting: Jeff Campbell
Proofreading: Charlotte Blom
Index: Theresa Duran
Production: The Production Department
Separations: Altaimage-NYC
Printed in China

Verlagsgruppe Random House FSC® N001967
The FSC-certified paper 157gsm SPCO matte art has been supplied by Stora Enso Suzhou Paper Co., Ltd., Jiangsu, China.

Front cover: Self-portrait in a distorting mirror, 42nd Street, New York, 1950

Back cover, clockwise from top: Marilyn Monroe on the set of *The Misfits*, Reno Nevada, 1960 (fig. 50); Joan Crawford checking her makeup, Hollywood, 1959 (fig. 47); Malcolm X at Black Muslim rally, Washington DC, 1961 (fig. 65); A mother's finger grasped by her newborn, Port Jefferson, Long Island, 1959 (fig. 64); Haiti insane asylum, 1954 (fig. 38)

Endsheets: Contact sheets from the set of *The Misfits* showing Clark Gable, Marilyn Monroe, and Montgomery Clift in rehearsal, Reno, Nevada, 1960 (front) and from Eve Arnold's reportage *In China*, 1979 (back)

Fig. 1 (p. 3): Eve Arnold on the set of *Becket*, 1963. Photo: Robert Penn